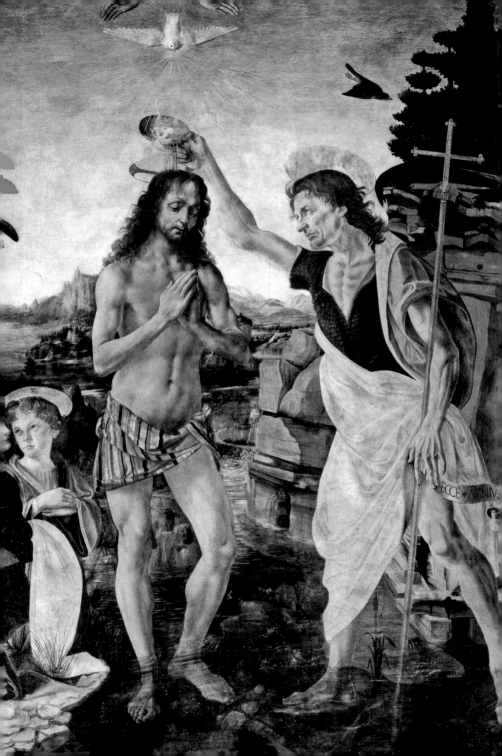

...isms

UNDERSTANDING RELIGION

THEODORE GABRIEL
and
RONALD GEAVES

UNIVERSE

Religion has been with us from antiquity and remains influential in most parts of the world. Even in the secularised parts of the West, it refuses to capitulate, throwing up new forms as older allegiances decline. Not all of the religions included in this volume are known by their followers as an 'ism'. However, they can be defined as such in that each religion remains a discrete and separate world defined by its own beliefs and practices.

Notoriously hard to define, religion is more easily identified by its constituent parts. The religious scholar Ninian Smart identified seven dimensions that constitute a religion: the doctrinal, experiential, ritual, mythological, social, ethical and material. It is the unique world that consists of the totality of these seven dimensions that makes each religion an 'ism'.

This book does not attempt to provide a comprehensive trawl through all of the world's religions. Such a task is encyclopaedic. Many are not included, but those that are fall within the various categories described below. Nor can such a small book hope to provide a detailed analysis of the depth and breadth of each religion's practices and beliefs. There is marked diversity in all religions as believers negotiate for themselves their own interpretations of a religion's truth claims. However, it does attempt to illustrate such diversity, particularly within Christianity, though Islam, Buddhism and Hinduism are no less diverse.

Of the world's religions, Christianity has the largest number of adherents. Its three main branches are the Roman Catholic, Eastern Orthodox and Protestant churches, all of which also include many denominations that differ in both doctrine and rituals. There are also heterodoxical groups, such as the Jehovah's Witnesses, the Church of Jesus Christ of Latter-Day Saints (Mormons) and Christian Scientists, who claim to be Christian but are not acknowledged as such by the mainstream churches.

The book concentrates on the ritual and material dimensions of religion, as these are visually graspable. Where religions have become linked historically with particular societies, cultures and civilisations, they have generated architecture, art, dress, ethics and rituals that are interwoven with cultural norms. But not all religions have manifested as such. There are those that exist in dissent with their dominant cultures and whose beliefs insist upon an iconoclastic approach. Such religions refuse to establish sacred spaces, art forms and sacred texts, and may even be anti-ritual. Where this occurs it has been difficult to recommend places to visit and readers may discover a paucity of elements that encourage spiritual tourism. Not all religions have influenced or found themselves easy bedfellows with civilisations or dominant societies. And even for those that have, the process may have taken hundreds of years.

There may be differences between believers' perspectives and those of the authors in terms of what should have been included in or omitted from the book. No offence to any religion is intended by the authors, who remain strictly neutral with regard to the various truth claims of any tradition.

THE SIX TYPES OF ISM

JUDAISM

Judaism has been given a category of its own because of its significance as the earliest form of Semitic monotheism, and its considerable impact on both Christianity and Islam, both of which could be said to have developed, reformed or reinterpreted its teachings.

CHRISTIANITY

Christianity is a section of its own because it is the largest religion in the world and the dominant movement in the Western world. Consequently, the full diversity of Christian denominations, or isms, is represented in this section.

ISLAM

Islam is the last of the great world religions that arose out of Semitic cultures and spread across the globe. For this reason, and its significance in both ancient and contemporary history, it fully deserves its own section.

BUDDHISM AND SOUTH ASIAN RELIGIONS

These isms consist of religions that originated in South Asia, such as Hinduism, Jainism, Buddhism and Sikhism. In some cases there is an overlap with the Regional Religions section. For example, Sikhism is associated with the Punjab in North India, and even Hinduism, the third largest religion in the world, is located predominantly in India. However, the processes of migration and globalisation have created diaspora communities of these religions around the world. Buddhism spread across Asia from its origins in India very early in its history, but has been included here because it began in India. The above religions including Judaism, Christianity and Islam are often labelled World Religions.

VERNACULAR RELIGIONS

Animism has existed as one of the most ancient forms of religion known to be practised by human beings. All of the religions in this section include some element of this ancient ism and often consider themselves to have originated in antiquity. However, in most cases they are modern transformations or revivals of ancient forms of religion that predate Christianity. 'Vernacular' here refers to religions that emphasise pragmatic elements in everyday life such as health, longevity, fertility, drought, floods and other natural forces that can bring either disaster or prosperity. Furthermore, it assumes that these requirements for daily well-being can be controlled by magical means that either enlist the assistance of benign beings or keep away the malign influence of supernatural beings through the intercession of specialist practitioners or ritual activity.

REGIONAL RELIGIONS

The religions included in this section are closely associated with the ideas and beliefs of a particular culture or society. All religions interact with culture, maybe a given topography or society, and may originate in certain historical factors that locate them with a national or regional identity. The isms included here may have spread to other locations around the world through missionary activities or migration, but they remain firmly located in a particular cultural form or region of the world. In many cases they are associated with various struggles to assert national identities or cultural norms.

How to use this book

INTRODUCTION
The first section of each ism is a brief introduction and definition of the particular religion.

KEY FIGURES
This is a list of prominent individuals associated with the ism, including founders. Where a religion is ancient and legendary, rather than historical, the Key Figures consist of the principal deities or spirits who are worshipped or venerated by the movement's adherents.

KEY WORDS
All religions possess their own specialist vocabularies, sometimes in languages considered sacred by believers. The Key Words listed are selective and refer to concepts or practices unique to the religion.

MAIN DEFINITION
This section explores the ism in more depth, providing an insight into the religion's history, practices and beliefs.

KEY EXAMPLES
Each ism is illustrated with one or two key images; for example, sacred buildings, pilgrimage sites, ritual acts of worship, festival locations and works of art. Wherever possible the illustrations are of places that can be visited by the public. However, some religions do not permit outsiders to enter certain sacred spaces.

SEE ALSO
This list is a supplement to the Key Examples and includes other places of interest for each particular ism.

Catholicism 28 / Catholicism 29

The word Catholicism (literal meaning 'universal') can indicate orthodoxy in the Christian Church, but more commonly refers to the doctrines of the Roman Catholic Church.

EMPEROR CONSTANTINE (274–337 CE); AUGUSTINE OF HIPPO (354–430 CE); JOHN HENRY NEWMAN (1801–90); POPE JOHN PAUL II (1920–2005); POPE BENEDICT XVI (1927–)

apostolic succession, hierarchical government; orthodoxy; papal infallibility; veneration of saints

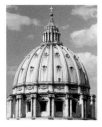

The Christian Church, which had been heavily persecuted by the Roman emperors, became legitimate and fully established during the reign of Emperor Constantine, who accepted Christ after a vision of the Cross in the sky in 312 CE.

The early Christian Church was organised under five sees, under the patriarchs of Rome, Alexandria, Antioch, Constantinople and Jerusalem, with Rome considered *primus inter pares* (first among equals), as the Bishop of Rome (the Pope) was believed to be the successor to St Peter (who Jesus named Peter after the Galilean word for rock, meaning the rock on which he would establish his church). However, in the 11th century, doctrinal disputes (based mainly on the earlier thinking of the theologian and philosopher Augustine of Hippo, or Saint Augustine), the evolution of different ritual practices and differences in church government resulted in the Great Schism of the Eastern and Western churches. This was followed by a further important rift in the 16th century when the Protestant, or Reformed, churches repudiated papal authority and practices such as the sale of indulgences in the Roman Church. John Henry Newman, a convert from Anglicanism to Roman Catholicism, sought in his Oxford Movement to bring the Church of England back to its Catholic roots.

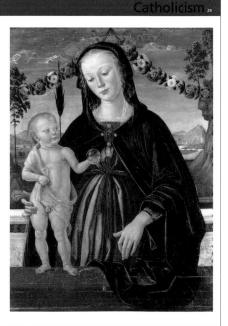

↑ Dome of St Peter's Basilica, Vatican City, Rome, Italy
The Basilica, which was built between 1546 and 1564, is believed to be at the site of the crucifixion of St Peter. Recent excavations have revealed a burial chamber beneath the altar containing what are believed to be St Peter's remains.

→ *The Virgin and Child,* c.1515–25, FIORENZO DE LORENZO
Mary (Mother of God), has always occupied a central position in the Catholic faith. The red roses in the background represent Mary and Christ's suffering, and the white roses her purity. The garland may also symbolise the rosary.

Other resources included in the book

GLOSSARY OF USEFUL TERMS

The Glossary of Useful Terms includes those that have been used in the book to describe the various isms, but also adds a general selection of key terms readers may come across when visiting religious locations or reading about religion elsewhere.

CHRONOLOGY OF RELIGIONS

The chronology of religions remains highly disputed amongst both scholars of religion and those who practise such religions. The birth dates of founders are not always known and some religions, such as Hinduism and Jainism, trace their origins to legendary pasts. Many of the 'new' religions described in the book claim ancient origins – for example, Wicca or Druidism – but the modern revivals are distinct from the ancient forms. Where this occurs, the editors have chosen to locate the religions as new phenomena. We are aware that our chronology is disputed and do not intend to cause offence to believers.

MAPS

After some consideration, the authors decided not to include maps that show the geographic spread of the religions covered in the book. Such maps are available in other sources for the major world religions, but become increasingly problematic as the forces of globalisation continuously transform the religious landscape. Instead we have chosen to locate the place of origin of each religion, where it is possible to do so. In the case of Animism, for example, there is no specific geographic point of origin. We are aware that places of origin may in some cases be approximate, and in others disputed.

PLACES TO VISIT

This gives approximate locations where examples of particular isms can be found. The list is by no means exhaustive and is only a selection of some of the most famous religious locations in the world. Most are cultural centres and places of worship that welcome visitors. However, visitors should be aware that they may be expected to observe certain cultural and religious norms of behaviour and dress codes.

I

JUDAISM

Judaism

Judaism is one of the family of the world's three great monotheisms – Judaism, Christianity and Islam. It has common origins with both Christianity and Islam, and also shares certain of their patriarchs, doctrines and practices.

ABRAHAM (2051–1976 BCE); **ISAAC** (1953–1773 BCE); **JACOB** (1893–1746 BCE); **MOSES** (1392–1272 BCE); **MAIMONIDES** (1135–1204); **THEODORE HERZL** (1860–1904)

Halakah; Israel; Moshiach; monotheism; Shabbat; synagogue

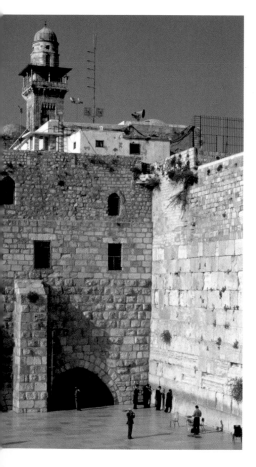

Judaism is not just a religion, but also a way of life, a race and a culture. It is very diverse, with Orthodox Jews, Reformed Jews, Ashkenazi, Sephardic and other ethnically defined groups spread across the world and from all races. Some Jews are completely secular and may not practise any of the religious rituals stipulated by the Halakah (Jewish code of law). Half the Jews of the US, for example, do not belong to a synagogue. Some do, however, observe certain Jewish celebrations and holy days, though these are not always seen as religious practices.

The term 'Judaism' comes from Judah, the fourth son of Jacob whose 12 sons became the founders of the 12 tribes of ancient Israel. Though technically Judaism thus implies only one such tribe, in the modern sense the Jews represent all the descendants of Jacob (also known as Israel). Theodore Herzl, who lived in Germany, is considered the initiator of Zionism – the move to resettle Jews in the Holy Land.

For Jews, there is only one God, who revealed himself to Abraham, Isaac and Jacob. His commandments, laws and regulations were conveyed to Moses who led Israel out of bondage from Egypt, at Mount Sinai, and form the Torah, the most eminent scripture of Judaism. God is incorporeal, omnipotent, omniscient, eternal, holy, merciful and just, and in this

← **Western Wall, Old City, Jerusalem, Israel**
The Western Wall (often known as the 'Wailing Wall' though the term is disliked by Jews) is the only remnant of the second Jewish Temple, destroyed by the Roman Emperor Titus in 70 CE. The wall is a symbol of God's continuing love despite the suffering and persecution suffered by Jews.

→ **King David's Tomb, Jerusalem**
David, who succeeded Saul as King of Israel when Saul fell out of God's favour, was not only a good warrior and leader of men, but also a great poet and musician.

sense Judaism has much in common with Islam. The idea of the Messiah (or Moshiach) is also central to the Jewish faith. A descendant of David (the great king of Israel), it is believed that the Messiah will establish the suzerainty of Israel in the world, creating a kingdom of peace, restoring Jerusalem and the Holy Temple there, and ending all wickedness and sin, during a time of great tribulation. Unlike the Christians, Jews do not consider Jesus to be the Messiah, and the concept of the Trinity is completely rejected.

The Halakah is made up of 613 mitzvoth (singular, mitzvah), or commandments, as prescribed in the Torah, but can also include laws propounded by rabbis (Jewish scholars or teachers), as well as traditional customs. The Shabbat (day of rest) is particularly important in Judaism, as are dietary laws such as kosher. The thinking of Maimonides, one of the greatest of Jewish rabbinical philosophers, who lived in Spain and Egypt in the Middle Ages, is considered the cornerstone of Jewish orthodoxy today.

Jews worship in sanctuaries within their synagogues. The Torah scrolls are housed in a cabinet called the Aron Kodesh, which faces Jerusalem, seemingly representing the inner sanctuary of the ancient Holy Temple, and are read on a lectern called a bimah. The Ner Tamid lamp burns constantly, like the flame outside the inner sanctuary in ancient practice, and a seven-branched menorah (sacred candelabrum) can also be found in front of the Aron Kodesh.

In Orthodox synagogues women usually sit separate from men, as in Muslim mosques. However, women are held in high regard in Jewish societies. Jews believe that God has endowed women with greater intuition, intelligence and understanding, and the Jewish Bible mentions seven female prophets. Women are exempt from certain provisions in the mitzvoth to facilitate childbearing and nurture, and their duties are different from those of men. However, this does not mean their responsibilities are any less important.

It is estimated that there are currently 15 million followers of Judaism across the world.

← *Jacob's Ladder, c.* 18th century, **WILLIAM BLAKE**
It is believed that the hill where Jacob, Patriarch of Israel, experienced his vision of angels ascending and descending a ladder to heaven is the site on which the Jewish Temple was built. Now held in the British Museum in London, the watercolour is symbolic of the belief that the Temple is where the sacred and the earthly worlds meet.

↓ **Old-New Synagogue, Prague, Czech Republic**
The Old-New Synagogue (Alt-Neu Schul), completed around 1270, is the oldest of Europe's synagogues still used for worship today. Originally called the New Synagogue, its name changed in the 16th century when further synagogues were built.

◉ **EGYPT** Mount Sinai: IRAQ Gates of Nineveh, near Mosul: **ISRAEL** Temple Mount, Jerusalem: **PALESTINIAN TERRITORIES** City of Jericho

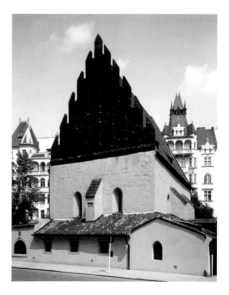

Orthodox Judaism

This is the generic term for the Jewish groups who adhere to a strict interpretation and application of Jewish scripture and law. It was used by more liberal Jewish groups in the early 19th century to denote conservative Jewish sections, but not accepted by some Orthodox Jews.

SAMSON RAPHAEL HIRSCH (1808–88); CHIEF RABBI YITZHAK HALEVI HERZOG (1889–1959); LUBAVITCHER REBBE MENACHEM MENDEL SCHNEERSON (1902–94); RABBI JOSEPH SOLOVEITCHIK (1903–93)

exclusivist; Halakah; Haredi; Hasidic; Modern Orthodox; tradition

Orthodox Jews declare that the Torah (the five books of Moses, the Pentateuch) is of divine origin and not open to human amendment. They also abide by oral Jewish law as presented in rabbinic literature, such as the Talmud and the Haggadah, and are rigorous adherents of the Halakah (Jewish code of law). Subgroups of Orthodox Judaism include Modern Orthodox, Haredi and Hasidic Jews, which differ according to their attitudes towards secular society, the importance of Torah study vis-à-vis secular studies, maintaining orthodoxy in dress, language and music, the importance of the State of Israel to Judaism, and the role of women in religious society. Each claims to be the true representative of Judaism.

At the beginning of the 19th century, when some elements of German Jewry began to follow a more liberal path, others, while also engaging with a post-Enlightenment society, wished also to preserve tradition. The ideas of Rabbi Samson Raphael Hirsch are representative of this camp, who were the precursors of Modern Orthodox Jews. It was Rabbi Lubavitcher Rebbe Mencahem Mendel Schneerson in America who intensified the outreach of Orthodox Judaism.

In the 20th century, the ardour and rigour of some Orthodox Jews increased, leading to the Haredi movement, labelled pejoratively by some as 'Ultra Orthodox'.

Modern Orthodox Jews integrate with non-Jewish society, while maintaining the importance of secular knowledge, religious Zionism and the State of Israel. Rabbi Joseph Soloveitchik was a prominent champion of this ideology, and Chief Rabbi Yitzhak Halevi Herzog was a keen protagonist of Zionism. Haredi Jews prefer segregation from non-Jewish culture, though not entirely from non-Jewish societies. They emphasise community studies of the Torah rather than studies by religious functionaries only. Hasidic Jews reject any interaction with non-Jewish society and, along with the Haredi, are ambivalent about the importance of the State of Israel to Judaism.

→ **Great Synagogue, Budapest, Hungary**
This is the second largest synagogue in the world, the largest being in New York. While the onion domes are evocative of the Orient, the twin towers that resemble church steeples represent the Hungarian influence.

HUNGARY Medieval Synagogue, Budapest: **INDIA** Jewish Synagogue, Cochin, Kerala: **UK** Princes Road Synagogue, Liverpool, England: **UKRAINE** Moorish-style Jewish Hospital, Lviv: **US** Rabbinical College of America, Morris Town, New Jersey

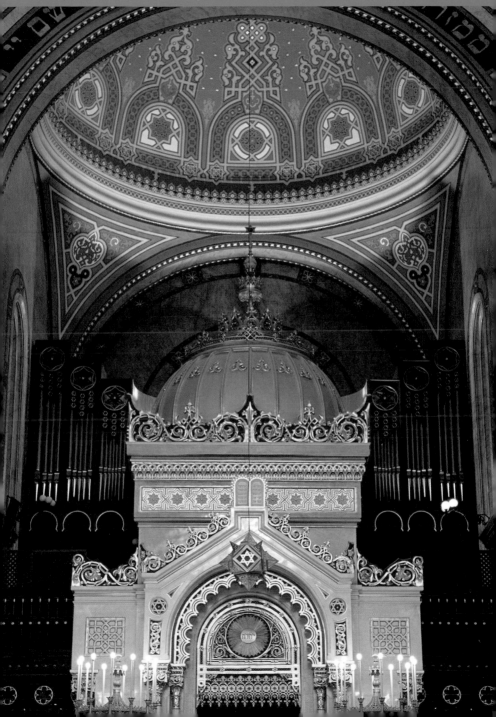

Reform Judaism

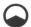 The inspiration for Reform Judaism came from the Jewish response to Enlightenment values, especially in 19th-century Germany, and the quest by Jews for equality and integration in European society. The movement has since spread to other regions, notably the US and Israel.

ISRAEL JACOBSON (1768–1828); **LEOPOLD ZUNZ** (1794–1886); **SAMUEL HOLDHEIM** (1806–60); **DAVID HEINHORN** (1809–79); **ISAAC MAYER WISE** (1819–1900)

autonomy; gender equality; modernisation; temples

Reform Judaism, a movement that originated in 19th-century Germany, treats Judaism as a religion, not a culture, and thus enabled Jews to counter accusations of Jewish separatism and become ordinary citizens in their host nations across the world, as well as to adapt to modern changes in social, political and cultural life. Reforms included autonomy in interpreting Jewish scriptures, which are no longer looked upon as divine, and allowing criticism and textual analysis of the Jewish Bible and rabbinic literature. Language, dress and customs were also modernised, and complete gender equality in religious and nonreligious matters was introduced in the form of the ordination of women rabbis, and the participation of non-Jews as cantors and choristers. The Hebrew phrase *Tikin olam* (repair of the world) is looked upon as the foremost way of serving God.

An early reformer in Germany was Israel Jacobson. Samuel Holdheim was well

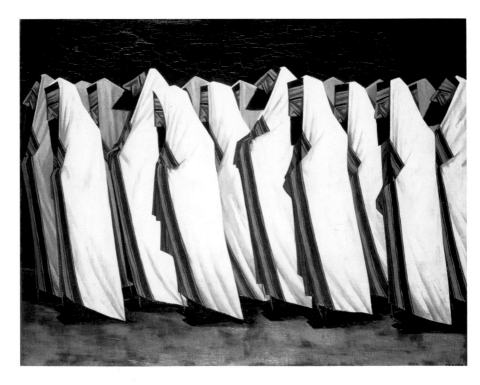

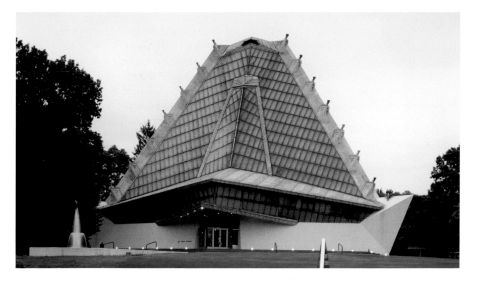

known for his very progressive views, and Leopold Zunz in Berlin was noted for his critical study of Jewish literature and ritual.

Worship tends to emulate Protestant Christianity. The use of Hebrew has been curtailed, and more music and the use of musical instruments such as the pipe organ introduced. Reform Judaism also introduced the rite of confirmation for young Jews. Services are shorter and places of worship called temples – a radical departure from the Jewish belief that this term could only be applied to the Temple in Jerusalem (the Holy Temple).

German immigrants continued these trends in the US. Isaac Mayer Wise was one of the pioneers of Reform Judaism in North America, and David Heinhorn argued for the use of the vernacular in worship as well as other reforms, and authored a revised prayer book that became the model for Reformed Jewish congregations across America. At the Pittsburgh Platform of 1885, Reform Jews decided to abandon dietary and dress codes, as well as ideas of priestly purity, resolving instead to observe only moral laws and those ceremonies that could sanctify and elevate their lives, abandoning all that were not compatible with modern civilisation. The religion currently has more than three million adherents.

↑ **Beth Sholom Synagogue, Elkin's Park, Pennsylvania**
Completed in 1959, the synagogue was designed by architect Frank Lloyd Wright. The triangular geometrical design of the roof simulates both Mount Sinai, where the Jewish Law was received by Moses from God, and the Tent of Meeting, which preceded the first proper temple built by King Solomon.

← *The Day of Atonement*, 1919, JACOB KRAMER
This painting, held at the Leeds City Art Gallery, England, shows Jews at prayer on the Day of Atonement (or Yom Kippur) and is by Jewish artist Jacob Kramer who is of Ukrainian origin. Yom Kippur falls on the the tenth day of the Jewish month of Tishri, and is a day of complete fasting spent in prayer at the synagogue.

◉ **UK** Reform Synagogue, Park Place, Cheetham, Manchester, England: **US** Bret Breira Synagogue, Miami, Florida; Mickve Israel Congregation (Reform Judaism), Savannah, Georgia; Temple Beth Teffiloh, Brunswick, Georgia; Temple Habonim, Barrington, Rhode Island

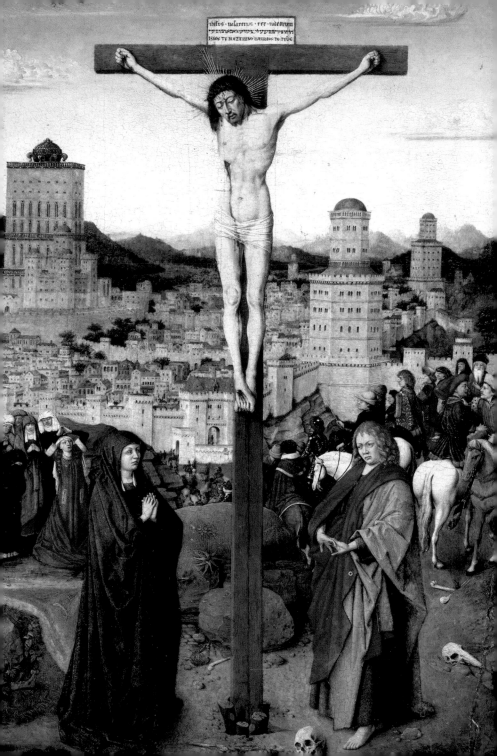

2

CHRISTIANITY

Adherents of the Christian faith follow the precepts and example of Christ (literally 'the anointed one'). Christianity is the largest religion in the world, with more than two billion followers worldwide.

ST PETER (1st century CE); ST PAUL (1st century CE); THE POPE; CONSTANTINE (272–337 CE); MARTIN LUTHER (1483–1546)

Cross; Jesus; Messiah; non-violence; Trinity

Originally a Jewish sect (in the 1st century CE), Christianity soon transcended national and ethnic boundaries to become a world religion, mainly as a result of the efforts of missionary to the gentiles (non-Jews) St Paul.

Christians are the followers of Jesus, who they accept as Christ and one of the Holy Trinity of the Godhead (namely, God the Father, God the Son and God the Holy Spirit). They believe Jesus to have been a human yet divine being who died on the Cross to make amends for the sins of humankind; thus all who accept him as their saviour will attain salvation and eternal life. Jesus was tried, tortured and executed on the Cross by Pontius Pilate, the governor of Judea in the Roman Empire, at the instigation of Jewish leaders who saw him as a threat to their authority and influence among the Jewish people.

Though the early church was severely persecuted by Roman emperors, Emperor Constantine became a convert to the faith in 312 CE after witnessing a vision of the Cross in the sky and adopted Christianity as the state religion.

Christianity developed as an interpretation of the references to the life and teachings of Jesus Christ in the Hebrew Bible (now known as the Old Testament).

The second part of the Christian Bible, the New Testament, consists of the four Gospels (records of his life), the Acts of the Apostles, the Epistles (letters from the Apostles and other early church leaders), and the Book of Revelation – the Apocalypse. Apocrypha are biblical or related writings of Jewish and Christian provenance, but are not part of the accepted canon of Scripture (though they are included in some versions of the Bible). Old Testament apocrypha can be read for instruction, but not for preaching or liturgical use in the church, while New Testament apocrypha are largely excluded. Some Christian sects have their own texts that are considered to be of scriptural standing.

Christianity has many divisions, or denominations. The first major schism (known as the Great Schism) occurred in 1054 between the Eastern and Western churches as a result of doctrinal and political differences, and the second in 1517 when Martin Luther, a German monk, embarked on a critique and reform of the Roman Catholic Church. The three resulting branches of Christianity – Roman Catholicism, Eastern Orthodoxy and Protestantism – are further subdivided

→ **Via Dolorosa, Jerusalem, Israel**
Christ's arduous and torturous passage from Pilate's Pretorium to the place of Crucifixion is an important part of the Passion of Christ. The Via Dolorosa (Latin for 'the way of grief') is believed to be the route he took. Fourteen stations marked along the route relate to specific incidents along the way. Pilgrims re-enact this passage, often carrying large crosses.

← *Crucifixion, c.* 15th century, JAN VAN EYCK (see page 20)
Completed in 1430, this dramatic portrait of the Crucifixion is one of the most famous depictions of this climactic episode. The Crucifixion, Christians believe, is the one act of Christ that has saved many from eternal damnation.

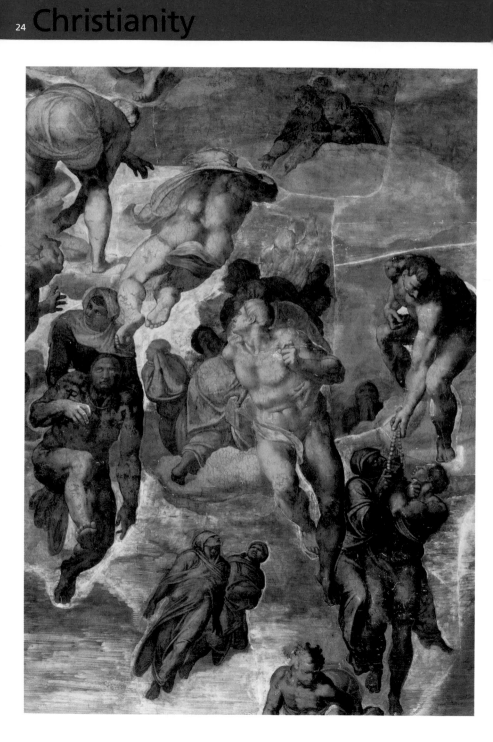

into various denominations. A number of heterodox sects also claim to be Christian, for example Jehovah's Witnesses, the Church of Jesus Christ of Latter-Day Saints (Mormons) and the Christian Scientists, but are not accepted as such by the main Christian churches. Recently, Christianity has been declining in the West, especially in Europe, though it is flourishing and even expanding in parts of Latin America, Asia and Africa.

The Pope, considered to be a successor of St Peter, a disciple of Jesus Christ to whom he entrusted his church, is head of the Roman Catholic Church and exercises authority in doctrinal matters and the appointment of bishops across the world. Likewise, the Archbishop of Canterbury is head of the worldwide Anglican communion, a group of Christian churches derived from or related to the Church of England and including the Episcopal Church in the US as well as national, provincial and independent churches. Both believe in apostolic succession, whereby their bishops can be ordained as successors of the Apostles of Christ.

Style of worship varies considerably across the different branches of Christianity, the more formal Roman Catholic and Eastern Orthodox churches, for example, adhering to centuries-old traditions (though incorporating the vernacular and other, more recent, changes), and the more charismatic to an open, less formal and more energetic style. Many modern churches use contemporary music and even dance in worship, and in the West such churches are proving more successful in attracting younger worshippers.

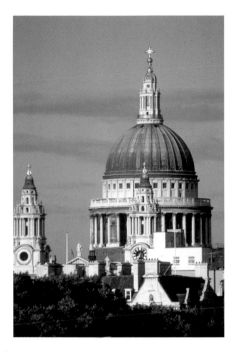

↑ St Paul's Cathedral, London
Built by Christopher Wren, the celebrated architect, in 1708, this magnificent cathedral has an impressive dome inspired by St Peter's Basilica in the Vatican. It is home to the tombs of famous British figures such as Lord Kitchener, Admiral Nelson, the Duke of Wellington and the poet John Donne.

← *Last Judgement*, c.1534–41, MICHELANGELO
This work by Michelangelo in the Sistine Chapel is the single largest fresco of the 16th century. Commissioned by Pope Clement VII in 1534, the work was not completed until after his death. It depicts the cataclysmic event when the dead are resurrected and the wicked and the good separated by Christ.

ISRAEL Golgotha Hill (where Christ was crucified), Jerusalem: ITALY The Catacombs, Rome; The Vatican, Rome: UK Coventry Cathedral, Coventry, West Midlands, England

The Greek Orthodox Church is a branch of the Christian denomination Eastern Orthodox Church. Greek Orthodox churches are therefore those that are ethnically Greek or use a Greek liturgy as well as subscribing to the tenets of Eastern Orthodoxy.

CONSTANTINE (274–337 CE); GERMANOS STRINOPOULOS (1872–1951); ARCHBISHOP GREGORIOS OF THYATEIRA AND BRITAIN (1928–); PETROS VII (1949–2004)

centrality of Easter; chanting; Dormition; Filioque clause; Great Schism

Christianity became well established during the reign of Roman Emperor Constantine, who converted to the faith after seeing a vision of the Cross in the sky. The Greek Orthodox Church is a branch of the Christian body the Eastern Orthodox Church, which separated from the Church of Rome in 1054 in an event known as the Great Schism. The split was partly influenced by the fall of the Roman Empire and the continued prosperity of the Byzantine Empire in the East, but also by the introduction of the Filioque clause in the Roman version of the Nicene Creed (the formal statement of Christian belief), which says that the Holy Spirit issues from both the Father and the Son. This is said by the Orthodox Church to be in direct violation of the Council of Ephesus and hence is regarded as noncanonical by the Eastern Church.

The Eastern Orthodox Church is the third largest Christian grouping in the world (with

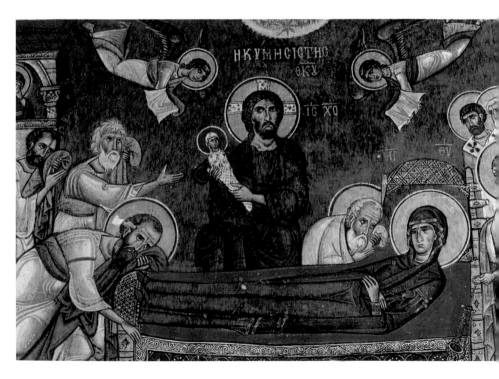

about 350 million adherents), after the Roman Catholics and Protestants, and has a particularly strong influence in Greece and Cyprus. London is the seat of the diocese of Thyateira, the headquarters of Greek Orthodox churches in Western and Central Europe. The eminent theologian Germanos Strinopoulos became its first Metropolitan (bishop) in 1922, and Archbishop Gregorios is the present incumbent. Petros VII was the Archbishop of Alexandria from 1997 to 2004.

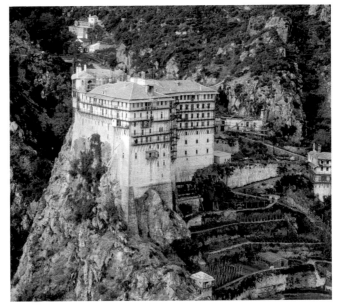

↑ **Monastery, Mount Athos, Halkidiki Peninsula, Greece**
The Monastic Republic of Holy Mount Athos could be described as the Vatican of Greek Orthodox Christianity since it forms an autonomous state within the Republic of Greece. It is consecrated to the Virgin Mary, and has been inhabited by monks since the 3rd century. Altogether there are 20 monasteries on the peninsula.

Though Mary, the Theotokos (Mother of God), is an important figure in their faith, Orthodox churches do not adhere to the Roman doctrine of the Immaculate Conception (that she was born untainted by original sin – the tendency to evil supposedly innate in all human beings). However, they do believe she remained a virgin and was sinless throughout life, but celebrate the Dormition (falling asleep or death) of Mary rather than her bodily assumption into Heaven.

Orthodox church buildings are either rectangular, symbolising Noah's Ark, or in the shape of the Cross. Stacidia (which resemble high chairs) are used in place of pews. Incense is an indispensable adjunct to worship and almost the whole liturgy is sung or chanted. Orthodox Christians celebrate Christmas in January instead of December, and Easter (which also falls on a different date) is the most important celebration.

← **The Dormition of Mary**
The Greek Orthodox Church celebrates the Dormition of Mary on 15 August annually. This Byzantine artwork is from the Asinou Church in Cyprus, a small church near the Troodos Mountains, famous for its frescoes.

◉ **EGYPT** Greek Orthodox Church of Marie Girgis, Cairo; St Catherine's Monastery, Mount Sinai: **GREECE** Greek Orthodox Church, Santorini: **TURKEY** Saint George Orthodox Christian Church, Istanbul: **UKRAINE** Holy Trinity Church, Toporoutz

The word Catholicism (literal meaning 'universal') can indicate orthodoxy in the Christian Church, but more commonly refers to the doctrines of the Roman Catholic Church.

EMPEROR CONSTANTINE (274–337 CE); AUGUSTINE OF HIPPO (354–430 CE); JOHN HENRY NEWMAN (1801–90); POPE JOHN PAUL II (1920–2005); POPE BENEDICT XVI (1927–)

apostolic succession, hierarchical government; orthodoxy; papal infallibility; veneration of saints

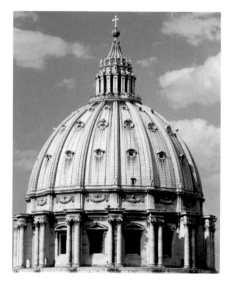

The Christian Church, which had been heavily persecuted by the Roman emperors, became legitimate and fully established during the reign of Emperor Constantine, who accepted Christ after a vision of the Cross in the sky in 312 CE.

The early Christian Church was organised under five sees, under the patriarchs of Rome, Alexandria, Antioch, Constantinople and Jerusalem, with Rome considered *primus inter pares* (first among equals), as the Bishop of Rome (the Pope) was believed to be the successor to St Peter (who Jesus named Peter after the Galilean word for rock, meaning the rock on which he would establish his church). However, in the 11th century, doctrinal disputes (based mainly on the earlier thinking of the theologian and philosopher Augustine of Hippo, or Saint Augustine), the evolution of different ritual practices and differences in church government resulted in the Great Schism of the Eastern and Western churches. This was followed by a further important rift in the 16th century when the Protestant, or Reformed, churches repudiated papal authority and practices such as the sale of indulgences in the Roman Church. John Henry Newman, a convert from Anglicanism to Roman Catholicism, sought in his Oxford Movement to bring the Church of England back to its Catholic roots.

↑ **Dome of St Peter's Basilica, Vatican City, Rome, Italy**
The Basilica, which was built between 1546 and 1564, is believed to be at the site of the crucifixion of St Peter. Recent excavations have revealed a burial chamber beneath the altar containing what are believed to be St Peter's remains.

→ *The Virgin and Child, c.1515–25,*
FIORENZO DE LORENZO
Mary (Mother of God), has always occupied a central position in the Catholic faith. The red roses in the background represent Mary and Christ's suffering, and the white roses her purity. The garland may also symbolise the rosary.

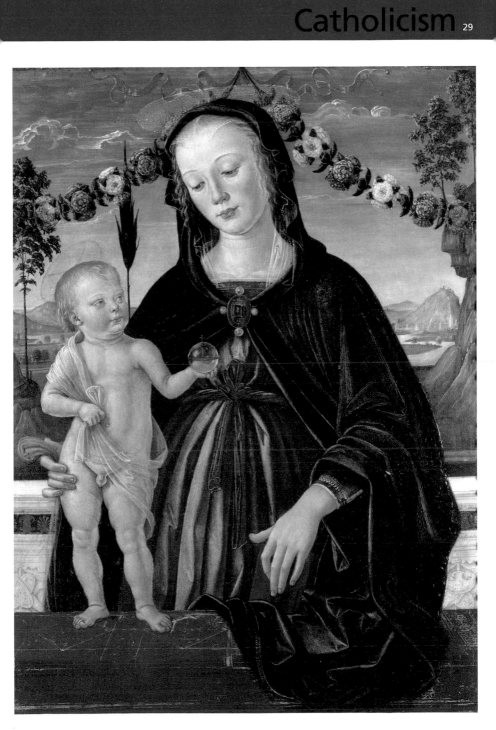

Distinctive doctrines of the Roman Catholic Church include papal infallibility, the premise that the church is the full and only repository of the true teachings of Christ and the Apostles, transubstantiation (which avers that the bread and wine in the Eucharist are the actual body and blood of Jesus), as well as belief in purgatory (a place or state of suffering inhabited by the souls of sinners where they expiate their sins before going to heaven).

Mary is considered to be the Theotokos (Mother of God) who is to be venerated. The Immaculate Conception (that Mary was born untainted by original sin – the tendency to evil supposedly innate in all human beings, held to be inherited from Adam in consequence of the Fall of Man)

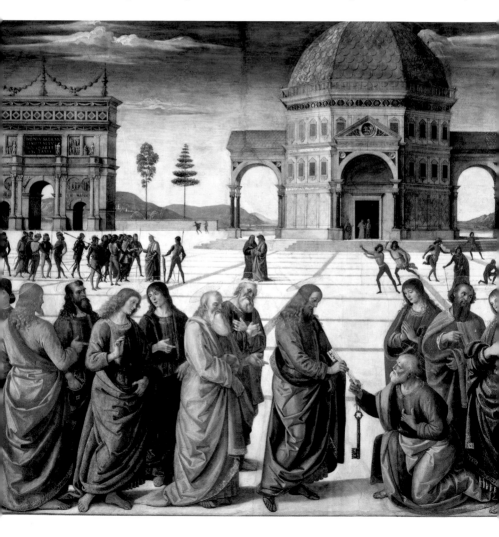

and her bodily assumption to heaven on death are other beliefs that distinguish the Catholic Church from the Reformed churches. Practices include the use of sacred images, incense and water in worship, prayers for the dead, and prayers to departed saints.

Though the Catholic Church has relaxed its stance on other Christian churches and other faiths, it has not changed its rulings on contraception, homosexuality, priestly celibacy and the ordination of women. Both the late Pope John Paul II and the present Pope Benedict XVI have tried to preserve the traditional teachings of the Roman Catholic Church on these issues.

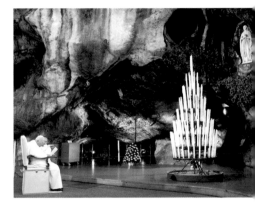

↑ **Grotto Massabielle, Lourdes, Hautes-Pyrénées, France**
Ever since a 14-year-old girl, Bernadette Soubirous, saw a vision of Mary in the remote Grotto Massabielle of Lourdes, the site has become a centre for mass pilgrimage. The waters of the spring in the Grotto are believed to have healing properties.

← *Handing of the Keys to St Peter*, c.1492, PIETRO PERUGINO
Christ designated Peter as the rock on which he would build his church on Earth, and this Sistine Chapel painting shows Christ giving the keys of the Kingdom of God to St Peter. The background in the painting seems more European than Semitic.

◎ **FRANCE** Cathedral of Our Lady of Chartres; Notre-Dame Cathedral, Paris: **INDIA** Remains of St Francis Xavier, Church of Bom Jesus, Goa: **ITALY** St Sebastian's Basilica, the Catacombs, Rome: **US** St Patrick's Cathedral, New York

Protestantism is the generic word for a wide variety of churches related to the Protestant Reformation, and is one of the three major divisions of Christianity.

MARTIN LUTHER (1483–1546); **ULRICH ZWINGLI** (1484–1531); **PHILIPP MELANCTHON** (1497–1560); **JOHN KNOX** (1505–72); **JOHN CALVIN** (1509–64)

evangelism; Reformation; schism; supremacy of scripture

Protestantism originated when in 1517 Martin Luther, a German monk, posted his 95 theses, a critique of the then Roman Catholic Church, on the door of the Castle Church in Wittenberg. His ideology spread rapidly throughout Germany and other Northern European nations, and in a broader sense the term Protestantism has come to signify those churches that argue for separation from the Roman Catholic Church.

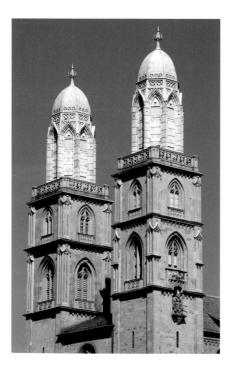

Philip Melancthon, a professor and theologian and close friend of Luther, was also a key figure in the Protestant Reformation, and another staunch supporter was the French theologian John Calvin, whose ideas and literature had a significant impact on the reformed churches of Europe. John Knox was a Scottish priest who was responsible for the reformation of the Church of Scotland, and preacher and theologian Ulrich Zwingli led the Reformation in Switzerland.

The main bone of contention for the Protestants was that the granting of indulgences by the Catholic Church, based on the premise that the forgiveness of sins could only be achieved through penance and even payment to the clergy, was spurious. Protestant churches believe salvation comes from faith in Christ's act of atonement on the Cross and is dependent on God's grace rather than human endeavour. For them, scripture is the only supreme doctrine, and they deny the authority of bishops, the Pope or tradition. Thus individual interpretation of the scriptures has become the norm for doctrinal understanding and practice. Protestant groups such as the Church of England accept temporal heads of state as the head of their churches.

The Protestant faith also diverges from the Roman Catholic Church in that its followers do not believe in purgatory, the Immaculate Conception, Assumption of Mary, clerical celibacy or the intercession of saints. The doctrine of transubstantiation has been modified, the bread and wine of the Eucharist accepted only as representations or symbols rather than the actual body and blood of Christ.

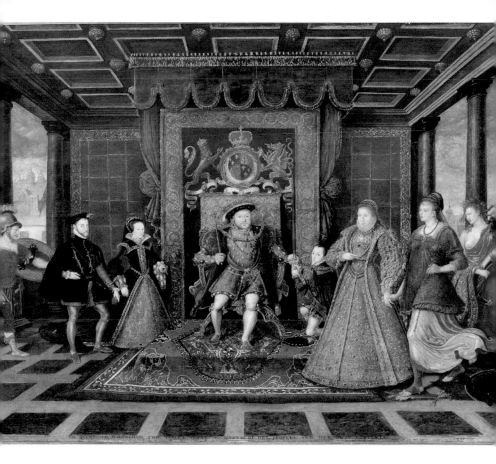

Protestant churches are generally less ornate and ostentatious. Statues, incense or water are not usually used in worship, though churches closer to the Roman Catholic tradition, such as the High Church, may adhere to such traditions.

There are now about 590 million Protestants worldwide.

↑ *The Family of Henry VIII: An Allegory of the Tudor Succession*, c.1570–75, LUCAS DE HEERE
The champion of Protestantism in England, Henry VIII was instrumental in the separation of the Church of England from the authority of the Pope in 1534, declaring himself to be the supreme head of the Anglican Church. The panel is now housed in the National Museum and Gallery of Wales in Cardiff.

← **Grossmunster Cathedral, Zurich, Switzerland**
The cathedral dates from as early as the 11th century and was probably built by Emperor Charlemagne. Ulrich Zwingli led an important sect of the Protestant Reformation from here, thus all internal decorations were removed in line with the austere Lutheran tradition.

FRANCE John Calvin Museum, Noyon: **GERMANY** Martin Luther statue, Eisenach; Martin Luther statue, Wittenberg, Saxony: **SWITZERLAND** Ulrich Zwingli statue, Zurich: **US** John Calvin Presbyterian Church, Metairie, New Orleans

 Lutheranism comes from the teachings of Martin Luther, a monk from Wittenburg, in Germany, which sought to reform corrupt doctrines and practices in the Roman Catholic Church of the early 16th century.

 FREDERICK THE WISE (1463–1525);
MARTIN LUTHER (1483–1546);
PHILIPP MELANCHTHON (1497–1560);
JOHANN SEBASTIAN BACH (1685–1750)

 justification by faith; original sin; reform; supremacy of the Bible; Amillennialism

 Officially, Lutheranism dates from the day when Martin Luther posted his famous 95 theses on the door of the Wittenberg Castle Church on 31 October 1517, challenging the Roman Catholic practice of granting the forgiveness of sins in

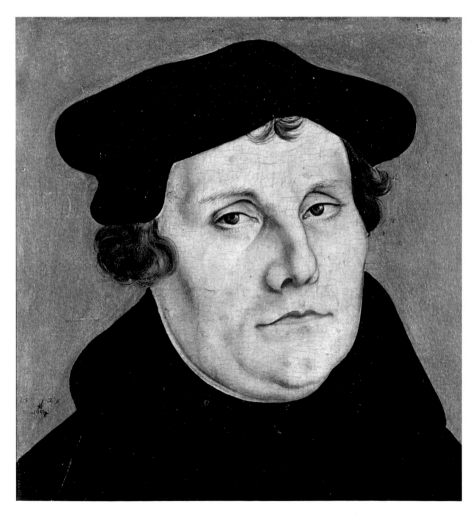

return for donations of money to the church. Despite opposition from the Pope and the Holy Roman Emperor Charles V, the Lutheran movement was soon to grow in popularity, particularly in Germany and Northern Europe. The Elector of Saxony, Frederick the Wise, was a central figure in defending Luther's protest against the Church of Rome.

The term 'Lutheran' was first used by Luther's opponents in 1519 and later became universally prevalent, though Luther preferred the designation 'evangelical' and today the movement is usually known as the Evangelical Lutheran Church. In Germany, however, the name Lutheran has been abandoned and the state church is styled simply the Evangelical or Evangelical United Church.

In 1530 Charles V called upon the Lutheran leadership to explain their religious convictions. To this end, German professor Philipp Melanchthon, a key leader in the Lutheran Reformation and a close friend of Luther, was called upon to draft a common confession. The resulting document, the Augsburg Confession, presented to the emperor on 25 June the same year, now forms the basis of all orthodox Lutheran teachings.

The central doctrine of Lutheranism is the supremacy of the Bible. Lutherans believe that all human action is tainted by sin as a result of Adam's and Eve's disobedience – and that salvation comes from faith alone, not good deeds. They take the depiction of apocalypse and millennialism in the Book of Revelation as symbolic, or figurative, and not literal, and hold that believing Christians are taken directly to heaven on death, where they await the resurrection of the body at Christ's second coming.

Music forms an important part of Lutheran worship, and many of the movement's chorales were composed by Johann Sebastian Bach, himself a staunch Lutheran. The Eucharist is retained from the

Roman Church and is a significant element in worship on Sundays.

With about 83 million adherents, the Lutheran Church is the third largest Christian denomination in the world.

↑ **All Saints' Church, Wittenberg, Germany**
The door of the church on which Martin Luther posted his famous critique of the Roman Catholic Church in 1517. The doors are now bronze, the wooden doors having been destroyed in a fire in 1760.

← *Portrait of Martin Luther*, 1529, LUCAS CRANACH THE ELDER
Housed in the Lutherhalle in Wittenberg, this portrait of the initiator of the Protestant movement is by Lucas Cranach the Elder, who became a portrait painter in the court of Frederick the Wise, then ruler of Saxony, and later Burgomaster of Wittenberg, the home of Lutheranism.

◉ **GERMANY** Augustinian Church and Monastery, Erfurt; Castle Church, Lutherstadt Wittenberg; Warburg Castle, Warburg: **US** St John's Evangelical Lutheran Church/First German Evangelical Lutheran Church, Newark, New Jersey; Risen Savior Lutheran Church – Missouri Synod, Wichita, Kansas

 The term Anglicanism (from the Latin for 'the English church') describes the people, institutions and churches as well as the liturgical traditions and theological concepts developed by the established Church of England.

ARCHBISHOP ST AUGUSTINE (d. 604 CE); **ARCHBISHOP CRANMER** (1489–1556); **HENRY VIII** (1509–47); **ROWAN WILLIAMS** (1950–)

39 Articles of Faith; Anglican Communion; Anglo-Catholic; apostolic succession; *Book of Common Prayer*

The Anglican Communion is one of the largest Christian denominations in the world with more than 70 million adherents, and includes churches such as the Episcopal Church of the US and the Church of South India. While Anglicans acknowledge that the repudiation of papal authority by Henry VIII led to the Church of England's existence as a separate entity, they also stress its continuity with the pre-Reformation Church of England. Their spiritual head is the Archbishop of Canterbury, who enjoys apostolic succession, a virtue formerly granted only to the Pope. Anglicans claim that the great St Augustine was the first Archbishop of Canterbury.

Many Anglicans do not consider themselves Protestants, though during the term of Archbishop Cranmer, author of the church's *Book of Common Prayer* (1549), the faith became more heavily influenced by the Protestant theological systems of Calvinism and evangelism. Liturgically, however, the practices of the Anglican Church, and especially the High Anglican churches, are similar to those of Roman Catholicism, and many churches call themselves Anglo-Catholic rather than Protestant.

Previously appointed by the monarch, today the Archbishop of Canterbury is selected by the UK prime minister in the name of the sovereign. The present incumbent, Rowan Williams, is the first to be appointed from outside the Church of England. His role is to coordinate the affairs of the Anglican Communion, and his official residence is Lambeth Palace in London.

The Anglican Communion has recently been marked by dissension, especially regarding the ordination of women, issues such as civil partnerships, the ordination of gay priests and the concept of just war, and compromise has been necessary to prevent the break-up of this large religious body.

→ **St Michael and the Devil**, 1958, JACOB EPSTEIN
Epstein's sculpture of St Michael vanquishing the devil guards the steps of Coventry Cathedral, which was rebuilt after it was bombed by the Luftwaffe during the Second World War.

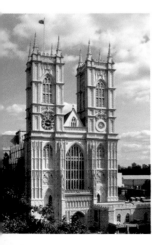

← **Westminster Abbey, London**
Built in the 13th century by Henry III, Westminster Abbey is not only an architectural masterpiece, but also the place where every coronation has been held since its inception. The tombs of kings and queens, and memorials to many a great personage, can be found here.

INDIA Church of St George the Martyr, Kolkata, West Bengal; St Mary's Church, Chennai, Tamil Nadu: **KENYA** Mombasa Memorial Cathedral, Mombasa: **UK** Canterbury Cathedral, Canterbury, Kent, England; York Minster, York, England

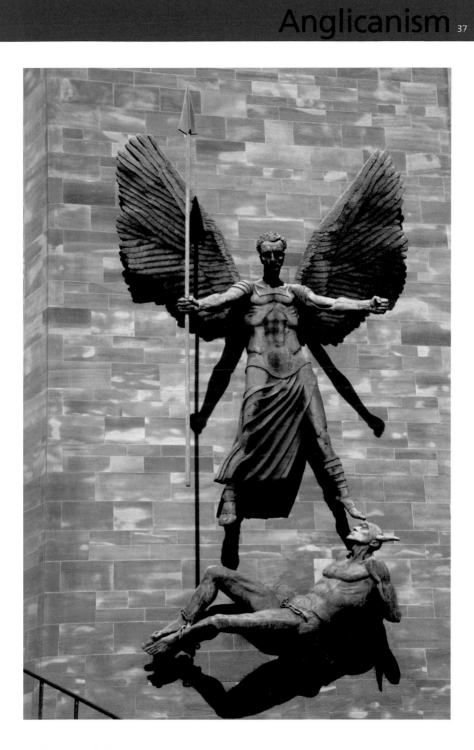

Presbyterianism

The impetus for Presbyterianism came from the Protestant Reformation initiated by Martin Luther in Wittenberg, Germany, in 1517, and the writings of John Calvin, the French theologian who crystallised the concepts of the Reformation.

JOHN KNOX (1505–72); JOHN CALVIN (1509–64); ANDREW MELVILLE (1545–1622); FRANCIS MAKERNIE (1658–1708); JONATHAN EDWARDS (1703–58)

Calvinism; congregational representation; predestination; presbyters; Reformation Theology

The name Presbyterianism comes from the Greek word *presbuteros* ('elder'). Presbyterian church government (known as the Church Order) is based on elders (ministers, or presbyters) who are ordained and form an assembly in the church called the Kirk Session, which is responsible for the discipline, nurture and mission of local congregations. The presbyters are responsible for teaching, worship and performing sacraments in their churches, with financial and other temporal matters overseen by a group of officers called deacons. Ministers and elders from constituent congregations form area presbyteries and send representatives to the synods and also to the General Assembly, the highest-ranking organisation in the Presbyterian hierarchy.

Though Calvinism, formulated by the French theologian John Calvin, formed the central ideology of the Presbyterian Church, not all of its tenets, especially the doctrine of predestination (the idea that God has chosen certain people to be saved), are adhered to by all Presbyterian churches; and the extent to which Calvinism is adhered to has caused schisms in the Presbyterian movement. The Calvinist Westminster

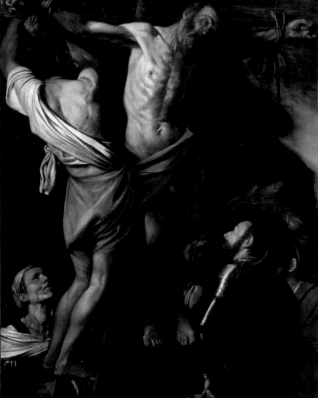

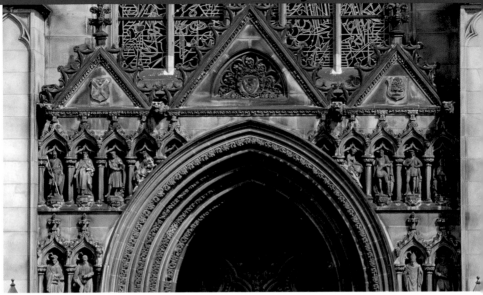

Confession of Faith is the main constitutional document of Presbyterian churches, and the one with which most conform.

John Knox is known as the father of Calvinistic Presbyterianism in Scotland. Another prominent figure in the rise of the Presbyterianism movement was Andrew Melville, who opposed the revival of Episcopalianism in Scotland.

The Presbyterian Church in the US, which has its origins in the Reformed churches in England, Scotland and Ireland, is one of the largest Christian denominations. Reverend Francis Makernie came from Ireland in 1683 and set up the first Presbyterian Church in Philadelphia, and in the early 18th century Reverend Jonathan Edwards and Reverend Gilbert Tennent were the driving forces behind a great revivalist movement.

In accordance with Reformation Theology, worship in Presbyterian churches is centred around the word of God and is free of ostentation. The reading of scripture, preaching based on scripture, singing, prayers, offerings and the sacraments of baptism and the Eucharist are similar to other mainstream Protestant churches. Infant baptism is permitted, and women have now been ordained in most Presbyterian churches.

↑ **St Giles' Cathedral, Edinburgh, Scotland**
Restored in 1872, St Giles' Cathedral is the historic city church of Edinburgh and is known as the High Kirk of Edinburgh. It is dedicated to St Giles, patron saint of cripples and lepers, and is the mother church of Presbyterianism.

← *The Crucifixion of St Andrew*, c.1607,
MICHAELANGELO MERISI DA CARAVAGGIO
Oil on canvas held at the Cleveland Museum of Art, Ohio, US. Andrew is the patron saint of Scotland, and St Andrew's Cross is the emblem on the Scottish flag, though the ascendancy of Calvinism in Scotland lessened the significance of saints and relics.

CANADA National Presbyterian Museum, Toronto: **INDIA** St Andrew's Kirk, Chennai, Tamil Nadu: **UK** John Knox House, Old Town, Edinburgh, Scotland: **US** St Andrew's Kirk, Georgetown, Washington DC: **ZAMBIA** Livingstone Memorial, Victoria Falls

Unitarianism

 Unitarianism is an umbrella term for groups who oppose the doctrine of the Trinity in Christianity. Its central tenet is that God is one being, not three (the Father, Son and Holy Spirit).

 MICHAEL SERVETUS (1511–53); **FAUSTUS SOCINIUS** (1539–1604); **JOHN BIDDLE** (1615–62); **JOSEPH PRIESTLEY** (1733–1804); JAMES MARTINEAU (1805–1900)

Humanism; liberalist; monotheism; rationalist; Universalism

Originating in the aftermath of the Protestant Reformation in Poland and Transylvania, and later spreading to other parts of Europe, the US and even India, Unitarians differ from orthodox Christians in that they do not give credence to the doctrine of the Trinity, which states that the deity consists of three beings – the Father, Son (Jesus) and Holy Spirit. Though they generally believe Jesus to be the Son of God, they also maintain that he was a created being and not part of the Godhead. Similarly, they hold that the Holy Spirit is a power created by God and not a person of the Trinity. The intrinsic goodness of humanity is an important part of their doctrine, thus Unitarians do not consider the death of Jesus on the Cross as redemptive or atoning for the sins of humanity, and do not believe in his resurrection.

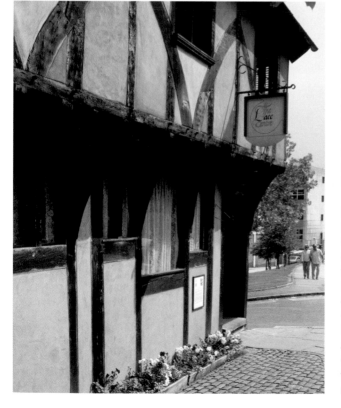

Unitarians also do not believe in the opposing elements of religion and knowledge, faith and science, and the sacred and the secular, maintaining that all are rooted in a single reality. They symbolise freedom of religious thought in which Humanism, Christianity and Universalism overlap.

Michael Servetus of Spain, who was burnt at the stake in 1553 for denying the Trinity, is considered to be the first Unitarian martyr. Faustus Socinius, a contemporary of John Calvin, is known as the Father of Unitarianism, and John Biddle, from Gloucestershire, was the founder of the Unitarian movement in England.

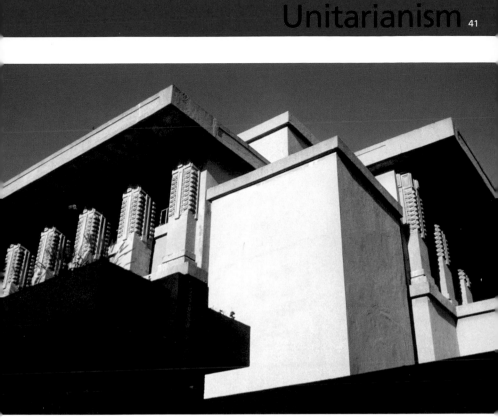

The famous scientist Joseph Priestley was also one of the prominent Unitarians of the 18th century, and James Martineau, noted intellectual and philosopher, was a prominent Unitarian minister and lecturer.

Unitarians champion gender equality and use gender-inclusive language in worship. Unitarian services lack formal liturgy and rituals but will use readings from many texts, not necessarily the Bible alone, and may include silences, hymns and songs.

↑ **Unity Temple , Lake Street, Oak Park, Chicago, Illinois, US**
A Unitarian Congregationalist church founded in 1871, this building was designed by the architect Frank Lloyd Wright who was a member of the congregation. The radical design is, in the architect's own words, intended to represent the 'unity, truth, beauty, simplicity, freedom and reason' of Unitarian Universalism

← **The Lace Centre, Nottingham, England**
This splendid example of 14th-century architecture, which now houses a lace museum, was once a Unitarian chapel where the celebrated poet Samuel Taylor Coleridge preached and Lord Byron, another poet of note, attended.

INDIA Brahmo Samaj (Unitarian) Headquarters, Kolkata, West Bengal: **SPAIN** Serveto, Aragon (home town of Michael Servetus's family): **UK** Joseph Priestley's House, Bethnal Green, London: **US** First Unitarian Church, South Side, Chicago, Illinois; Unitarian Universalist Church, Province Town, Massachusetts

As evangelical Protestant Christians, Baptists emphasise the baptism of adult believers by full immersion in water, which is performed after their profession of faith in Christ as Lord and Saviour.

HENRY JACOB (1563–1624); **JOHN SMYTH** (1570–1612); **JOHN BUNYAN** (1628–88); **JOHN SPILSBURY** (17th century); **ANDREW FULLER** (1754–1815); **WILLIAM CAREY** (1761–1834)

adult baptism; congregational governance; supremacy of scripture; universal priesthood

In the 17th century, the issue of congregational government as opposed to the hierarchical structure of the official Church of England caused some Christians in England to separate from the state church; thus the baptism of adult believers became the sign of entrance into the church. In 1609, John Smyth led some believers to the Netherlands to form the General Baptist Church, while in 1616 Henry Jacob took a group of Puritans with Calvinist beliefs and formed a church under John Spilsbury, called the Particular Baptists. A few years later, a number of believers from both groups embarked to America to escape religious persecution in England and Europe, and eventually formed Baptist churches there too. The Baptist Union of Great Britain, formed in the 19th century by Andrew Fuller and William Carey, eventually united all these branches of Baptists.

John Bunyan, the author of the celebrated Christian allegory *Pilgrim's Progress* (1678), is one of the most famous Baptists. He was prosecuted for preaching without a licence and it was while he was imprisoned in Bedford jail that he wrote his classic work.

A congregational governance system gives autonomy to individual local Baptist churches. However, churches often associate in organisations such as the Southern Baptist Convention in the US, which is the largest Baptist association in the world.

Adult baptism after professing Christ as Lord and Saviour is a key ritual. The cleansing with water by full immersion symbolises the inward transformation of faith that has already taken place in the individual; thus infant baptism is not recognised by the church. Scripture is believed to be the sole authority, in contrast to other churches that place more importance on apostolic succession and church tradition. The sermon is therefore the foremost element of worship in a Baptist church. However, other items such as music and prayers are also part of Baptist worship. Even the communion is subservient to the sermon, and in most Baptist churches is taken with non-alcoholic wine to adhere to the historical teaching of temperance and abstinence.

The Baptist pastor's principal duty is the pastoral care of the fellowship, seen as the application of the Bible to peoples' lives. Baptists generally believe in the priesthood of all believers and do not consider the pastor to be a special figure in the congregation, though he is considered a leader in spiritual matters.

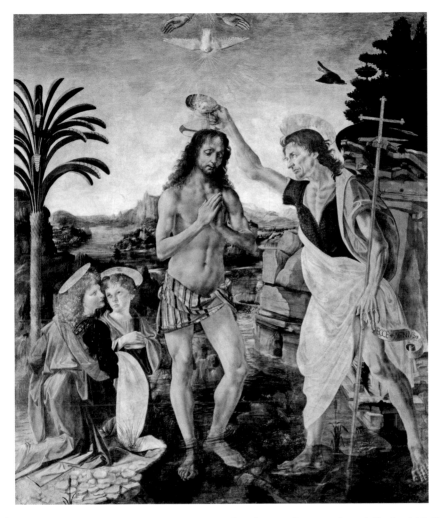

↑ *Baptism of Christ*, c.1470, ANDREA DEL
VERROCCHIO and LEONARDO DA VINCI
The Holy Spirit descends on Christ in the form of a dove
as he is baptised by John the Baptist, and two angels
hold up his garments. Da Vinci was only 20 years old
when he assisted his master, Verrocchio, in this oil and
tempera on wood altarpiece, now housed in the
Uffizi Gallery in Florence, Italy.

← Ebenezer Baptist church, Atlanta, US
A popular Baptist church in the southern US city
of Atlanta, Ebenezer Baptist Church is noted for its
long-standing community work. The church is led by
Reverend Dr Raphael Gamaliel Warnock, a sought-after
theologian and preacher and notable peace activist.

CANADA Middle Sackville Baptist
Church, Sackville, New Brunswick:
GERMANY CrossWay International Baptist Church,
Berlin: INDIA Serampore University, Kolkata, West
Bengal: UK Regent's Park College, Oxford University,
Oxford, England; Spurgeon's Missionary College, South
Norwood, London

The Religious Society of Friends (commonly known as the Quakers) was founded in England in 1652 by George Fox and other dissenters, Puritans, seekers and separatists dissatisfied with the existing denominations and sects of Christianity.

MARGARET FELL (1614–1702); JAMES NAYLOR (1618–60); GEORGE FOX (1624–91); WILLIAM PENN (1644–1718); ISAAC PENNINGTON (1745–1817)

austerity; meditation; pacifism; righteousness; Secessionist

The Quakers were one of a number of nonconformist, free-thinking dissenting groups to emerge in England in the 17th century, their main aim being the regeneration of religion, morals and behaviour. They believed in the supremacy of Christ over the church, the priesthood and the word, and were convinced that by 'waiting on the Lord' they would come to know the will of God through direct communication.

George Fox, a charismatic, bold and visionary individual reputed to have healing powers, was responsible for establishing the Quakers as an organised movement, with the support of Margaret Fell of Swarthmore Hall, near Ulverston in Cumbria, England. This eventually became a main centre of the Quakers' spiritual, administrative and communications network. Other notable Quakers include William Penn, who established a community of Quakers on the land he was granted to the west of New Jersey, US (Pennsylvania) in lieu of a debt owed by Charles II to his father, a noted admiral; James Naylor, a former soldier but deeply religious man who brought Quakerism into disrepute by arranging a triumphal entry into Bristol on the back of a donkey in emulation of Jesus Christ; and

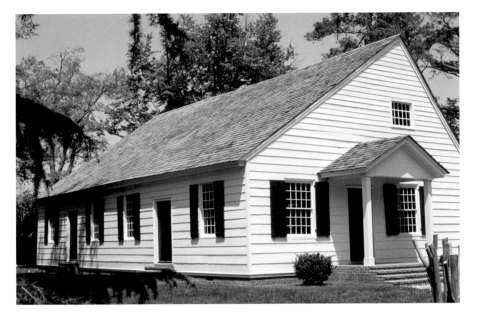

Isaac Pennington, an influential promoter and defender of the movement who was often imprisoned for his beliefs and whose complete works were first published in 1681. Quakers are noted for righteous living, simplicity in manner, lifestyle and speech, and their emphasis on pacifism. They were previously also characterised by their aversion to music and resistance to 'hat honour' (refusal to doff their hats in deference). In times of war, and especially during the First World War, several Quakers were imprisoned as conscientious objectors, and the movement is still well known for its peace activities.

Many Quakers believe their faith does not fall into the traditional categories of Catholic, Orthodox or Protestant, but is rather an expression of another way to experience God in their lives. They worship at meeting places, with meetings characterised by long silences that are broken only if members are inspired to speak or give testimony. The meetings are generally unprogrammed and without readings from scripture or the singing of hymns.

↑ **Third Haven Meeting House, Easton, Maryland, US**
Nestled in a grove of trees, this meeting house is one of the most important historic structures in Maryland's history. It was constructed in 1682 near the headwaters of Tred Avon Creek to serve the Third Haven monthly meeting of the Society of Friends.

← **Statue of William Penn, Philadelphia City Hall, Pennsylvania, US**
Philadelphia, meaning 'brotherly love', was the first Quaker city to be established by William Penn and the first Quaker settlers in America, and provided a haven for Quakers fleeing persecution in Europe.

◉ **UK** George Fox's tomb, Quaker burial ground, Bunhill Fields, London; Quaker Meeting House, Bunhill Fields, London; Swarthmore Hall, near Ulverston, Cumbria, England: **US** Llewelling Quaker Museum, Salem, Oregon; William Penn's cottage, Fairmont Park, Philadelphia

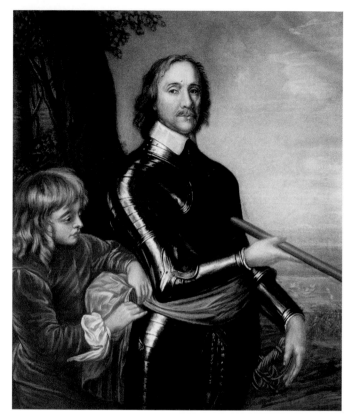

 Congregationalism originated in the idea that every church is free to govern itself and is in control of its own affairs. Congregationalists recognise only Jesus as their head and have thus dispensed with bishops, priests and presbyters.

ROBERT BROWNE (1550–1633); JOHN ROBINSON (1576–1625); THOMAS GOODWIN (1600–79); JONATHAN EDWARDS (1703–58)

autonomy; egalitarianism; equality; independence; Protestantism

Congregationalism is an offshoot of the Protestant Reformation in Britain, whose principles were first laid down by Robert Browne in 1582. Congregationalist churches subscribe to the autonomy and independence of their congregations and were originally called 'Independents', a term still used in Wales. Pastors, teachers, elders and deacons are thus chosen by the congregation, and not by any hierarchical body above them.

In the 17th century, government opposition to the separatist churches forced many of their members into exile in Holland. Notable among these was Thomas Goodwin, a prominent nonconformist academic and preacher, who fled to Arnhem where he worked as a cleric. It was John Robinson, another refugee in Holland, who keenly promoted the idea that individual churches should consist of committed Christians free from any external secular or clerical authority. However, under the Protectorate of Cromwell, which was supportive of the Independents, the movement did begin to make some progress, until the Restoration of the monarchy when they were again severely oppressed.

In England, the tendency has been the forming of larger fellowships, and in 1972,

along with the Presbyterians, the Congregationalists became part of the United Reformed Church.

Congregationalists in Holland migrated to America with the Pilgrim Fathers, and Congregationalism has found its fullest expression there. Jonathan Edwards, considered to be one of the most profound and ardent of preachers, was responsible for a great revival of the Congregationalist movement in the US in 1733. The broad fellowship of the National Council of the Congregational Churches of the United States was formed in 1871 and, in accordance with the principles of Congregationalism, each of its churches is free to form its own declaration of faith and form of worship. In 1931, a number of Congregationalists joined the Churches of Christ (autonomous Christian congregations modelled on the early church) to form the United Church of Christ.

Learning is an important aspect of Congregationalism, and the movement has established a number of educational institutions, including Harvard and Yale in the US.

↓ **Stoddard Congregational Church, Stoddard, New Hampshire, US**
Established in 1787, the church sits in the picturesque surroundings of the small town of Stoddard. The current building was completed in 1836. A memorial to the American Civil War stands in front of the building.

◉ **NEW ZEALAND** London Missionary Society Church, Rarotonga, Cook Islands: **UK** Albany Congregationalist Church, Haverfordwest, Pembrokeshire, Wales; Castle Green Congregationalist Church, Bristol, England: **US** Beecher Bible and Rifle Church (Congregationalist/United Church of Christ), Wabaunsee, Kansas; First Congregationlist Church, Marion, Ohio

← *Portrait of Oliver Cromwell, c.1649*, ROBERT WALKER
This well-known portrait of Oliver Cromwell is housed in the National Portrait Gallery, London. Cromwell, who as Lord Protector of England, Scotland and Ireland from 1653 to 1658 was virtual ruler of the country, was supportive of the Independents, as the Congregationalists were known at the time.

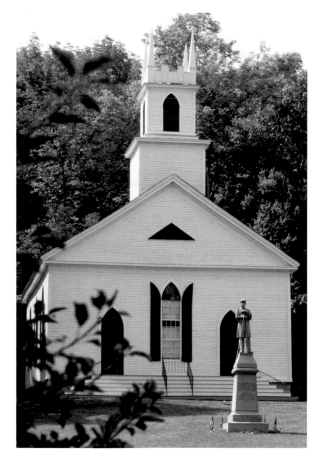

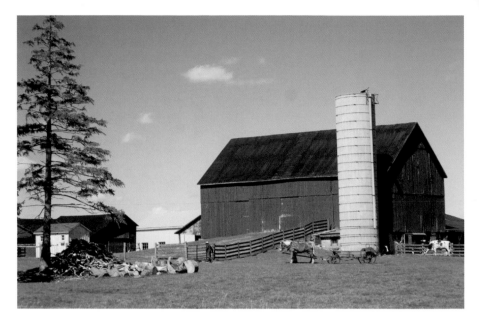

 The Amish are an extremely conservative Protestant Christian group, mainly found in the US, and best known for their austere lifestyle and shunning of the trappings of the modern world.

MENNO SIMONS (1496–1561); JACOB AMMAN (1644–1708); JOSEPH STUCKEY (1826–1902); MOSES M BEACHY (1874–1946)

adult baptism; austerity; pacifism; patriarchy; social exclusivism

The Amish are an offshoot of the religious group in Europe known as Mennonites, a term derived from the name of their leader, Menno Simons. The name Amish comes from their founder, Jacob Amman.

In the 18th century many Amish migrated to America to escape religious persecution, settling mostly in Pennsylvania. In 1927 a splinter group called the Beachy Amish, led by Bishop Moses M Beachy, relaxed some elements of the rigorous lifestyle of the Amish, such as using electricity and buying motor cars. Another earlier division, the Stuckey division, was based on the belief that every human being would be saved. Bishop Joseph Stuckey was the central figure in this split.

It is estimated that there are 180,000 Amish in the US, the majority of whom are to be found in the state of Ohio.

The Amish are noted for their pacifism (they were conscientious objectors during the American War of Independence, Civil War and the world wars), preservation of rural European culture and shunning of the cultural trappings of modern life in the US. They avoid modern technology, such as electricity, cars, radio and television, and farming is their main activity. They dress in simple black apparel, and the men sport long beards, but without moustaches to

avoid association with the military. They do not take out insurance, since they believe in communal solidarity and the support of the church.

Amish refer to other Americans as 'the English'. They speak a language they call Deutsch (German), but which is actually a mixture of German and Swiss. The language is termed Pennsylvania German by other Americans.

Amish churches are autonomous and elect bishops, ministers and deacons for life. Meetings are held in houses for worship and, as in some other evangelical churches, the Bible is understood literally.

Generally endogamous (marrying within their own community), the Amish are said to be plagued by genetic disorders as a result. They do not practise any form of birth control and couples bring up large families.

← **Amish farm**
This photograph amply illustrates the tranquillity of an Amish farm and the use of primitive equipment such as horse-drawn wagons. The Amish reject the use of modern technology as corrupting their pure and pious way of life.

↓ **Waterwheel, Amish village, Lancaster County, Pennsylvania, US**
This picture of a waterwheel in an Amish village again illustrates the use of older technology and the avoidance of modern equipment such as electricity by the Amish in order to preserve their original way of life.

US Amish communities, Lancaster, Lancaster County, Pennsylvania; Amish settlements, Arcola, Illinois; Hershbergers' Amish home and Hillside Bulk Foods and Crafts store, Baltic, Ohio

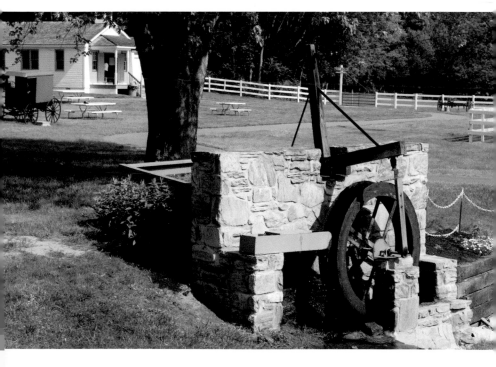

Episcopalianism

A term originating from the Greek *episcopus* (bishop), Episcopalianism denotes the system of church governance by bishops.

JOHN SAGE (1652–1711); JOHN SKINNER (1721–1807); SAMUEL SEABURY (1729–96); PATRICK CAMPBELL RODGER (1920–2002)

Anglicanism; apostolic succession; democratic; ecumenical; episcopy

The terms Episcopalianism and Anglicanism are synonymous, with both the Episcopal Church and the Anglican Church being governed by bishops. The bishops trace their descent to the Apostles, thus their ordination is by three or more other bishops and the principle of apostolic succession is maintained. Episcopalianism is used in preference to Anglicanism to assert autonomy and distinctiveness from the Anglican Church of England, though most Episcopalian churches are members of the worldwide Anglican Communion, and some Methodist churches are also Episcopalian.

Episcopalian churches such as the unions in the Church of South India and Church of North India, and the Church of Pakistan, are ecumenical.

The Episcopalian churches of the US were established by the ordination in 1784 of Bishop Samuel Seabury by a bishop of the Scottish Episcopal Church in Aberdeen. His ordination had been refused by the Church of England, as English bishops were forbidden by law to consecrate anyone who would not take an oath of allegiance to the British Crown. Episcopalianism flourished in the US, where the movement currently has 2.3 million members. A bicameral convention of the House of Bishops and House of Deputies is held once every three years.

Bishop John Sage, a prominent scholar of the fathers of the early Christian Church, and historian and songwriter John Skinner, were prominent post-Revolution Episcopalians. Another of the movement's notable figures was Patrick Campbell Rodger, from the Scottish Episcopal Church, who became Bishop of Oxford and was an ecumenist who served in the World Council of Churches.

In the Episcopalian Church of Scotland, bishops are elected by a synod of constituent bishops, clergy and laity, unlike in the Anglican Church where bishops are appointed by the government. The College of Bishops constitutes the Episcopal synod – the supreme court of appeal – which elects from among its own members a presiding bishop who has the title Primus (from *primus inter pares*, or first among equals). Currently, the Episcopalians are a small minority in Scotland.

Episcopalian churches in India and Pakistan elect a moderator of the central synod from among the bishops of the constituent dioceses.

In doctrine and practice the Episcopalian churches follow the Anglican tradition. However, in ecumenical unions, as in India and Pakistan, a common liturgy has evolved that incorporates elements from constituent denominations.

← Portrait of Samuel Seabury, 1785, RALPH ELEASER WHITESIDE EARL
A portrait of Samuel Seabury, the first bishop of the Episcopalian Church in America. He was ordained in the Scottish Episcopal Church, a factor in the adoption by the American Anglican churches of the name Episcopalian. The portrait is now in the National Portrait Gallery, Smithsonian Institution, Washington DC.

↓ Canterbury Cathedral, Canterbury, Kent, England
This is the oldest cathedral in England, dating from Saxon times and is associated with the great bishop St Augustine. It is the seat of the Archbishop of Canterbury, the primate of the worldwide Anglican Communion and a great symbol of episcopacy in the world. The formal name of the cathedral is Cathedral and Metropolitical Church of Christ at Canterbury.

◉ UK Bishopthorpe Palace, near York, England; Christ Church Cathedral, Oxford, England; Lambeth Palace, London; York Minster, York:
US Catholic University of America, Washington DC

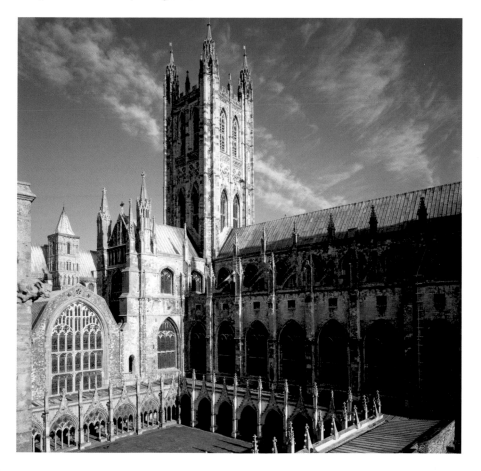

Methodism

Methodism originated in the 18th century as a movement within the Anglican Church that sought to bring the working classes to the Christian church.

JOHN WESLEY (1703–91); **CHARLES WESLEY** (1707–88); **GEORGE WHITEFIELD** (1714–70); **THOMAS COKE** (1747–1814)

biblical foundation; discipline; practicality; prominence of the laity; virtue

Brothers John and Charles Wesley founded the Methodist movement in England in the 18th century after realising that the poor and the working classes were often reluctant to attend Anglican churches, which they viewed as snobbish and only catering to the middle and upper-middle classes. The term 'Methodist' was initially a pejorative college nickname given to a small society of Anglican students at Oxford University, to which the Wesleys belonged, who were noted for their disciplined, abstemious and methodical way of life. The Wesleys believed the Anglican Church had become apathetic, and sought to inject fervour into the practice of Christianity via enthusiastic preaching, often in the open air, to the less fortunate. Despite this, there is no radical departure in Methodism from Anglican articles of belief, though its early followers were excommunicated from the Anglican Church. Methodist beliefs are articulated in the 28 Articles of Faith.

John Wesley proposed a doctrine of salvation for all, rather than the Calvinistic doctrine of predestination adopted by the Anglican Church. He also emphasised a doctrine of sanctification that depicted true Christians as leading pure lives, free from sin, and believed that Christians could reach a state of moral perfection whilst still on Earth. The Methodist laity also has a stronger role and more involvement in Church activities than is the case in the Anglican Church.

George Whitefield, from Gloucester in England, also played a significant role in the spread of Methodism, and Thomas Coke, whom Wesley intended to be his successor, was largely responsible for shaping the Methodist Church in the US.

Methodism is now divided into various branches, such as the Primitive Methodists, Bible Christians, Wesleyan Reform Union and United Methodist Free Churches, each differing slightly regarding doctrine and ritual practice. It places special emphasis on the practical aspects of religion, therefore extensive theological training was deemed superfluous in the early days of the movement, and ministers were chosen more for their religious zeal than for their theological expertise. However, theological schools were later to be established (the first in 1834), and in 1890 a Methodist university was founded in Washington DC.

← **Methodist Central Hall, Westminster, London**
Now also a conference and exhibition centre, this prominent structure, designed by Edwin Alfred Rickards, was built by the Methodist Church in 1912 to mark the centenary of the death of John Wesley.

↑ Statue of John Wesley, Wesley's Chapel, London
The statue stands outside Wesley's Chapel, known as the Cathedral of World Methodism, opposite Bunhill Fields Cemetery where many nonconformist church leaders are buried. It is a bronze cast of Wesley's marble statue sculpted by Samuel Manning in 1831 which stands in Methodist Central Hall in Westminster, London.

CANADA Dundas Street Centre United Church, London, Ontario: **UK** Museum of Methodism, Wesley's Chapel, London; Wesley Memorial Church, Oxford, England: **US** Perry Hall United Methodist Church, Perry Hall, Baltimore, Maryland; Spring Valley United Methodist Church, Dallas, Texas

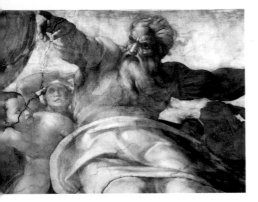

Jehovah's Witnesses emphasise the uniqueness of Jehovah as God and deny the Trinity. Keenly evangelical, their insistence on the loyalty and commitment of members to their teachings has caused them to be viewed as a cult by some Christians.

CHARLES TAZE RUSSELL (1852–1916); **JOSEPH FRANKLIN RUTHERFORD** (1869–1942); **NATHAN HOMER KNORR** (1905–77); **DON A ADAMS (1925–)**

evangelism; pacifism; prohibition; supremacy of scripture; Unitarian

Jehovah's Witnesses believe that Jehovah is the only true God and that Jesus is Archangel Michael incarnate – the first of God's creations through whom all other things in the world, including human beings, were created. The Holy Spirit is God's power acting in the world, and not another being or person of the Godhead.

From their inception, Jehovah's Witnesses have been concerned with the second advent of Jesus, who they believe died on a stake, rather than a cross, as a ransom for the saved of humankind, and was resurrected in a spiritual body. He will return to establish God's kingdom on earth at Armageddon (the great battle between Jesus and the powers of darkness), when the wicked in the world will be destroyed and 144,000 Jehovah's Witnesses will form a new society and live in an earthly paradise.

Charles Taze Russell, the founder of Jehovah's Witnesses, was influenced by Adventist teachings, particularly those of Jonas Wendell who predicted the return of Christ in 1874. When this second coming failed to materialise, Russell stated that Christ had in fact returned, though invisibly, and that 1914 would be the year of the establishment of God's kingdom.

Joseph Franklin Rutherford's presidency of the sect was notable for its adoption of the name Jehovah's Witnesses (the movement was originally called the Bible Students), and Nathan Homer Knorr's for its focus on education, such as the training of missionaries. The current president is Don A Adams, a former secretary to Nathan Knorr.

Jehovah's Witnesses are also known for their views on blood transfusion, which is not permitted (though blood substances such as plasma may be transfused), and pacifism, which led to many of them being imprisoned during the First and Second World Wars. Participation in politics, voting in elections, saluting the national flag and singing of the national anthem are also forbidden, as are abortion, homosexual activity, adultery, drunkenness and gambling, all of which can result in disfellowship.

Jehovah's Witness evangelists, sometimes called 'publishers', are especially committed to propagating their beliefs and go from door to door distributing the movement's *Watch Tower* and *Awake!* journals and talking to people. Women can take part in this missionary activity, though they are not given leadership roles in the church or in worship.

← *Creation of the Sun and Moon and Plants on Earth*,
1512, MICHELANGELO
This detail from the ceiling of the Sistine Chapel in
Rome, Michelangelo's massive and best-known work,
shows Jehovah engaging in the creation of the universe,
which Jehovah's Witnesses believe was carried out
through Archangel Michael.

↓ *The Expulsion from Paradise*, 1740,
CHARLES JOSEPH NATOIRE
This oil on copper work housed in the Metropolitan

Museum of Art, New York, is by Charles Joseph
Natoire. Completed in 1740, it shows Jehovah accusing
a repentant Adam and Eve, standing near the Tree
of Knowledge, of disobeying his command not to
eat its fruit.

ANGUILLA Kingdom Hall of Jehovah Witness:
REPUBLIC OF IRELAND Kingdom Hall,
County Dublin: **ROMANIA** Kingdom Hall, Bucharest:
US Kingdom Hall, Sky Ranch, near St George, Utah;
Watch Tower Bible and Tract Society, Brooklyn, New York

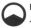 Mormonism is an umbrella term referring to churches of recent origin that claim to have effected a restoration of true Christianity. The foremost of these is the Church of Jesus Christ of Latter-Day Saints.

 BRIGHAM YOUNG (1801–77); **JOSEPH SMITH JR** (1805–44); **OLIVER COWDERY** (1806–50); **GORDON B HINCKLEY** (1910–)

baptism for the dead; Book of Mormon; polygamy; pre-existence; restoration

The Church of Jesus Christ of Latter-Day Saints was founded by Joseph Smith Jr, of Vermont, US, who, in 1820, at the age of only 15, claimed he was visited by God the Father and God the Son. At the age of 17 he was visited by a holy messenger, called Moroni, who revealed to him a hidden gospel inscribed on golden plates, written by the prophet Mormon. The mysterious texts, known as the Book of Mormon, were eventually transcribed into English by Oliver Cowdery, and thus became the principal scripture of the Mormon movement.

The Mormons believe that theirs is the true church of Christ, that all Orthodox Christian churches have been compromised, and that they are also the only church in possession of the true scriptures. They also affirm the physical nature of God the Father, God the Son and God the Holy Spirit, and the pre-existence of all humans as spirit beings to which they will be restored after death. After resurrection they are assigned to places of glory, while those who have deliberately chosen to follow Satan will go to a place called the Outer Darkness. Like Roman Catholics, the Mormons believe in a place

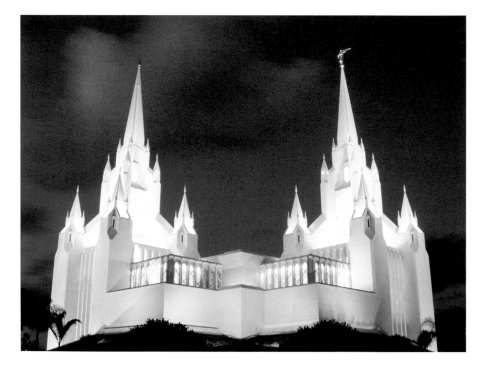

of correction after death (Spirit Prison) where individuals can achieve atonement for their sins and merit salvation. In addition, a dead person can be baptised by proxy, which means that a Mormon can be baptised on behalf of someone who has already died. Baptising for an ancestor who died without hearing the true gospel as restored by the church is seen as a demonstration of love for that person.

Though Brigham Young, the second prophet and president of the Church of Jesus Christ of Latter-Day Saints, advocated and practised polygamy, not all Mormons agree with this. The church's current president is Gordon B Hinckley.

Worship takes place on Sundays during which a Eucharist of bread and water is followed by two or three sermons by church members, with hymns sung throughout.

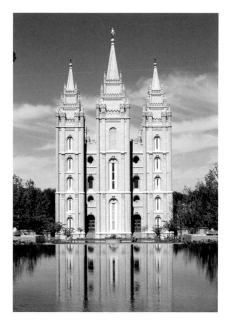

↑ **Salt Lake Temple, Salt Lake City, Utah, US**
Salt Lake is the largest Mormon temple. It was founded in 1847 by the Mormon leader Brigham Young, who fled to the area to escape persecution. Salt Lake City is the world headquarters of the Church of Jesus Christ of Latter-Day Saints (Mormons).

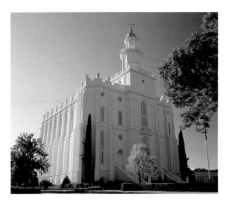

↑ **St George Utah Temple, St George, Utah**
Dedicated in 1871, this temple was built by Mormon pioneers led by Brigham Young. Built of volcanic rock brought down from the ridges above the city, the temple is a testament to the dedication and hard work of Mormon pioneers.

← **San Diego Mormon Temple, La Jolla, California, US**
This imposing, fairy-tale-like structure is 58 metres (190 feet) tall. Mormon temples are dedicated to God and reserved for special forms of worship. Weekly services are held in church meeting houses

AUSTRALIA Mormon Temple, Carlingford, New South Wales: **UK** London England Temple, Newchapel, Surrey, England: **US** Homestead of Joseph Smith, Nauvoo, Illinois; House of Brigham Young, Salt Lake City, Utah; Museum of Church History and Art, Salt Lake City

The Seventh-day Adventists originated in the US in the 1840s and, as the name suggests, celebrate the seventh day of the week, Saturday, as the Sabbath, rather than Sunday, the first day.

WILLIAM MILLER (1782–1849); **JOSEPH BATES** (1792–1872); **RACHEL OAKES PRESTON** (1809–68); **ELLEN GOULD WHITE** (1827–1915)

abstinence; adult baptism; democratic; evangelistic; Parousia; Sabbath

In 1831, Baptist preacher William Miller predicted 22 October 1844 as the date of the second coming of Christ, or Parousia, based on calculations from the Bible. When in the end the day turned out to be a seemingly uneventful one (known as the Great Disappointment), many of his followers deserted him. As a result, some of his remaining supporters became convinced that this was in fact the day when Christ had begun his investigative judgement of the world, a process that determines who is entitled to the benefits of atonement, after which Jesus will return to earth.

Seventh-day Adventists arose out of the Millerite movement and now hold that the day of the second coming cannot be predicted, but is imminent and will be preceded by a time of great trouble and persecution of the followers of Christ.

At about the same time as Miller's prediction, Joseph Bates and Rachel Oakes Preston advanced the idea of keeping the seventh day holy, believing the changing of the Sabbath from the seventh day to the first was not in keeping with the fourth of the Ten Commandments, and an act of the Papacy; and in 1849 it was accepted as a doctrine of the church that the Sabbath, which commences from sunset on the sixth day of the week, should be observed as a holy day. Ceremonies on the seventh day begin with vespers, an evening act of worship. Biblical study in a Sabbath School is also an important part of Sabbath activities.

Seventh-day Adventists follow the Anabaptist tradition of adult baptism with full immersion. Their abstinence from meat, alcohol and tobacco is the result of a vision of American religious leader Ellen Gould White in 1863, and generally the church advocates a healthy diet and lifestyle (John Harvey Kellogg, of Kellogg cereals fame, was another early proponent of this lifestyle).

The church is committed to evangelistic outreach to non-Christians and other Christian denominations. Government is democratic. The General Conference, headed by a president, is the highest body and has the final say in matters of doctrine and administration. The church is estimated to have 10 million members worldwide.

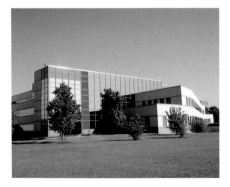

← **General Conference Building, Silver Spring, Maryland, US**
Situated in spacious land acquired by the Seventh-day Adventist Church, this stylish building houses the headquarters of the North American Division of the church. Built in 1989, it has excellent facilities for conferences, committee meetings and concerts, in addition to offices for 800 employees.

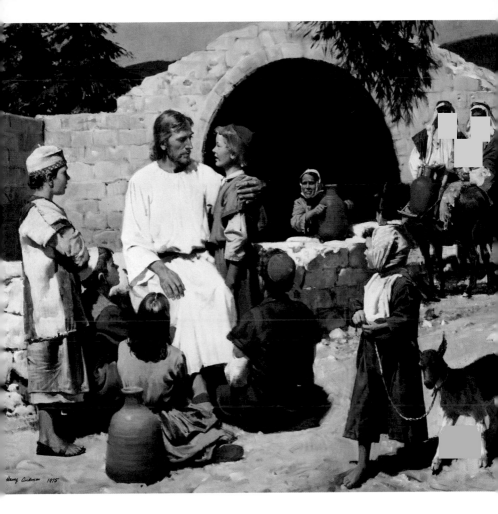

Christant and the Children, 1945, HARRY ANDERSON
Harry Anderson joined the Seventh-day Adventists in 1944 and generously offered to contribute illustrations to the church's publications. Though he continued to paint commercially for a premium remuneration, he offered his services to his church for a reduced fee. He is considered by followers of the movement to be one of the greatest artists in modern history.

GERMANY Seventh-day Adventist Church Health Food Company, De-Vau-Ge, Luneburg:
US Birthplace of Ellen G White, Gorham, Maine; Seventh-day Adventist Church, Washington, New Hampshire; Battle Creek Tabernacle, Battle Creek, Michigan; Voice of Prophecy Broadcasting House, Simi Valley, California

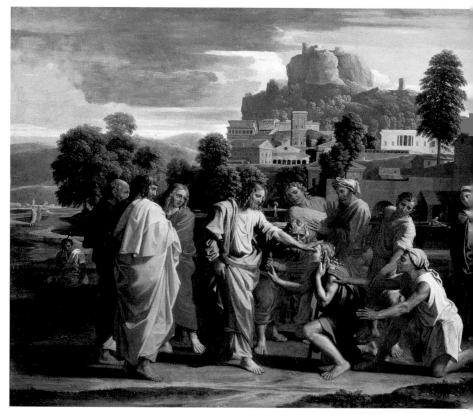

 Christian Science, founded by Mary Baker Eddy, of New England, US, presents a world in which all matter is illusion, and only God and the mind have ultimate reality. Illness and sin are thus considered unreal, and can be overcome through prayer and faith.

ROBERT PEEL (1788–1850); **PHINEAS P QUIMBY** (1802–66); **MARY BAKER EDDY** (1821–1910); **HIRAM CROFTS** (1839–1911); **EM RAMSAY** (1875–1955)

healing through scripture; illusory world; mind over matter; unorthodox theism

After a serious accident in 1866 that left her unable to walk, it was the Biblical story of Jesus healing a palsy sufferer that led Mary Baker Eddy to believe that only God was real, and that sickness, fear, sorrow and even sin were illusions that could be healed by realising this truth. Her beliefs intensified when she, too, appeared to heal herself to the amazement of doctors, and she established the Church of Christ, Scientist to implement her ideas, also expressing them in her book *Science and Health with Key to the Scriptures* (1875).

The origins of Christian Science have been ascribed to sources as varied as the German philosopher Hegel and a 19th-century healer

called Phineas P Quimby. The core of the movement is the teaching that God is wholly good and totally spiritual, and that God has made all things in his image and likeness. Thus, the actual reality of our being and all existence is spiritual, not material.

In 1881, the Boston Metaphysical College was founded to teach and propagate Baker Eddy's ideas on mind healing (her friend and benefactor Hiram Crofts also ran a Christian Science clinic for healing the sick in Taunton, Somerset, for a while). The institution flourished all over America and Europe despite the high fees charged for a three-week course. However, Baker Eddy closed the college after eight years, claiming its demands on her were too great. The proceeds from her book and the sale of the college left her a millionaire by the time she died, a fact seized upon by her detractors. There are detailed accounts of her life and teachings by the Christian Science writers EM Ramsay and Robert Peel.

The word Christian in relation to Christian Science is misleading, as many of the movement's beliefs oppose Christian orthodoxy. Worship in Christian Science churches is very simple, since Baker Eddy disliked elaborate rituals and ceremonies. There is no clergy, only practitioners who are devoted to healing. The central element is the Lesson-Sermon, which selects topics from Baker Eddy's book and expounds on them. There is no Eucharist, and the communion meal is supposed to be a remembrance of the meal the risen Christ shared with his disciples on the shores of the Sea of Galilee rather than the Last Supper.

← *The Blind of Jericho, or Christ Healing the Blind,*
1650, NICOLAS POUSSIN
The healing of a man blind from birth was one of the most astounding miracles performed by Christ and led to a bitter controversy between Jesus and the Pharisees, resulting in the healed man being thrown out of the Jewish synagogue. Poussin's oil on canvas now sits in the Louvre, Paris.

↓ The First Church of Christ Scientist,
Boston, Massachusetts, US
The headquarters of the Christian Science Church, which is noted for its publications, especially the *Christian Science Monitor*. The prominent symbols of Christian Science, the Cross and the Crown, can be seen on the dome of the church.

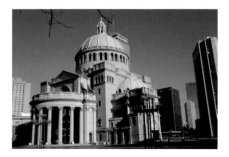

CANADA Christian Science Church and Reading Room, Nelson, BC: **UK** First Church of Christ, Scientist, Bedford, England: **US** Christian Science Brothers University, Memphis, Tennessee; Christian Science Monitor Library, Boston, Massachusetts; Pleasant View (home of Mary Baker Eddy), Concord, New Hampshire

 This umbrella term includes the group of churches belonging to the Pentecostal movement, which emphasises the gifts of the Holy Spirit (as described in the Biblical account of the Day of the Pentecost), and especially the gift of speaking in tongues (*glossalia*).

ALBERT BENJAMIN SIMPSON (1843–1919); ALEXANDER DOWIE (1847–1907); CHARLES HARRISON MASON (1866–1961); WILLIAM J SEYMOUR (1870–1922); REVEREND CHARLES FOX PARHAM (1873–1929)

Baptism of the Holy Spirit; charismatic worship; evangelism; interracialism; speaking in tongues

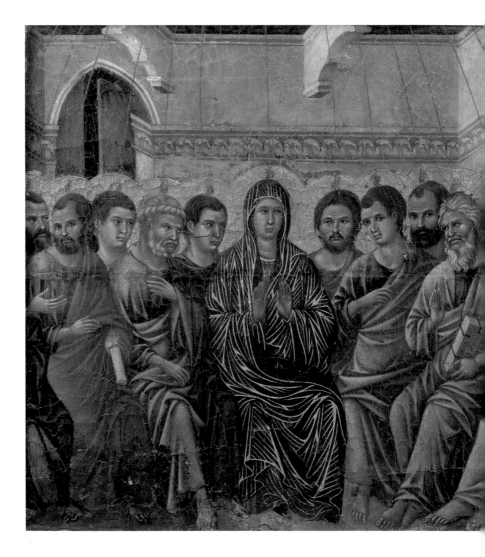

Pentecostalism attracted worldwide attention in 1906 as a result of the Azusa Street Revival in Los Angeles, California. It was here that the African-American preacher William J Seymour, inspired by the teachings of Reverend Charles Fox Parham during his time at Parham's Bible School in Houston, conducted a meeting one afternoon in April. During this, many who attended claimed to have received the blessing Pentecostalists call the Baptism of the Holy Spirit, an event they believe to be similar to the gift of the Holy Spirit to the Apostles described in Acts, Chapter 2.

From Azusa Street, Pentecostalism spread rapidly across the globe to become a major force in contemporary Christianity, and there are currently an estimated 105 million Pentecostal Christians worldwide. Charles Harrison Mason, who received the Holy Spirit blessing at Azusa Street, went to Memphis where he founded the Church of God in Christ, which is now the largest Pentecostal denomination in the world. Albert Benjamin Simpson of the Christian and Missionary Alliance is another figure whose teachings had a great impact on Pentecostalism.

Pentecostal doctrines are the same as those of other evangelist mainstream churches, for example belief in the Trinity and in the inerrancy of the Bible. However, they stress the continuation of baptism by the Holy Spirit, believed by some to have ended in apostolic times, as well as its manifestation as speaking in tongues – those who do not speak in tongues are said not to have received the blessing (Baptism of the Holy Spirit). Healing is also an important part of the movement and Alexander Dowie, a famous Pentecostal minister, was especially noted for his healing powers.

The interracial character of Pentecostal churches was a noted feature during the first decade of the movement's existence, even in the then segregated Southern states of the US, right up until 1924, when the church experienced a racial schism. However, in 1994 the segregated churches reunited, in an event known as the Memphis Miracle, to form the Pentecostal/Charismatic Churches of North America.

Pentecostal worship is characterised by praying out loud, the clapping of hands and singing, lifting up of hands and personal testimonies.

← *Maestà* (upper section): *Pentecost,* 1308–11, **DUCCIO DI BUONINSEGNA**
One of the panels from Buoninsegna's original altarpiece for the cathedral in Siena, Italy, this is an unusual depiction of the Pentecost. The only indication of the coming of the Holy Spirit is in the tongues of flame resting on the heads of Christ's disciples, with Mary occupying a central position. The panel is now housed in the city's Museo dell'Opera della Metropolitana.

UK Elim Pentecostal Church, Uxbridge, Middlesex, England; Kensington Temple, London. **US** Bethel Bible College, Iopeka, Kansas; 312 Azusa Street, Azusa, Los Angeles, California (site of the Pentecostal revival of 1906); Church of God in Christ, Memphis, Tennessee

Referred to by critics as the Moonies, the Unification Church (full name: The Holy Spirit Association for the Unification of World Christianity) was founded by Reverend Sun Myung Moon, a Christian minister from North Korea who fled to South Korea during the Korean War.

REVEREND SUN MYUNG MOON (1920–); BO HI PAK (1930–); HAK JA HAN MOON (1943–); HYO JIN MOON (1962–); MICHAEL JENKINS (unknown)

arranged mass marriages; The Divine Principle; Fall of Man; Messiahship

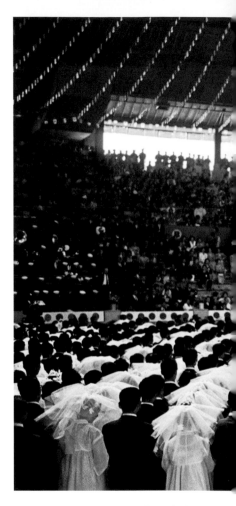

The Unification Church is based on the claims of the Reverend Sun Myung Moon to be the new Messiah (or 'True Parent'). Though Moon's orignal intention seemed to be Christian ecumenism, the church has now been categorised as a separate Christian denomination, and even a cult, as some of its beliefs diverge widely from those of orthodox Christianity.

Moon claims that when he was 15 years old Jesus appeared to him and asked him to complete the mission of establishing the Kingdom of God he had left unfinished when he went to the Cross. Moon blames John the Baptist for not adequately supporting Jesus in his mission on Earth, thereby compelling him to die on the Cross for the salvation of humanity, and blames Eve's sexual temptation of Adam for the Fall of Man. The Unification Church thus insists on absolute fidelity in marriage and abstinence before it. Moon himself arranges the marriages of most of his followers, which are often solemnised en masse.

Hak Ja Han Moon, the wife of Sun Myung, is the co-leader of the Unification Church and is referred to as the True Mother by church members. Hyo Jin Moon, the eldest of Reverend Moon's 13 children, is named as his successor, and his right-hand man is Bo Hi Pak, a former officer of the South Korean army. The current president of the Unification Church of America is Michael Jenkins.

The church's principles are enunciated in the scripture known as Wolli Wonbon (The Divine Principle). Members of the Unification Church take a generally pro-Jewish and pro-Israel stance. However, some Jews criticise Moon and his church as being anti-Semitic,

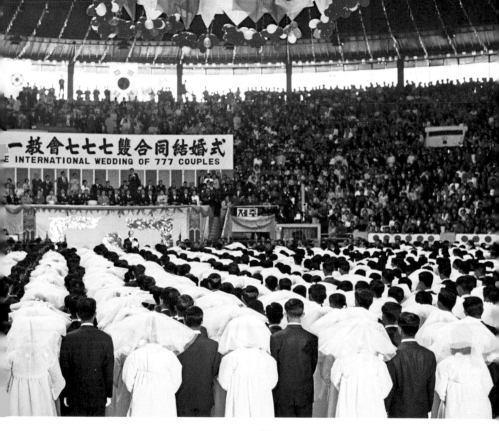

as Moon is said to have accused the Jews of killing Jesus and depicted the Holocaust as retribution for Jesus' crucifixion.

Unification Church mass marriage, Seoul, South Korea
Mass marriages are a unique feature of the Unification Church. Reverend Sun Myung Moon has presided over the marriage of thousands of couples at such mass ceremonies. The matches are usually arranged by the church. On this occasion, 790 Korean and foreign couples were married in one ceremony.

SOUTH KOREA Cheongpyeong Heaven and Earth Training Centre, Gyeonggi-do; First Unification Church, Pusan; Old Korean Church Headquarters, Seoul; Sun Moon University, Asan: **US** Unification Church, Adams-Morgan, Washington DC

3

ISLAM

Islam

Islam is a religion based on faith in Allah and obedience to his revelation contained in the Quran (Koran) and exemplified in the character and behaviour of Muhammad, the final prophet of God.

MUHAMMAD (571–632 CE); **ABU BAKR** (573–634); **UMAR IBN UL-KHATTAB** (d. 644); **UTHMAN** (d. 656); **ALI IBN ABI TALIB** (d. 661)

Hijra; Kaaba; Quran; rasul; tawhid

Islam means the state of peace achieved through surrender to God, and a Muslim is one who has attained such a condition. Muslims do not believe the religion to have begun with Muhammad in the 7th century, but to be the true path that God has provided for humans since the beginning of time. They exist to bear witness to God's oneness (tawhid) and believe in the struggle to remain obedient to God's will. A number of prophets have exemplified this life of surrender, warning of the consequences of disobedience and preaching the rewards in store for the faithful.

Of special significance among such prophets (rasul) are Abraham, who

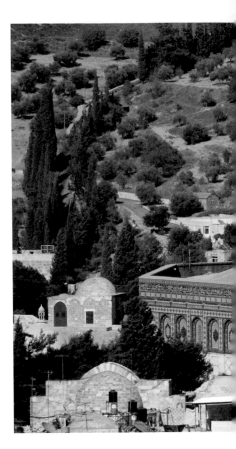

↑ **Dome of the Rock, Jerusalem, Israel**
Built by the Umayyad caliph Abdul Malik ibn Marwan in 685 CE, the Dome of the Rock remains one of the world's best-known architectural treasures. The gold-domed shrine covers a large stone believed to be the location from which Muhammad ascended through the heavens to God accompanied by the Angel Gabriel.

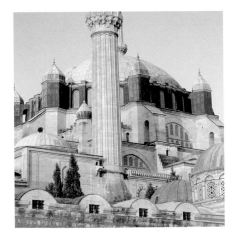

← **Selimiye Mosque, Edirne, Turkey**
The Selimiye Mosque (Selimiye Camii in Turkish) was commissioned by Sultan Selim II and built by the famous architect Sinan between 1568 and 1574. The grand mosque stands at the centre of a complex of buildings that includes a medrese (islamic learning centre), a dar-ul hadis (boys' school), a time-keeper's room and an arasta (row of shops).

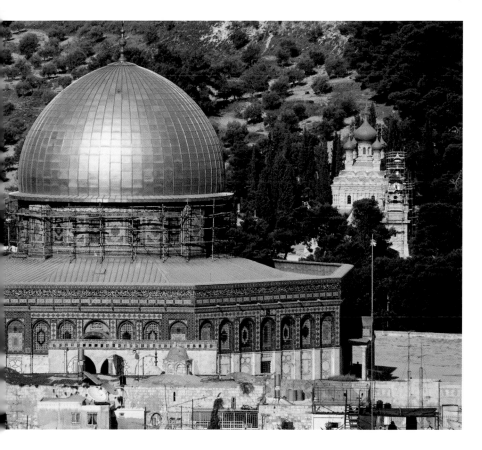

epitomised the condition of obedience to the divine will, Moses, David and Jesus. The last three are special because of the revelations contained in the sacred texts associated with them. It is believed that the followers of these revelations corrupted the sacred texts sent down to them and introduced human error to the eternal law of God. As a consequence, a final prophet was required to receive the Quran, the last and complete revelation of God's will, and an ultimate community was required to maintain the primacy of God's law without corruption.

At the age of 40, Muhammad, by then married to Khadijah, and a merchant known for his integrity and sense of justice, began to receive the verses of the Quran in a cave above Mecca, western Saudi Arabia, revealed to him through the agency of Gabriel. This was to continue for 22 years until the full revelation had been passed on. After persecution by the merchants and ruling elites of Mecca, in 622 CE Muhammad departed to the city of Medina, whose leaders had invited him to resolve differences between the city's tribes. This was fortuitous as, fearing their livelihoods as guardians of the city's traditional deities would be jeopardised, the Meccan merchants and ruling classes had rejected

the message of worship of one God and begun to persecute the fledgling religious community. In Medina, Muhammad was acknowledged as a respected leader and organised his followers into the first Muslim community (which went on to spread the message of Islam very effectively throughout the Arabian peninsula), and when the struggle against the Meccan leaders eventually escalated into a bloody conflict, the Quran's continuing revelations gave permission for the Muslims to defend their religion through armed struggle. A triumphant Muhammad entered Mecca in 623 and returned the Kaaba, a site sacred to the Arabs, to the worship of one God. Muslims believe the Kaaba stone was placed here as an altar to worship God by Abraham when he was visiting his exiled wife Hagar and her child Ishmael, and to this day all

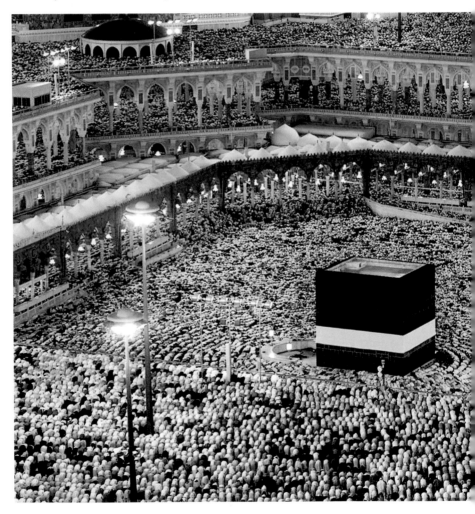

Muslims turn in its direction when they pray. Muhammad's departure to Medina is known as the Hijra, and marks the beginning of the Islamic calendar.

After the death of Muhammad in 632, the religion of Islam provided unity among the traditionally warring Arab tribes, and gave the impetus for expansion by the Arabs, who conquered both the ailing Persian and Byzantine empires under the leadership of the first four caliphs, Abu Bakr, Umar ibn ul-Khattab, Uthman and Ali ibn Abi Talib.

Reaching into Europe and as far as India, within a century Muslims were to become the most powerful civilisation in the world and the religion of Islam the major rival to Christianity. Until their conquest in 1258 by the Mongol hordes of Genghis Khan, the Arab cities of Damascus and Baghdad were the repositories of art, literature, philosophy and mathematics, and remained great religious centres. Even after the Mongol invasion, Islam was to remain dominant until the advent of European power, and created three significant empires: the Moghuls in India, the Safavids in Persia, and the Ottomans in Turkey, the Middle East and the Balkans.

Today, Islam is the second biggest religion after Christianity and is experiencing a renaissance in most Muslim countries, even though troubled by Western modernity and the struggle for supremacy among its various ideologies and factions.

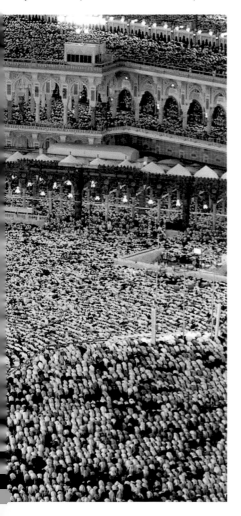

← **The Kaaba, Grand Mosque, Mecca, Saudi Arabia**
The Kaaba in Mecca is the focal point of Muslim prayer and consists of an oblong stone building located in the centre of the Grand Mosque's quadrangle. The Grand Mosque is the holiest shrine in Islam.

Quran, Morocco, 1568 (see page 66)
The image shows a highly decorated end-piece from a Moroccan Quran printed in 1568. Calligraphy has developed into a very sophisticated art form in the Muslim world, a result of the general antipathy to representational art as such duplications of human or animal forms are believed to rival God in the creative process. However, more important has been the attempt to display God's word in the Quran in beautiful and unsurpassable forms.

INDIA Taj Mahal, Agra, Uttar Pradesh; The Red Fort, Delhi: **ISRAEL** Al-Aqsa Mosque, Jerusalem: **SPAIN** Alhambra Palace, Granada: **TURKEY** Topkapi Palace Museum, Istanbul

Sunni is the term used to describe the overwhelming majority of Muslims who believe in the succession of caliphs, rather than the Imamate, after the death of Muhammad.

ABU BAKR (573–634); **ABU HANIFA** (699–765); **ANAS IBN MALIK** (715–96); **IBN IDRIS AL SHAFII** (767–820); **AHMAD IBN HANBAL** (d. 855)

Hanafi; Hanbali; Maliki; Salafi; Wahhabi

The Sunnis are the largest group within Islam and constitute the majority of the population in most Muslim nations, with the exception of Iraq and Iran. However, the Sunni population is deeply divided between traditional Muslims influenced by the teachings of the Sufis, and the more recent revivalist movements such as the Wahhabis and Salafis who have a more political agenda. All claim to be the genuine Sunni community, sometimes to the exclusion of opponents.

Historically, Sunnis were those who acknowledged that the first four caliphs, beginning with Abu Bakr, were the legitimate successors to Muhammad as leaders of the Muslim community. The name is derived from *sunna* (literally 'the path'), and Sunni Muslims regard the exemplary practices, customs and traditions of Muhammad as written down in the Hadith to be the second most authoritative textual source after the Quran (Koran) and the normative model for Muslim behaviour and custom.

Sunnis are divided into four legal schools of jurisprudence (fiqh) – Hanafi, Hanbali, Maliki and Shafii – founded by Abu Hanifa, Ahmad ibn Hanbal, Anas ibn Malik and Ibn Idris al Shafii in the 8th and 9th centuries to interpret and frame law based on interpretation of the Quran and the Sunna, by the means of two principles known as Qiyas (analogy) and Ijma (consensus). There is agreement between them on most issues, though they differ on the methodology used to authenticate primary textual evidence. More contested differences exist over the authority of the fiqh itself. The ulema, the Sunni clerics able to interpret matters of law, claim that the right to interpret direct from the Quran and Hadith is no longer permitted. Deeply conservative, they interpret from the body of law rather than the primary sources. Contemporary religious reform movements with political agendas argue that the right to such individual interpretation of the primary sources remains open to qualified scholars and religious leaders.

← **Wazir Khan Mosque, Lahore, Pakistan**
The mosque was built by by Ilam-ud-Dinansari, commonly known as Nawab Wazir Khan, who was Governor of Lahore until 1639. It was constructed in seven years, starting around 1634 during the reign of the Mughul Emperor Shah Jehan.

EGYPT Al-Azhar University, Cairo: **INDIA** Jami Masjid Mosque, Fatehpur Sikri, Rajasthan: **SYRIA** Ummayad Mosque, Damascus: **UK** Regents Park Central Mosque, London: **UZBEKISTAN** Hoja Ahrar Mosque, Samarqand

Shi'ism

Shi'a refers to several Muslim movements that are distinguished by their support for Ali, the son-in-law of Muhammad, and his direct descendants, as the legitimate successors to the leadership of the Muslim community.

ALI IBN ABI TALIB (d. 661); **HASAN** (626–70); **HUSSEIN** (627–80); **HASAN AL-ASKARI** (d. 874); **MUHAMMAD AL-MAHDI** (b. 869); **AYATOLLAH RUHOLLAH KHOMEINI** (1900–89)

ayatollahs; Imams; Ishmaelis; Muharram; Zaidis

Literally meaning the 'Part of Ali', the various groups that form the Shi'ite movement, the largest Muslim minority, all recognise that Ali, the son-in-law of Muhammad, was his legitimate successor, rather than Abu Bakr, the first caliph. The claim is based on the belief that Muhammad took aside Ali when returning from the final pilgrimage to Mecca shortly before his death, and acknowledged him as the next leader by saying 'He, of whom I am the Patron, of Him, Ali is also the Patron'. Ali was married to the Prophet's daughter, and the father of his grandchildren, Hussein and Hasan, who are regarded as the second and third Imams.

For the sake of unity, Ali's supporters did not secede at the time of the appointment of the first three caliphs, even though they considered them to be usurpers. The real conflict began with the reign of Muawiyya, the Umayyad caliph, who it is believed reneged on a promise to return the Muslim leadership to Ali's descendants after his death.

Shi'a reject the concept of leadership by election and argue that it belongs to the realm of divine injunction. The leadership is a hereditary principle going back to Muhammad through Ali and his blood descendants. Shi'a put their trust in the Imams, the successors of the Ahl-al-Bayt: that is, Muhammad's direct family members. They believe that the Imams are immaculate and contain the light of Muhammad. The final Imam, known as al-Mahdi, will return triumphant on Judgement Day.

The faith in charismatic leadership has led to divisions among the Shi'a over who is regarded as the true Imam. The first division occurred after the death of the fourth Imam, creating the Zaidis, who ruled over Yemen until 1959. Disagreements re-emerged over the eighth Imam, creating the Ishmaelis. The dominant group of Shi'a acknowledge 12 Imams and are known as Twelvers, or Imamiyyah. Today, the Imamiyyah Shi'as are the majority in Iran and Iraq and are led by ayatollahs as representatives of the Imams. The well-known Ayatollah Khomeini was the leader of the Islamic revolution and founder of the Islamic republic of Iran. Further divisions have created the Druze and the Bahai, which are now independent religions.

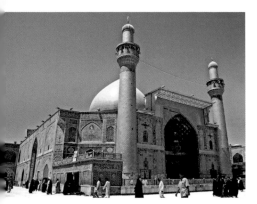

← Mausoleum of Ali ibn Abi Talib, Najaf, Iraq
Ali ibn Abi Talib was the first Imam of all Shi'a Muslims. The tomb shrine is one of the holiest in the Muslim world and has the largest cemetery in the wider world, believed to also include the graves of the prophets Adam and Noah. Many devout Muslims aspire to be buried here.

Mausoleum of Imam Hussein, Karbala, Iraq
The mausoleum of the third Imam, Hussein, rivals Najaf as the second most sacred site for Shi'a Muslims after Mecca. Hussein is known as the 'Prince of Martyrs', and millions flock to his tomb during the month of Muharram, which commemorates his death. The original shrine was constructed in 850 CE, but was rebuilt in 969.

AFGHANISTAN Tomb of Ali, Mazar al-Sharif: **IRAN** Shrine of Imam Raza, Mashad; Shrine of Fatima Musamah, Qum; Tomb of Ayatollah Khomeini, Tehran: **IRAQ** Al-Askari Mosque and Askariyya Shrine, Samarra, Baghdad

Sufism

Sometimes described as Islamic mysticism, Sufism is based on a master/disciple relationship intended to bring the practitioner into an intimate relationship with God through the practice of a range of spiritual disciplines.

RABIA AL-ADAWIYYAH (d. 801); HUSAIN IBN MANSUR AL-HALLAJ (858–922); ABU HAMID AL-GHAZZALI (d. 1111); MUHIYUD-DIN MUHAMMAD IBN ARABI (1165–1240); JALAL UD-DIN RUMI (1207–73)

dhikr; murids; sheikh; tariqas; Tassawuf

The origins of the word Sufism are disputed, as are its origins in the Muslim world. To its adherents it began with Muhammad and was the original practice of his first followers. To its opponents it is tainted by contact with, and the influence of, Buddhism, Christianity and Neoplatonism, corrupting the original Islam. Although not as influential as in its heyday from the 10th to the 12th century when it dominated the Muslim world, it still has some influence in North and sub-Saharan Africa, South and Southeast Asia, and Egypt. The term is most commonly believed to have originated from the Arabic *suf*, or wool, describing the plain woollen garb of the early Sufi mystics. Others argue it is derived from Tassawuf, the practice of ego negation and purification of the heart through the dhikr (the remembrance of God's names) that is mentioned in the Quran (Koran). Many Sufis prefer to claim that it is taken from *ahl al-Suffa*, the 'people of the porch', who the Quran describes as poor but very pious Muslims offered shelter by Muhammad in the porch of his home and first mosque in Medina.

The first Sufis would appear to have been individuals who retreated to an austere life of piety in reaction to the worldliness of the Umayyad dynasty, the first Arab empire, founded in 661 CE. By the end of the 9th century, Sufis had developed both the doctrine and the methodology of the path to mystical union. The 12th century, in particular, saw the greatest expansion of Sufi orders (tariqas) in which prominent Sufi masters (sheikhs) taught and systemised their respective disciplines to their students (murids), spreading across the Muslim world. Prominent among these are several well-known mystics such as Rabia al-Adawiyyah, Husain ibn Mansur al-Hallaj, Muhiyud-Din Muhammad ibn Arabi, Jalal ud-Din Rumi and the reformer and philosopher Abu Hamid al-Ghazzali.

As thousands of pious sheikhs taught their individual methods to achieve divine unity, attracting variously sized groups of

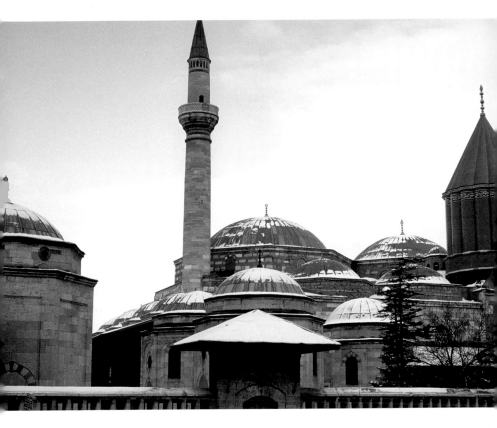

disciples, it was not long before a cult of saints began to develop, complete with miracle stories and its own literature. The proliferation of tomb shrines to the deceased Sufis brought a new dynamic into Muslim beliefs and customs as millions of adherents concentrated their practices and petitionary prayers around these tombs. To this day, they provide an alternative sacred space to the mosque.

↑ Mevlana Mausoleum, Konya, Turkey
The mausoleum, since 1927 a cultural centre and museum, was once the school of Jalal ud-Din Rumi and contained a mosque, living quarters for the dervishes, and halls in which the famous Mevlevi 'turning' or mystical dancing took place.

← Tomb of Jalal ud-Din Rumi, Mevlana Mausoleum
Typical of most Sufi tombs, this one is contained at the heart of the building. Although now a museum visited by thousands of tourists from around the world, the tomb remains a centre of pilgrimage visited by both Muslims and spiritual seekers from other religious traditions.

INDIA Sacred Shrine of Hazrat Amir Khusrow and Nizamuddin Aulia, Delhi; Tomb of Hazrat Shah Wailiullah, Coprastham Mehndiyan, Old Delhi; **IRAQ** Mosque of Hazrat Sheikh Abdul Qadir Gilani, Baghdad; **PAKISTAN** Shrines and mausoleums, Multan, Punjab; Shrine of Shaykh Lal Shahbaz Qalandar, Sehwan Sharif

Ishmaelism

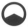 The Ishmaelis are the second largest movement of Shi'a Muslims, and their members acknowledge only the authority of the first seven Imams, rather than 12. For this reason they are sometimes known as 'Seveners'.

JAFAR AS-SADIQ (702–65 CE); MUSA AL-KAZIM (745–99); ABDULLAH AL-MAHDI (881–934); AGA KHAN IV (b. 1936)

Aga Khan; Fatimids; Imams, Mustaalis; Nizaris

Ishmaelis are traditionally found in South Asia, Syria, Saudi Arabia, Yemen, Tajikistan, Afghanistan and East Africa, but during the 20th century also migrated into Europe. They give their loyalty to the Aga Khan as a living embodiment of the Quran (Koran), and believe that his instructions supersede the revelation contained in the Book, which they regard as time bound and not a universal message for all time. Nor do they give pre-eminence to the five pillars of Islam, as they consider each outer component of the religion to have an esoteric meaning known only to the Imams.

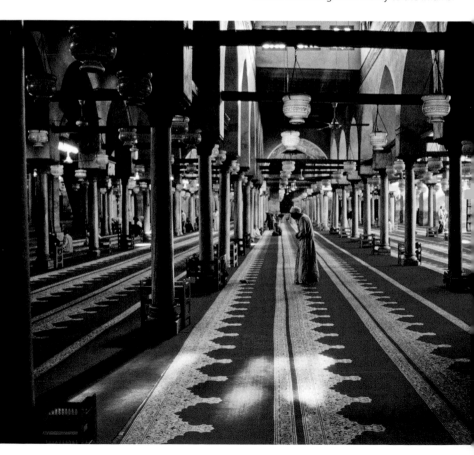

Historically, the Ishmaelis originated in a dispute over the succession to the Shi'a Imamate. The Twelver (or Ithna-Ashari) Shi'as and the Ishmaelis both accept the same Imams until Jafar as-Sadiq, the sixth Imam. After Jafar, the Twelvers regard his son, Musa al-Kazim, as the authentic heir, while the Ishmaelis acknowledge his elder brother, Ishmael.

In the period following this dispute, the Ishmaelis promoted their sect secretly from their base in Salmiyah, in Syria. The eleventh Imam, Abdullah al-Mahdi, established the Fatimid (named after the Prophet's daughter) dynasty and empire in North Africa during the 10th century, and this eventually spread to Egypt. The city of Cairo was built by this dynasty.

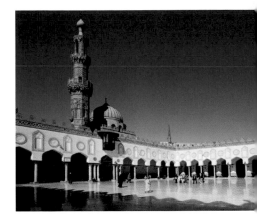

The largest group are the Nizari (or Imami) Ishmaelis, who follow the Aga Khan and believe that the present Aga Khan IV is the 49th Imam. (A smaller subsect is known as the Mustaalis.) The Nizaris trace their line to Persia, where the survivors of the Fatimids established themselves in the 12th century.

After the invasion of the Mongols, the Ishmaelis survived as scattered communities until the Shah of Persia gave the honorary title of Aga Khan to the 46th Ishmaeli Imam, providing a focus for the revitalisation of the community. The present Aga Khan is well known for his service to international affairs and was given the title of 'His Highness' by Elizabeth II in 1957.

↑ **Al-Azhar Mosque, Cairo, Egypt**
The Al-Azhar Mosque was built in 972 CE on the founding of the new city of Cairo as the Fatimid capital. Originally called Jamil-Qahira, the mosque was renamed Al-Azhar ('the Splendid') as an indication of its magnificence. In 988 it was converted into a theological college and is now the foremost Sunni educational institution in the Muslim world.

← **Prayer hall, Al-Azhar Mosque**
The oldest part of the mosque, the prayer hall, consists of five aisles running parallel to the old Fatimid kiblah (direction of the Kaaba). The Ottomans removed the old kiblah wall in 1753, but kept the old mihrab (niche in the wall at the point nearest to Mecca) in situ, covered with a restored carved stucco.

◉ **EGYPT** Aga Khan Mausoleum, near Aswan:
INDIA Aga Khan Palace, Pune, Maharashtra:
TUNISIA Mahdia city (founded by Abdullah al-Mahdi):
UK Ishmaeli Centre, Kensington, London

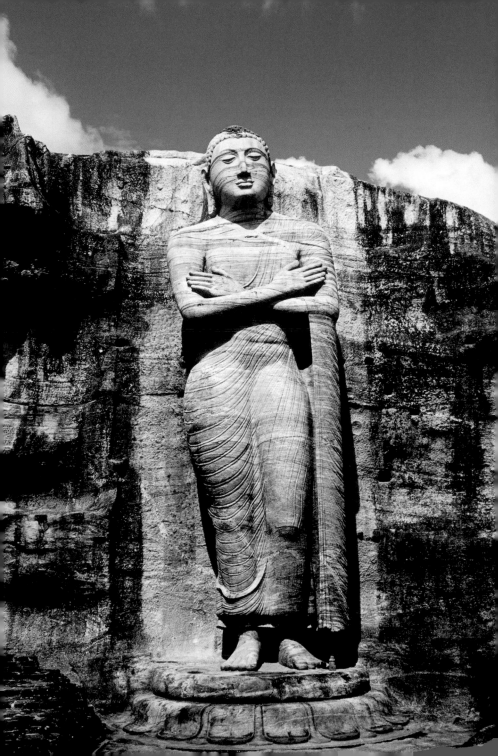

4

BUDDHISM &
SOUTH ASIAN
RELIGIONS

Hinduism

A polytheistic religion originating in India with a strong awareness of an underlying oneness, Hinduism acknowledges the authority of the Vedic texts, and organises human society according to a strict caste hierarchy.

SWAMI DAYANAND (1824–83); RAMAKRISHNA (1836–86); VIVEKANANDA (1863–1902); GANDHI (1869–1948); SRI AUROBINDO (1872–1950)

atman; Brahman; karma; moksha; varna

Hinduism is not easy to define and does not fit into a simple categorisation, as do Islam or Christianity. It is the dominant religion of the people of the Indian subcontinent and the third largest in the world. Thousands of years old, it incorporates literally hundreds of sacred texts and has no single founder, instead worshipping countless gods, from village deities to divine beings such as Vishnu, Shiva and Krishna, and the goddesses Durga, Kali and Lakshmi.

Attempts to define Hinduism have defeated most observers. Although most branches of Hinduism acknowledge the canon of sacred texts known as the Veda, there are many that do not. Ritual is diverse and, although considered by most as essential for human salvation, many others deny its significance. In addition, some of the ancient philosophies of India still influence Hindu thought in speculating that the universe was created and sustained by an all-powerful God, while yet other thinkers deny the existence of such a being. And, whereas millions accept the idea that human society is hierarchically divided into four divinely ordained varnas, subdivided into thousands of castes, which an individual is born into and cannot leave, others have argued that caste is a human construction and passionately advocate that salvation is open to all.

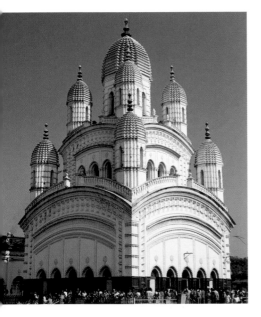

→ Riverfront, Varanasi, Uttar Pradesh, India
The riverfront of the ancient pilgrimage city of Varanasi, also known as Kashi or Benares, remains one of the most distinctive sights in the world, where millions of Hindu pilgrims bathe and perform religious rites in front of its ancient temples and palaces.

← Dakshineshwr Kali Temple, Kolkata, West Bengal, India
In 1852, a young Brahmin was appointed assistant priest here and went on to become one of the most important influences on modern Hinduism. Renamed Ramakrishna by a wandering ascetic, he is considered by many Hindus to be an incarnation of God, and the Ramakrishna movement is now an international Hindu presence. The temple remains an important pilgrimage centre.

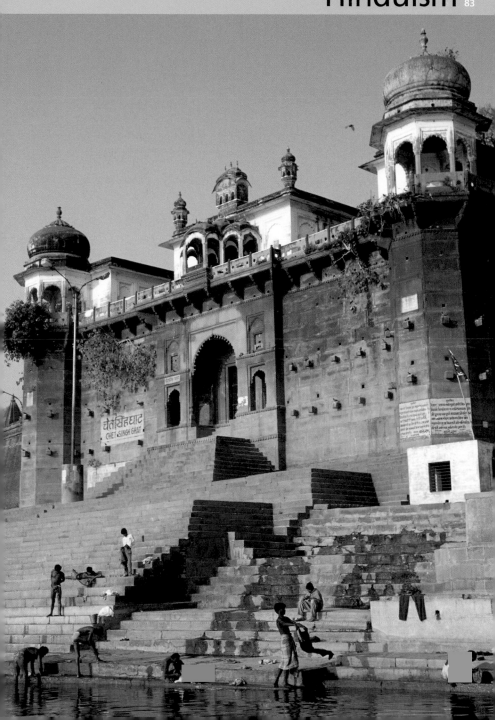

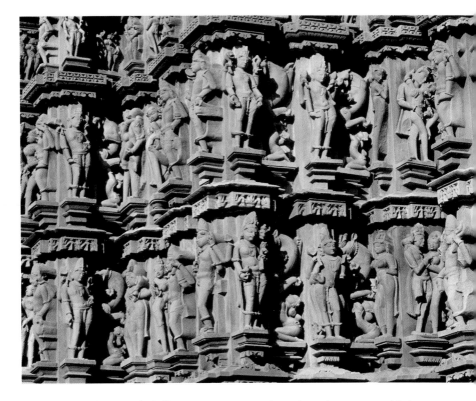

All Hindus adhere to a belief in reincarnation – that all souls move through a cycle of birth and death (samsara), determined by the law of action and its effect (karma) until eventual release (moksha). However, the means to such final release, and the nature of it, are disputed among Hinduism's countless sects.

Problems of definition are partly the result of outside influences, initially Muslim invaders and then the British. And even the perception of Hinduism as a world religion is to a large degree a construct of Western Orientalists and Hindu intellectual elites responding to the Christian criticisms and European superiority of the 19th century. In reality, Hinduism consists of a wide range of rural practices confined to local areas of the subcontinent, interwoven with the various philosophies that have developed over the last five millennia.

Hinduism has been described as henotheism, a form of religion in which individual devotees worship one particular god out of many, all of which are embodiments of one supreme being. The devotee's chosen god (isvara) thus becomes the embodiment of the supreme being for that individual. In Hinduism, the supreme being is Brahman, an impersonal power upon which the universe is woven. Brahman is the essence of all existence and remains as the ultimate reality when everything else decays and eventually transforms. Its omnipresence within the universe means that it exists within every

created being, and this individual inner presence is known as atman.

For many Hindus, liberation or salvation is the complete identification of atman with Brahman – a recognition that the innermost being of the human (atman) is identical to the omnipresent power of the ultimate being (Brahman). For many millions more, however, atman remains eternally separate from Brahman, so that the individual can remain in eternal devotion to God. In such devotional traditions, Brahman is generally worshipped not in the impersonal form as life energy, but in one of the countless manifestations of Brahman as a personal god. Principal among these devotional forms of Hinduism are Vaishnavism (the worship of Vishnu), Shaivism (the worship of Shiva), and Shaktism (the worship of the goddess Shakti), and most Hindus can be found within the many sects of these three main streams of the religion.

Although it has no single founder, Hinduism has been formed and re-formed through the activities of countless saints and sages through the ages. Prominent among these in the modern period are Gandhi, Vivekananda, Ramakrishna, Swami Dayanand and Sri Aurobindo.

← **Erotic carvings from the sculptures at Khajuraho, Madhya Pradesh, India**
Built during the Chandella dynasty (950–1050 CE), only about 20 of the estimated original 85 sculptures remain. The temples are some of the finest examples of central Indian religious architecture and provide fascinating glimpses into Hindu society in the medieval period.

↓ **Ganesha, c. 1070**
Ganesha, the elephant-headed god, is one of the most widely worshipped and is variously described as the deity of wisdom, prudence and salvation. He is popularly regarded as the god who can remove all obstacles; thus Hindu rituals usually begin with an invocation to him, and many Hindus will begin their daily activities with a short prayer to him.

👁 **INDIA** Pilgrimage city of Ayodhya, Uttar Pradesh; Pilgrimage city of Haridwar, Uttar Pradesh; Pilgrimage city of Madurai, Tamil Nadu; Pilgrimage city of Rishikesh, Uttar Pradesh; Pilgrimage city of Vrindavan, Uttar Pradesh

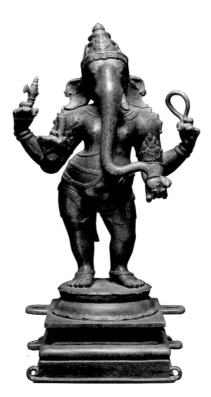

Vaishnavism

 Vaishnavism is the term for a number of movements that have developed historically in various parts of India and which worship the manifestations, or incarnations (avatars) of Vishnu, especially the human avatars Rama and Krishna.

RAMANUJA (1017–1137); **MADHVA** (1238–1317); **VALLABHA** (1481–1533); **CHAITANYA** (1486–1533)

avatar; bhakti; Krishna; Rama; Vishnu

Although there are problems defining Hinduism as a religion, Vaishnavism operates as a clearly defined body of rituals and beliefs with its own discrete sacred texts and founder figures. Today it is the largest of the Hindu traditions and its origins lie in the Vedic religion, but also in the assimilation of tribal gods over the millennia. The heart of Vaishnavism lies in devotional worship (bhakti) to the god Vishnu, who is regarded as a saviour. The medieval period in India is associated with intense devotional traditions that spawned a number of sects that developed from the teachings of saintly

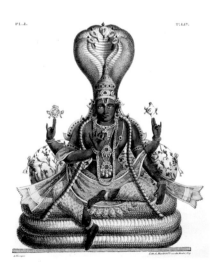

devotees such as Vallabha, Mira Bai (1498–1547) and Surdas (1479–1586). Most Hindus perceive Vishnu to be the power of preservation in the trilogy that includes Brahma and Shiva as, respectively, the creative and destructive powers.

The three powers drive the eternal wheel of samsara (the material world), but Vishnu's power of preservation also includes two other roles, as the maintainer of dharma (the eternal law of the cosmos) and the sustainer of righteousness. This idea gives rise to the belief that Vishnu incarnates in the world to save his devotees. The many myths that sustain these ideas have their origin in Vedic literature, but developed into a cult of Vishnu worship in medieval texts.

However, although it is stated that there have been 10 incarnations of Vishnu, it was the two human avatars of Rama and Krishna that developed into major theistic devotional religions complete with temples, sacred texts, theology and practices. Rama was worshipped as a hero and divine king in northern India perhaps even as far back as the first centuries BCE, but came to be identified relatively late as an incarnation of Vishnu, though the *Ramayana*, the well-known and much loved epic text that tells of his exploits, demonstrates that Rama had clearly become the object of intense devotional worship by the medieval period. Every year, pilgrims in their millions flock to Ayodhya, the city associated with his birth. But the most popular of the Vishnu avatars is Krishna. Worshipped throughout India, many of his devotees regard him not only as an avatar of Vishnu, but as the eternal form of the supreme Lord come to offer salvation through loving worship to his devotees. The latter form of worship is associated with the Bengali mystic and reformer Chaitanya. Ramanuja and Madhva are the two principal exponents of Vaishnavite philosophy.

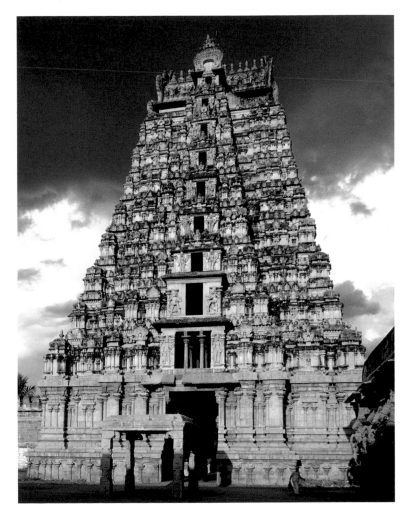

↑ **Gopuram, Sri Rangam Temple, Tiruchirappalli, Tamil Nadu, India**

The Sri Rangam Temple is one of the most significant of India's Vaishnava temples and the largest temple in the country. In all it has seven gopurams (gateways) that must be negotiated before reaching the inner sanctum of the main deity, which is a large reclining Vishnu, or Ranganath as he is known in southern India.

← **Typical iconographic representation of Vishnu**

Here Vishnu is represented as blue in colour. His vahana (vehicle) is Garuda, the winged half-man, half-bird and king of birds, and his consort is the goddess Lakshmi. Vishnu is said to have four arms in which he usually holds a conch shell, quoit, club and lotus.

INDIA Festival of Jagannath, Puri, Orissa; Pilgrimage city of Vrindavan, Uttar Pradesh; Pilgrimage city of Ayodhya, Uttar Pradesh, Pilgrimage city of Dwarka, Gujurat: **UK** Bhaktivedanta Manor, Headquarters of the International Society for Krishna Consciousness, and the Krishna and Radha Temple, near Watford, England

Shaivism

cross-legged, with long hair and snakes draped around his neck.

Shiva's diverse origins and assimilation into the mainstream make him a god for all seasons. His errant behaviour in Hindu legends is identified with by the outcast and fringe elements of Indian society, yet he is also accessible to the ascetic, the devotional lover of God, yogi, philosopher, Brahmin priest and those who reject the Vedic tradition. He is worshipped in wayside shrines and village temples as well as the grand temple complexes of southern India. Worship can consist of devotional songs, revelry, temple rituals and even self-mutilation. However, Shiva belongs predominantly in the world of folk religion, thus Shaivist movements present a panoply of rites and ceremonies, sentiments and customs belonging to the common people who were not governed by the Sanskrit texts and their high-caste representatives.

Today, the main centre for the worship of Shiva is in southern India, especially the Tamil-speaking regions where, in the 11th and 12th centuries, the school of Shaiva Siddhanta emerged, resulting in the creation of an intensely emotional dualistic bhakti (devotion) to Shiva expressed in the mystical experiences and poetry of the Tamil saints (Nyanmars). It was this form of Shaivism, which probably originated in northern Indian forms of Kashmiri Shaivism known as Trika, that spread the worship of Shiva also to the Brahmin elites.

 Shaivism is the term for a number of movements that have developed historically in various parts of India and worship the various forms of Shiva, his consort Parvati and their two sons, Ganesha and Karttikeya.

GANESHA; KARRTIKEYA; PARVATI; SHAKTI; SHANKAR; SHIVA

lingam; Nyanmars; Shaiva Siddhanta; Tantra; Trika

Shaivism refers to the traditions that follow the teachings of Shiva, and which focus on him as the principal deity and, sometimes, on the goddess Shakti, where she appears as his consort. In the Hindu mainstream, Shiva appears as the god of destruction in the classical Hindu trilogy of Brahma (creator), Vishnu (preserver) and Shiva (destroyer). The most common iconographic form of this god is that of Shankar, the ash-covered ascetic sitting

↑ **Shiva lingam, Pashupatinath, Nepal**
A typical example of a Shiva lingam found in a temple at Pashupatinath, a sacred pilgrimage city in Nepal on the River Bagnati. One of the most common forms of Shiva is the aniconic lingam, or phallus-shaped upright stone, which stands in the middle of a teardrop-shaped bowl representing the union of Shakti and Shiva, the female and male principles of divine energy as believed in Tantra forms of the religion.

↓ **Shiva and Parvati, Omkarananda Kamakshi-Devi Temple, Rishikesh, Uttar Pradesh, India**
The images of Shiva and his consort, Parvati, constructed on the temple's gopuram (tower entrance). The temple reproduces typical southern Indian architecture in northern India and was built on the site of the extensive spiritual disciplines carried out in the Himalayan foothills by Gurudev Paramahansa Omkarananda Sariswati.

INDIA Chidambaram Natarajar Temple, Chidambaram, Tamil Nadu; Chezerla Temple, Chezerla, Andhra Pradesh; Temples of Kurnool Fort, Kurnool, Andhra State; Kashi Vishwanath Temple, Varanasi, Uttar Pradesh; Dakeshwar Temple, Haridwar, Uttar Pradesh

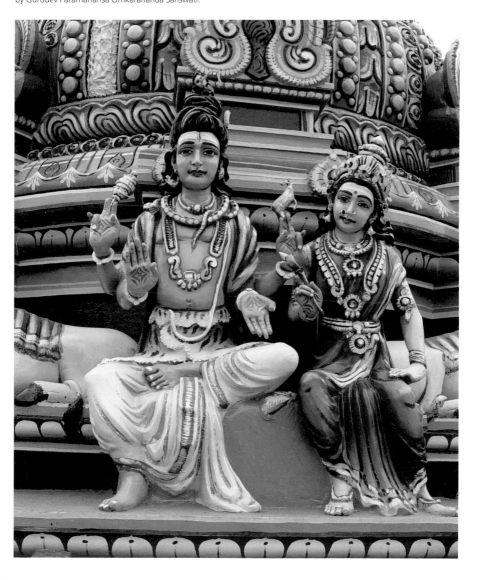

Shaktism

 Shaktism is a denomination of Hinduism whose followers focus their worship primarily on the various forms of Shakti, the Mother Goddess (also known as Devi), but without rejecting the importance of masculine divinity (though this is deemed to be inactive in her absence).

RAGHUNANDAN BHATTACHARYA (15th–16th century); **RAMAKRISHNA PARAMHANSA** (1836–86); **RAMPRASAD SEN** (19th century)

Amma; Devi; Mata; Shakti

The worship of goddesses is an extremely ancient practice in India, and female figurines used in worship can be dated back as far as the fifth and sixth millennia. However, the Vedic texts (the Vedic religion was the precursor to Hinduism, dating from around 2000–1200 BCE) include no mention of the Mother Goddess or any of her various manifestations, suggesting that original forms of Indian goddess worship developed outside the Vedic traditions. Even to this day, the worship of goddesses ranges from village deities known as matas (mothers) to the veneration of all-Indian forms of the Mother Goddess such as Lakshmi (the goddess of wealth), Sarasvati (usually associated with the arts), and Sita, Radha and Parvati (the divine consorts of the popular male deities Rama, Krishna and Shiva). Shaktas generally perceive all the manifold goddesses as aspects or manifestations of the one Mother Goddess.

A common term for the goddess in India is simply 'Mother', variously known as Ma, Mata or Mataji in the north, and Amma in the Dravidian languages of the south. Her worship is much less clearly demarcated than the groupings that form around the male deities Shiva or Vishnu, as most Hindus will offer worship to the Mother Goddess at some stage of their lives. Thus it is more accurate to describe Shaktas as those who solely or primarily focus their devotions on the Mother Goddess in her various forms. This kind of worship is particularly strong in Bengal, parts of northern Punjab and in Tamil-speaking southern India, and has inspired a number of well-known poet-saints such as Raghunandan Bhattacharya and Ramprasad Sen. Ramakrishna Paramhansa, a renowned Bengali mystic and reformer of modern Hinduism, was also a devotee of the Mother Goddess.

Like Shiva, the Mother Goddess is a deity of paradoxes, including the 'goddesses of tooth' such as Kali and Durga, who are ferocious, erotic and dangerous, and the 'goddesses of breast' such as Lakshmi and Sita, the benign role models for Hindu women, who manifest the qualities expected of idealised wives.

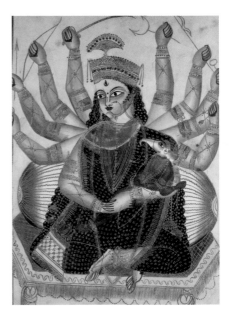

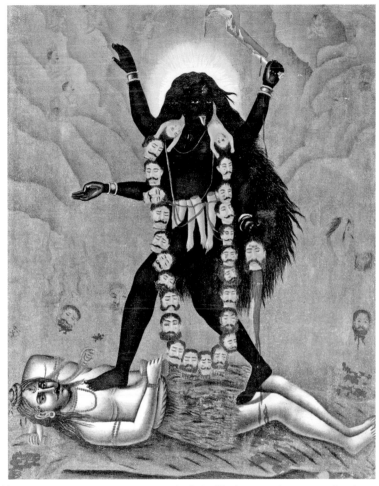

↑ Kali, the dark goddess

This typical iconographic depiction shows the angry and terrifying form of Kali who destroys and devours all forms of evil. She is also the personification of time, her dark form being symbolic of a future that is beyond our knowledge. Only Shiva, upon whose prostrate form she dances, can contain her energy and prevent the world from collapsing when she begins her dance.

← Parvati, consort of Shiva

Parvati is far from the wild excesses associated with Kali. In Hindu legends her role is to tempt Shiva away from the life of asceticism and a yogic focus on the other world. She was capable, with the god Kama's assistance,

of seducing Shiva into a sexual encounter and marriage; however, she represents the householder ideal of sublimated sexuality. The marriage of the two allows for the merging of the two great cults of Shaivism and Shaktism.

INDIA Chamundi Temple, Chamundi Hill, Mysore, Karnataka; Dakshineshwara Temple, Kolkata, West Bengal; Jwalaji Temple, Kangra, Himachal Pradesh; Kalighat Temple, Kolkata; Mansa Devi Temple, Churu, Rajasthan; Naina Devi Temple, Nainital, Uttar Pradesh

An Indian religion founded historically by Mahavir, but believed to have been transmitted by an ancient succession of legendary liberated souls, Jainism teaches release from karmic bondage through strict asceticism and the practice of non-violence.

GOMATESHVARA; RISHABHDEV (5TH MILLENNIUM BCE); MAHAVIR (d. 527 BCE); CHANDAGUPTA MAURYA (4th century BCE); ACHARYA SRI TULSI (1933–93 CE)

ahimsa; anekant; aparigraha; Digambaras; Svetambaras; tirthankaras

Jainism, like many Indian traditions, does not acknowledge a historical beginning, but rather interprets creation as an endless cycle of existence formed of two interdependent entities: infinite

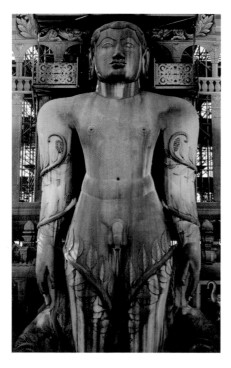

independent conscious souls (Jivatman) and matter (ajiva). The souls are held down and trapped in material existence through karma, which is believed to be a form of subtle matter. Thus all beings, even including plant life, are perceived to be suffering as a consequence of this karmic bondage. However, as in other Indian traditions, human beings have the capacity to be liberated from such suffering.

The Jainist path to liberation was taught by a succession of enlightened souls known as tirthankaras (ford crossers), the first of which was Rishabhdev. Mahavir, the most recent tirthankara and the historic founder of Jainism, is believed to be a contemporary of the Buddha. Mahavir's journey to enlightenment was based on extreme asceticism, and he thus taught a method of human emancipation that focused on three ideals: ahimsa (non-violence), aparigraha (non-possession) and anekant (non-absolutism). Ahimsa is the avoidance of causing mental, physical or verbal suffering to any creature (and includes vegetarianism); aparigraha is an attitude of non-attachment to both material possessions and states of mind; and the ideal of anekant insists that truth or reality is perceived from many viewpoints rather than being absolute.

The growth of Jainism was aided by the conversion of a number of Indian kings, including Chandagupta Maurya, who established a Jain dynasty, and the splendid Jain temples throughout Gujarat and Rajasthan were the results of such empire building.

The main Jainist groups are the Digambaras and the Svetambaras (Digambaras are concentrated in Karnataka, southern India, and the Svetambaras in Rajasthan and Gujarat, northern India). Besides location, a principal difference between the two divisions is the Digambara

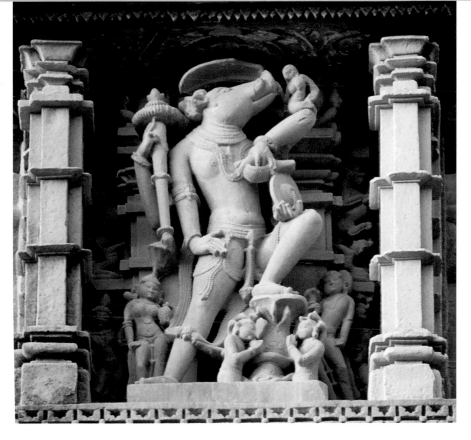

practice of wandering naked – whereas the Svetambara monks wear white robes. Digambaras also hold much stricter views on the impossibility of women and laity obtaining liberation. The Svetambaras are divided into Muripujakis (who worship images of the tirthankaras) and Sthanakvasis (who refuse to worship images). Among the latter are the Terapanthis, a recent revival movement founded by Acharya Sri Tulsi.

↟ **Parsvanatha Temple, Nakoda, Rajasthan, India**
Jains build extraordinary temples that feature many columns, no two of which are ever identical. Many of the ancient Jain temple complexes contain hundreds of temples, all of which are exquisitely carved. Inside, many such temples contain white marble images of the tirthankaras.

↤ **Gomaeshvara statue, Sravanabelagola, Karakala, Karnataka, India**
The giant statue of the naked tirthankara, Gomateshvara, found in the village temple and sacred site at Sravanabelagola. The statue was constructed in 981 CE and is 17 metres (56 feet) high. It is believed to be the world's tallest monolithic statue.

◉ **INDIA** Mallinatha Temple, Girnar Hill Jain temple complex, Junagadh, Gujarat; Muktagiri temple complex, Amravrati, Maharashtra; Palitana Jain Temples, Samvasaran Mandir, Gujarat; Ranakpur Temple, Mount Abu Dilwara temple complex, Rajasthan: **UK** Jain Temple, Jain Centre, Leicester, England

Buddhism

 A religion based on a path of practice and spiritual development leading to insight into the nature of life, Buddhism was taught by Siddhartha Gautama after his enlightenment around 2,500 years ago in Bodhgaya, northern India.

ANANDA (5th–6th century BCE); **MAHAPRAJAPATI GAUTAMA** (5th–6th century BCE); **SIDDHARTHA GAUTAMA** (c. 563–460 BCE); **DALAI LAMA; ASHOKA** (273–232 BCE)

ariya atthangika magga; Bodhi tree; dharma; dukkha; nirvana

Buddhism originates in the teachings of Siddhartha Gautama, born a member of a minor royal family in Nepal, who achieved spiritual awakening, or enlightenment (*budhi*, to 'awaken'), after a long search for truth. The story of the Buddha's journey begins after his experiences upon seeing in succession an old person, a sick man and, finally, a corpse. According to the legend, his father had raised him in a way that had avoided any contact with suffering, in order to avoid a prophecy that stated his son would be a world renouncer. Shocked by his discovery of the inevitable condition of human life, Siddhartha left his family and tried a number of ascetic disciplines, though all failed to bring him the peace he longed for. He eventually achieved enlightenment after meditating under the Bodhi tree, believed to be situated in Bodhgaya in present-day Bihar, northern India.

The Buddha's teachings, or dharma, to which he committed his life, are based on four noble truths. The first is that life as we know it is unsatisfactory, an experience of suffering (dukkha), as nothing is permanent or able to provide real satisfaction. It consists of pain, old age, sickness and death. The remaining three noble truths examine the cause of suffering and its prevention. The second explains that suffering is caused by desire, the third that it can be overcome, and the fourth provides the path by which suffering can be eliminated. It is from this noble Eightfold Path (ariya atthangika magga) – the right view (the right way to see the world), right intention, right

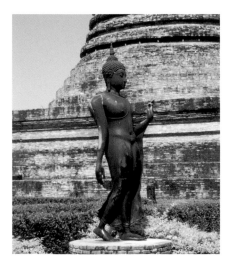

← **Bronze walking Buddha, Sukhothai Historic Park, Thailand**
The statue represents the Buddha's return from visiting his mother in heaven after his enlightenment. In the 13th and 14th centuries, the Sukhothai was the first uniquely Thai and Theravada Buddhist kingdom.

→ **Mahabodhi Temple, Bodhgaya, Bihar, northern India**
The Mahabodhi, or Satabodhi, Temple marks the place where Buddha attained enlightenment. The site is also believed to contain the original Bodhi tree under which the Buddha meditated. The temple dates back to the Gupta period (300–600 CE) and contains the Vajrasana, or diamond throne, commissioned by Ashoka.

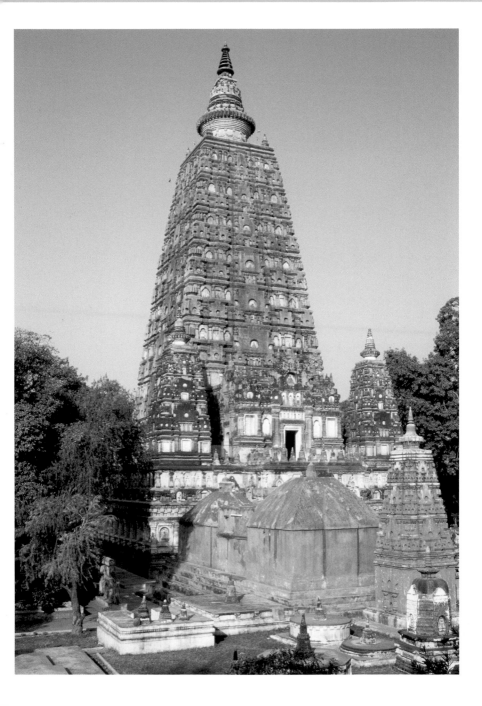

Buddhism

speech, right discipline, right livelihood, right effort, right mindfulness and right concentration – that Buddhist ethics and spiritual practices, especially meditation, are developed. The final goal of Buddhism is nirvana, an indescribable state of cessation from the struggle to exist, in which the almost endless cycle of life and its countless rebirths comes to an end.

According to Buddhists, the cycle of rebirth is driven by karma, the universal law of action and reaction binding upon all creatures that keeps them in an almost endless cycle of birth and death in six realms of existence. Only an enlightened Buddha is free from this condition. However, the Buddha is not a god, and all human beings can strive to achieve such a condition.

The spread of Buddhism throughout India owes much to the influence of Ashoka, the

ruler of the kingdom of Magadha in northern India, who embraced the religion after his conquest of the kingdom of Kalinga. Feeling remorse at the loss of life, he adopted a policy of non-violence and based his administration on Buddhist dharma (teachings). Although originating in India, Buddhism gradually spread throughout Asia to Central Asia, Tibet, Sri Lanka and Southeast Asia, as well as the East Asian countries of China, Mongolia, Korea and Japan.

The Central Asian, Tibetan and East Asian forms of Buddhism follow the Mahayana tradition in which it is believed that there are countless Buddhas, known as bodhisattvas, who have renounced their entry to nirvana out of compassion and empathy in order to help all living beings end suffering. The supreme head of Tibetan Buddhism is the Dalai Lama, and the current Dalai Lama has become a renowned spiritual figure throughout the world. The Theravada tradition, practised mainly in Sri Lanka and Southeast Asia, focuses on the historical Buddha and arhats – enlightened disciples or those who are believed to have attained enlightenment.

The Buddhist hierarchy is formed of male and female monks, followed by male and

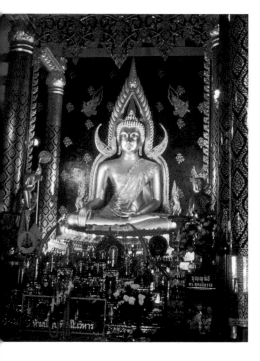

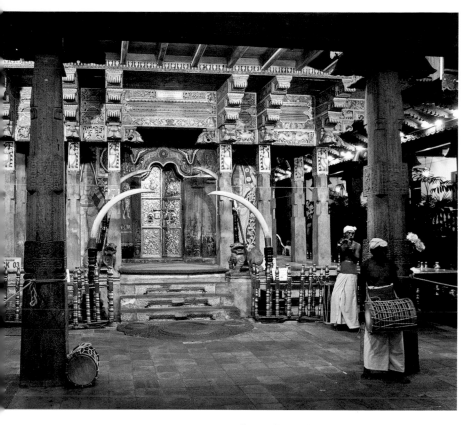

female laity. The two communities of monks
and laity are interdependent, the monks
providing spiritual teaching and the laity
supporting them by providing basic needs
such as food, shelter and clothing. The first
female monk was Mahaprajapati, the
Buddha's foster mother; tradition asserts
that this was at the request of Ananda,
Buddha's personal attendant and
foremost disciple.

↑ **Sri Dalada Maligawa (Temple of the Sacred
Tooth Relic), Kandy, Sri Lanka**
Relics of the Buddha are common and highly venerated.
The Sri Dalada Maligawa is believed to contain a tooth
of Siddhartha Gautama and is one of the most visited
Buddhist pilgrimage centres in the world. The tooth
is reputed to have been brought to Sri Lanka from
India in the 4th century CE.

**Phitsanulok Buddha, Phitsanulok,
Changwat Province, Thailand**
The Phitsanulok Buddha is considered to be the most
beautiful in Thailand. The Buddha is represented with
a flame-like protrusion from the top of his head,
symbolising his radiant spiritual energy.

AFGHANISTAN Buddha statues and cave art,
Bamiyan Valley, Bamiyan Province: **INDIA**
Magadha University Museum, Bodhgaya, Bihar; Sanchi
Buddhist monuments, near Bhopal, Madhya Pradesh;
Sarnath Museum, near Varanasi, Uttar Pradesh: **UK**
Buddhist Pagoda, Battersea Park, London

Theravada Buddhism

Also referred to as Hinayana Buddhism, Theravada Buddhism emphasises the life and teachings of the historical Buddha, the monastic path, and believes enlightenment is achieved through self-effort.

SIDDHARTHA GAUTAMA (c. 563–483 BCE); MAHINDA (3rd century BCE); ANAGARIKA DHARMAPALA (1864–1933 CE); AJAHN MUN BHURIDATTA (1870–1949); AJAHN SAO KANTASILO (d. 1942)

Abhidharma Pitaka; Bodhi; dharma; sangha; Sutta Pitaka; Vinaya Pitaka

Theravada Buddhism is contemptuously known as Hinayana (the Lesser Vehicle) by Mahayana Buddhists, but it can only be referred to as 'lesser' in terms of number of adherents. Theravada

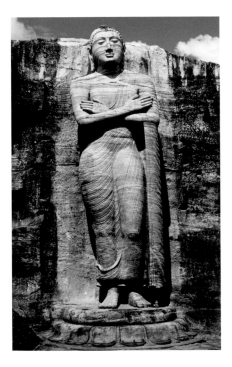

Buddhists argue that they are the original form of Buddhism developed from the teachings of Siddhartha Gautama, the historical Buddha, who they believe to be an ordinary human being whose special status was in his ability to achieve enlightenment. Theravada Buddhists do not believe that prayer to, or belief in, supernatural beings can aid enlightenment; for them, the possibility of release from suffering cannot be achieved by any other means than through one's own efforts to follow the path to liberation provided by Siddhartha Gautama and those qualified to give instruction on the dharma (Buddhist teachings). However, faith, defined as trusting confidence, is an important element of Theravada teachings, as without it followers are unable to subject themselves to the disciplines of the Eightfold Path to enlightenment.

The teachings and practice of this form of Buddhism are contained in the Pali Canon, compiled and edited by three monastic councils over a period of three centuries from 483 BCE to 225 BCE. The councils determined that Siddhartha Gautama's teachings concerning enlightenment were complete and required no further development. The Pali Canon remains the final authority for Theravada Buddhists and is divided into three collections known as Pitaka (baskets). The first contains the rules for monastic discipline (Vinaya Pitaka), the second the sermons of the Buddha and his monks (Sutta Pitaka), and the third the intellectual and philosophical codification of the teachings (Abhidharma Pitaka). Unlike Mahayana forms of Buddhism, Theravada traditions remain organised around the communities of monks (sangha) who are regarded as the Buddhist ideal, and it is believed that only male monks can attain nirvana.

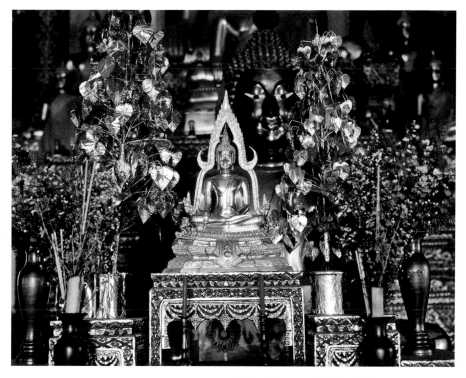

Theravada Buddhism is found predominantly in Sri Lanka and Southeast Asia. It was spread to Sri Lanka by Mahinda, the son of the Emperor Ashoka, who became a Buddhist monk at the age of 20. In the 20th century, Sri Lankan Buddhism became associated with nationalism, primarily through the work of Anagarika Dharmapala.

Theravada's ancient Thai Forest Traditions, marked by monastic retreat to the forests, mountains and caves to seek isolation, was revived in the 20th century by Ajahn Mun Bhuridatta and Ajahn Sao Kantasilo. The tradition has attracted a number of Western followers and is established in several Western nations including Australia and the UK.

↑ **Temple statue of Siddhartha Gautama, Lamphun, Thailand**
A typical Thai temple statue of Siddhartha Gautama, the historical Buddha and focus of Theravadan veneration. Buddhist temple statues differ from place to place according to culture and tradition, but all Theravadan temples are centred on the historic Buddha and his teachings rather than a succession of legendary supernatural beings.

← **Gal Vihara standing figure, Polonnaruwa, Sri Lanka**
The statues of Lord Buddha at Gal Vihara (rock shrine) rank among the finest in the country. Cut from a single granite wall, they were carved out in the 12th century. The standing figure here is 7 metres (23 feet) tall and is believed to represent Arahath Ananda, Buddha's favourite disciple.

SRI LANKA Aukana Buddha, near Anuradhapura; Maha Bodhi Tree, Anuradhapura; Ruwanweliseya, or Great Stupa, Anuradhapura: **THAILAND** Golden Buddha, Wat Traimit, Bangkok; Suan Mokkabalarama Monastery, Suan Mokkh

Mahayana Buddhism

 This largest of the Buddhist groups consists of various forms, most notably based on Tibetan, Chinese and Japanese traditions that emphasise the bodhisattva ideal and elevate compassion alongside wisdom as the foremost virtue.

NAGARJUNA (2nd century CE); ASANGA (4th–5th century); BODHIDHARMA (5th–6th century); 14TH DALAI LAMA (b. 1934)

Amitabha; bodhisattvas; Chan; Mahasanghikas; Zen

Mahayana (the Greater Vehicle) Buddhism emerged out of a loosening of the strict conservatism of the Sthavira (ancients) who had maintained the traditions and doctrines associated with the Buddha in a canon of sacred texts written in the Pali languages. Around 400 years after the Buddha's death, a group of innovators, especially new voices of the Buddhist laity, began to question these traditions and to record their views in Sanskrit, a language more open to development. These innovators, known as Mahasanghikas (Members of the Great Assembly), were the pioneers of Mahayana Buddhism. Contemptuously they began to label the strict conservatism of the Sthavira as Hinayana, the narrow or lesser vehicle. Other significant figures in the development of Mahayana Buddhism were Nagarjuna, the founder of the Madhymaka School in India, and Asanga, the founder of the Yogacaras.

The various forms of Mahayana Buddhism are distinguished by key differences in their doctrines concerning the nature of reality and the Buddha. Mahayana movements regard suffering as belonging to the realm of illusion, though this is only recognised by the enlightened. Mahayana Buddhism also teaches an absolute reality, or Eternal Absolute, which is not transcendent, but is immanent within samsara (the material world), creating a monistic outlook. The historical Buddha is perceived as a projection of this Eternal Absolute, and is one of an eternal chain of such beings, some of which appear on earth, with others residing in Buddha realms. Liberation or enlightenment can be achieved with the assistance of these Buddha beings. Consequently, Mahayana traditions tend to emphasise compassion

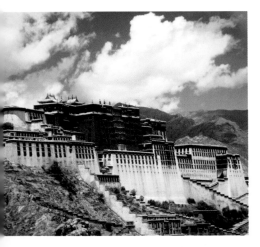

→ Nepalese Thangka painting depicting a central image of the bodhisattva Avalokiteshvara
The bodhisattva Avalokiteshvara, 'the Lord who sees the world with pity', described in the 8th-century text *Karanda-vyuha* as the being who views with compassion all beings suffering from the evils of existence. The bodhisattva has a thousand eyes to observe the sufferings of all creatures and a thousand arms to help alleviate the misery.

← Potala Palace, Lhasa, Tibet
This renowned palace is home to the Dalai Lama, the spiritual and temporal leader of Tibetan Buddhists. It is believed to be built on the site of a cave considered the dwelling place of the Bodhisattva Avalokiteshvara. The original palace was constructed in 637 CE by Emperor Songtsen Gampo, who used it as a meditation retreat. The present palace was built in the 17th century on the foundations of the original.

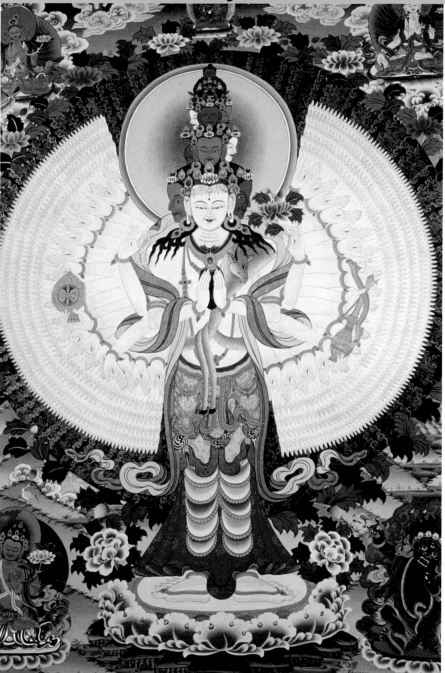

over and above wisdom, and introduce the concept of bodhisattvas, Buddhas who refuse to enter the final nirvana and remain active in the world until all beings are liberated. Mahayana Buddhism gives a new role to the laity in believing that they, too, can achieve enlightenment.

The dominant varieties of Mahayana Buddhism are its Tibetan, Chinese (Chan) and Japanese (Zen) forms. Chinese Buddhism is also renowned for its worship of the bodhisattva Amitabha. Both the Chinese and Japanese forms of Buddhism are believed to have been taught by the Indian monk Bodhidharma.

← **Carving of the Maitreya Buddha, Lingying Temple, Hangzhou, China**
The Maitreya Buddha – the future Buddha – remains as a bodhisattva in the Tushita heavenly realm. Maitreya is derived from the Sanskrit for 'friendliness', and in China he is believed to have been incarnated as a Chan monk, Hotei, and is popularly depicted as the Laughing Buddha.

CHINA Yung-Kang cave shrines, Shansi: **INDIA** Dharamsala (summer home of the Dalai Lama and largest Tibetan community outside Tibet), Himachal Pradesh: **JAPAN** City of Nara; Zen temples, Kyoto: **THAILAND** The Reclining Buddha, Bangkok

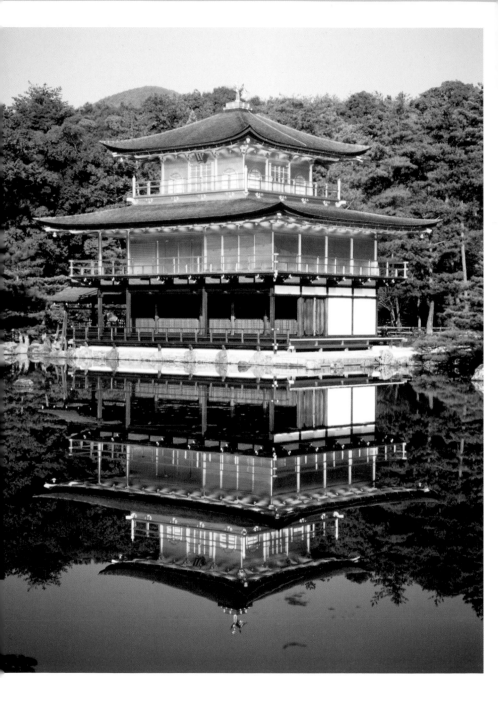

This form of Buddhism, introduced into Japan from China, refocuses Mahayana Buddhism on meditation as the sole means of enlightenment and seeks to achieve satori, an intuitive grasp of the underlying unity of all existence.

BODHIDHARMA (6th century CE); EISAI (1141–1215); DOGEN (1200–53); IKKYU (1394–1481); SHURYU SUZUKI (1904–71)

Bompu Zen; koans; Rinzai; satori; Soto; zazen

Zen Buddhism originated in the Chinese Mahayana school of Buddhism known as Chan, which in turn was influenced by Tao. The legendary origins of Zen are in the flower sermon of Siddhartha Gautama, in which it is believed that the Buddha responded to the question of enlightenment by holding up a flower and smiling. It is said that the disciple Mahakasyapa intuitively grasped the meaning of the sermon and taught it to his followers. Bodhidharma, the 28th in line from the Buddha to receive the teaching, took it to China from India where it flourished.

The word 'zen' originates from 'chan', which is derived from 'dhyana', or meditation. Zen turns Mahayana Buddhism away from supernatural or otherworldly cosmic Buddhas and restores meditation as the sole instrument to achieve liberation (zazen). However, it does not reassert the centrality of the historical Buddha. Instead it focuses on the master/student relationship and the founders of the various Zen schools. Zen found its way into Japan around 1200, creating a form of Buddhism that rejects both devotionalism and intellectualism. Through extensive meditation, practitioners aim to achieve satori, an insight into the essential nature of all existence, the Buddha heart or essence. The different schools of Zen are divided as to whether such an experience is achieved as a sudden flash of insight (Rinzai, founded by Eisai), or ripens gradually over time (Soto, founded by Dogen). The Rinzai school also makes use of koans, paradoxical anecdotes or riddles without solutions, to demonstrate the inadequacy of logical reasoning and provoke enlightenment. In addition, Bompu Zen, in which religious or philosophic content is absent, is used as a means of improving physical or mental well-being.

Zen has had profound implications for Japanese art and culture, and in the 20th century became increasingly popular in the West, mainly through the writings of Shuryu Suzuki.

← Kinkaku-ji Temple of the Golden Pavilion, Kyoto, Japan
Kinkaku-ji, known as the Golden Pavilion, was built in Kyoto's northern hills in 1398 by Yoshimitsu, the third Ashikaga shogun, and was part of a larger villa complex. When Yoshimitsu died it became a Zen temple in accordance with his will. The original temple was burned in 1950 and restored. Each floor of the Kinkaku-ji is a different style and its design has influenced later Zen temples.

⇉ Zen Garden, Zuiho-in Temple, Daitokuji Temple complex, Kyoto
The ancient city of Kyoto is renowned for its Zen gardens, many of which are located in Zen temples. However, it is difficult to ascertain the degree to which the gardens reflected religious or philosophical attitudes. Modern interpreters tend to see them as expressions of Zen thought, but gardens also existed in Japan as part of ancient Shinto beliefs. What is certain is that such gardens are a significant aspect of Japanese aesthetics.

JAPAN Ginkakuji (Temple of the Silver Pavilion), Kyoto; Menji Jingu Shrine, Tokyo; Nanzen-ji Temple, Kyoto; Saihoji (Moss Garden Temple), Saihoji, Kyoto; Shokoku-ji Temple, Kyoto

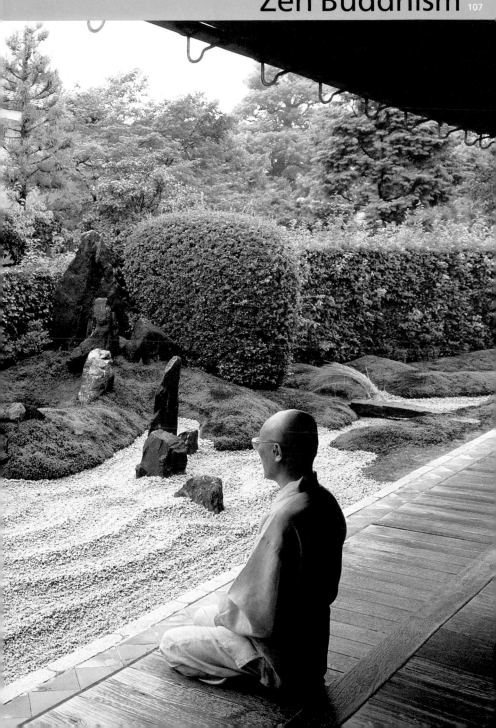

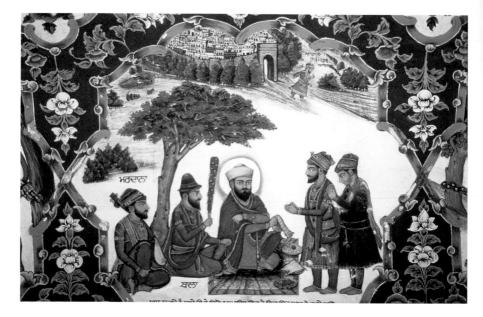

The Sikh religion originated in the teachings of Guru Nanak and passed down through a succession of 10 human gurus, culminating in Guru Gobind Singh, before being invested in the authority of the *Guru Granth Sahib*.

GURU NANAK (1469–1539); GURU ARJAN (1563–1606); GURU TEGH BAHADUR (1621–75); GURU GOBIND SINGH (1666–1708); RANJIT SINGH (1780–1839)

Guru Granth Sahib; Guru Panth; Khalsa; satguru; satnam

This Indian religion began with the teachings of Guru Nanak, the first Sikh satguru (true guru) who was born in the Punjab, near Lahore, in 1469. According to Sikh tradition, Nanak had some kind of mystical experience when meditating on the banks of the River Bein, near Sultanpur. It is believed that he was called into the presence of God, who charged him with the mission of preaching his true name (satnam). The authority of the guru was then passed through nine successors, including Guru Arjan and Guru Tegh Bahadur, the first martyrs of the religion, until the last, Gobind Singh, declared that after his death the Sikhs were to look upon their sacred text, the *Guru Granth Sahib,* and the Sikh community (Guru Panth), as their guides and as the representations of all 10 gurus, though some Sikh movements do acknowledge living gurus after him. During the reign of Ranjit Singh, the Punjab became a Sikh kingdom and remained so until conquered by the British in the 1840s.

In April 1699, Gobind Singh founded the Khalsa (a body of fully initiated Sikhs), marking a turning point in the development of Sikh tradition. The Khalsa gave Sikhs a distinctive identity based on physical appearance. It helped to create Sikhism as a separate religion from Hinduism, with its own symbols, rituals and code of conduct.

After, initiation into the Khalsa, a Sikh is expected to demonstrate his or her allegiance to the faith by the wearing of five Ks: kesh, uncut hair and beard; kangha, a comb to keep the hair tidy; kara, a steel wristband; kaccha, a special kind of modest underwear or baggy shorts; kirpan, a sword or dagger.

Although not all Sikhs join the Khalsa, it has come to represent Sikh orthodoxy. Khalsa Sikhism defines a Sikh as any man or woman whose faith consists of belief in one God, and in the teachings of the *Guru Granth Sahib* and the 10 gurus, who has faith in the amrit (nectar) of the 10th master, and who professes no other religion. However, many Sikhs who regard themselves as belonging to the religion do not fulfil these conditions.

← **Painting of Guru Nanak, Baba Atali gurdwara, Amritsar, Punjab, India**
This historic painting of the young Guru Nanak is kept in the Baba Atali gurdwara that overlooks the Golden Temple complex in Amritsar. It depicts Nanak receiving the jeweller Satis Rai Johri and accepting him and his wife as disciples. A Sikh tradition states that the wealthy jeweller donated his mansion to the guru, claimed to be on the site on which the Golden Temple complex was later built.

↓ **The Golden Temple, Amritsar**
The Golden Temple, or Harmandir, is the most sacred site of the Sikhs. Guru Arjan laid the foundations of the temple in 1588 and the building was completed in 1601. The first volume of the Sikh sacred text, the *Guru Granth Sahib*, was installed here in 1604.

INDIA Gurdwara Bangla Sahib Temple, New Delhi; Gurdwara Chaubara Sahib Temple, Machiwara, Ludhiana, Punjab; Sacred site of Takht Sri Keshgarh Sahib, Anandpur, Punjab; Sisganj Temple and Shrine, Chandichowk, Old Delhi: **PAKISTAN** Nankana Sahib (birthplace of Guru Nanak), Punjab

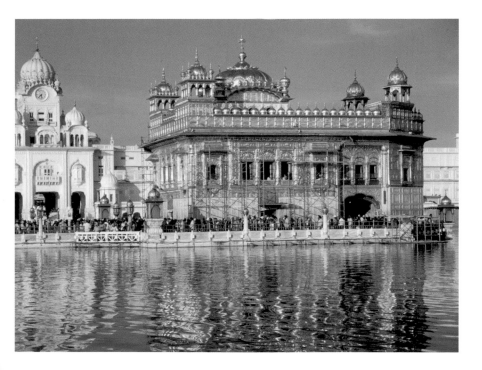

5

VERNACULAR
RELIGIONS

Animism

 The belief that everything is alive or has a soul, Animism asserts that supernatural beings inhabit ordinary objects as well as animate beings, and govern their existence.

 EDWARD BURNETT TYLOR (1832–1917)

 shaman; totem

 The term 'animism' was coined by the anthropologist Sir Edward Burnett Tylor in his book *Primitive Culture* (1871), in which he used it to mean a belief in spirits. However, today the term essentially signifies a belief in the world as a community of living beings, only some of whom are human, others being animals, birds, rocks, plants and ancestors, all possessing their own soul, or spirit. Animism also extends to the

cultures or philosophies that its adherents live by as a result of their attempts to respectfully interact with such living beings. Some Animist cultures do not make a distinction between animate and inanimate objects, and treat natural phenomena, geographic features, everyday objects and even manufactured objects as possessing souls.

Animist communities can be found in parts of Africa, Southeast Asia, Russia and the US. Although usually associated with indigenous people, modern Neopagans, especially eco-pagans, also describe themselves as Animist in that they respect the diversity of life forms with which human beings share the planet. In indigenous societies, ritual is often considered essential for survival as it enables the tribe or village to secure the favour of the spirits who can provide supernatural help in finding food and shelter, ensuring fertility and keeping away malevolent forces. Such rituals are often performed by shamans, or priests, who have powers that enable them to be possessed by the spirits. They are employed among Animist communities to mediate with non-human beings in situations that would be dangerous for the uninitiated or untrained, or to deal with the great host of unattached spirits who are able to create problems for human existence.

Animism should not be regarded as an 'ism' in the sense of an overly systematic approach to religion, but rather as a lived reality.

↑ North American Indian eagle totem pole
The bald eagle could be considered the totem of the indigenous people of North America, but totemistic beliefs are not limited to Native American Indians. Similar beliefs have been found throughout much of the world, including Western Europe, Eastern Europe, Africa, Australia and the Arctic polar region. A totem can be defined as any animal or natural object that protects or aids a group of people, whether a family, clan or tribe.

← Spirit house, Chiangmai Rajabhat Institute, Thailand
Although Thailand is a Theravadan Buddhist nation, it contains a rich Animist tradition. The elephants here represent royalty, and the flowers are offerings to both royalty and the spirits. The spirit house is maintained in the grounds of the Rajabhat Institute, a government vocational college that now has university status.

◎ **AUSTRALIA** Ayers Rock, Uluru, New South Wales: **CANADA** Stanley Park, Vancouver: **THAILAND** Erawan Shrine, Bangkok

Voodoo

The term 'Voodoo' and its variant spellings (Vodun, Vodou, Voudou, Vudu) refers to the various branches of, originally, West African ancestor-based spiritist-animist religious traditions that spread to other parts of the world via slavery.

AGWE; OBATALA; OGUN; OLORUN; SANGO

hounfour; houngan; loa; poteau-mitan; mambo

Although commonly known to the public as Voodoo, the faiths associated with this practice have nothing to do with Hollywood depictions of an evil religion linked to violence and bizarre rituals. Vodun shares common roots with a number of religions that originated in West Africa, particularly Benin, Togo, Nigeria and Ghana. These religions were practised by the Yoruba people and spread to Haiti and the West Indies through the forced migration of slaves, beginning in the 17th century.

It is estimated that around 60 million people now practise Vodun worldwide. Religions similar to Vodun can be found in South America; for example, Santeria, Candomble, Quimbanda and Umbanda. However, Vodun is primarily practised in Haiti, and various centres in the US where Haitian migrants have settled. In general, only a small group belonging to the Fon, Mina and Evhe peoples of the Southern River States of Nigeria (formerly Dahomey) and Benin practise Vodun in Africa.

Vodun priests, who are able to be possessed by the spirits, can be either male (houngan or hungan) or female (mambo), and practise their rituals in a temple called a hounfour (or humfort). At the centre of the temple is a poteau-mitan, a pole where Obatala and spirits (loa) communicate with the people. Altars are elaborately decorated with candles, pictures of Roman Catholic saints who are usually associated with the loa, and symbolic items.

Vodun focuses on relations between the living and the dead (ancestors) and invisible spirits and gods. Practitioners attempt to gain the favour of such spirits by offering animal sacrifices and gifts. As a consequence, spirit possession, music and dance feature highly in the religion's practices. However, it is healing that is of primary importance, and traditional healers and priests are available to all, removing bad spirits believed to cause disease.

Practitioners believe in many powerful spirits – for example Agwe (the sea spirit), Ogun (the war spirit) and Sango (the storm spirit) – but in only one god, Olorun, who is remote and unknowable.

The traditional view of Vodun is that it is a syncretic mix of African religions and Roman Catholicism as, both in Haiti and the West Indies, slaves were forcibly baptised into the Roman Catholic Church yet continued to follow their indigenous religions. However, Vodun differs from Santeria, for example, in that it has not merged Roman Catholic saints and Yoruba gods, but rather kept the identities of Vodun spirits distinct.

Vodun was significant in sustaining African slaves during periods of horrendous oppression when up to 25,000 died each year. It was also the organising principle behind the 18th-century slave rebellions and the creation of the first independent black state in the New World in 1804.

← **Sakapta Vodun celebration, Benin, West Africa**
Benin is the birthplace of the Vodun religion and the holder of the largest annual Vodun festival in the world. Ceremonies can involve the ritual sacrifice of a goat, sheep, chicken or dog, usually killed humanely by slitting its throat, with the blood collected in a vessel. The hunger of the loa is then believed to be satisfied, and the animal is usually cooked and eaten. Animal sacrifice is a method of consecrating food for consumption.

HAITI Duverger's Temple, Carrefour; Gressier Temple, Gressier: **TOGO** Epe Ekpe Festival, Glidji, near Lome: **US** The Church of Seven African Powers, Miami, Florida; City of New Orleans Voodoo Tours, New Orleans

Druidism

 Neo-Druidism is one of the Neopagan family of religions that attempts to reconstruct the beliefs and practices of ancient Celtic Druidism.

 IOLO MORGANWG (1747–1826); ROBERT MACGREGOR REID (d. 1964); ROSS NICHOLS (1902–75)

bards; Beltaine; Imbolc; Lughnasad; ovates; Samhain

There are a great number of Druid groups throughout the UK, Europe and the US with varying claims to the historical traditions of ancient Druidism. Others have little interest in historical Druidism, working directly with the spirits of place, of the gods, and of their ancestors to create a new Druidism, or neo-Druidism. The term Druid denotes the priestly class in ancient Celtic societies. It is believed that there were categorisations, or specialisms, in Celtic Druidism: bards who maintained traditions and memories through Celtic arts; ovates who were healers, diviners and prophets; and, finally, Druids who were ritual priests and priestesses. Many neo-Druid groups, such as the Order of Bards, Ovates and Druids in the UK, founded by Ross Nichols, maintain these divisions.

However, little is actually known about ancient Druidism. There is some evidence that the main pantheon of gods and goddesses might have totalled about three dozen, some of the more famous of which are Arawn, Brigid, Cernunnos, Cerridwen, Danu, Herne, Lugh, Morgan, Rhiannon and Taranis. From the 18th century, a number of secret societies in the UK, such as the Ancient Order of Druids and the Order of the Universal Bond (later known as the Ancient Druid Order) claimed to be the successors of ancient Druids. These organisations drew upon Iolo Morganwg for their teachings, and neo-Druidic movements have continued to adopt his

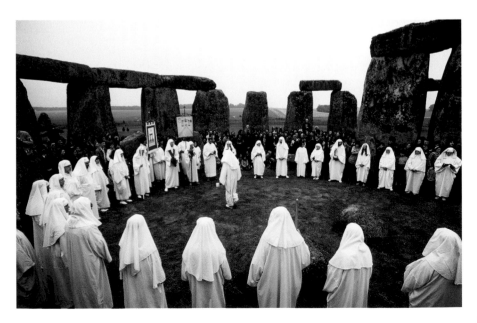

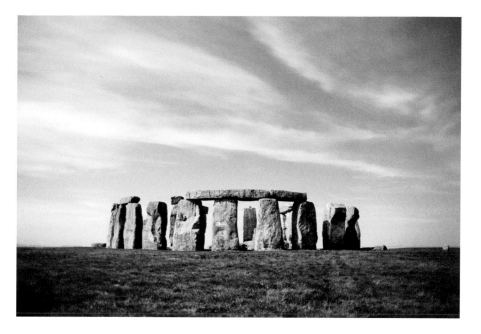

ideas. The Ancient Druid Order has survived and, in 1964 when the chief of the Ancient of Order of Druids, Robert MacGregor Reid, died, various factions of this organisation also developed.

Recent decades have seen an explosion of Druidic orders and groups in the UK, including the British Druid Order, the Secular Order of Druids and the Glastonbury Order of Druids. In the US, the first congregation of the Reformed Druids of North America (RDNA) was founded in 1963.

Druid practices include many techniques to foretell the future: interpreting dreams via the patterns of sticks thrown to the ground, and studying the flight of birds. Druid values are the Celtic virtues of honour, loyalty, hospitality, honesty, justice and courage. Druids past and present celebrate a series of fire festivals on the first of each of four months: Samhain, Imbolc, Beltaine and Lughnasad. The festivals begin at sunset and last for three days. Bonfires are built on a hilltop, and couples jump over the fire or run between two fires.

← ↑ **Stonehenge, Wiltshire, England**
Stonehenge has a long association with modern Druids. In 1624 Edmond Bolton credited the Celtic warrior queen Boudicca with building it as her monument. However, in 1649 John Aubrey suggested that Druids were probably responsible for its construction. Although both theories are highly speculative, Druids have performed the celebrations of the solstices at Stonehenge since at least the 19th century.

UK Avebury stone circle, Avebury, Wiltshire, England; The Longstone, Isle of Wight; Mount Snowdonia, Snowdonia National Park, Wales; Thornborough Henges, North Yorkshire, England; Woodhenge, Amesbury, Wiltshire

Neopaganism

Neopaganism is used by academics to describe the contemporary reconstruction of a range of nature-venerating religious traditions that often deify nature, but which practitioners prefer to call paganism.

JAMES GEORGE FRAZER (1854–1941); ARTHUR EDWARD WAITE (1857–1942); WILLIAM BUTLER YEATS (1865–1939); ALEISTER CROWLEY (1875–1947)

Celtic; Druid; Wicca

Neopaganism is an umbrella term for a group of new religions influenced by ancient or pre-Christian religions, usually of Indo-European origin. These religions are pagan in nature, though their exact relationship to older forms of paganism is the source of much contention. Neopaganism is divided into two main subcategories. The first is syncretic and welds together various religious practices, folk customs and rituals deriving from an array of sources; the second is reconstructionist in that its adherents attempt to recreate historically authentic traditions, with varying degrees of success.

A post-Christian, modern phenomenon, Neopaganism has its roots in early 19th-century Romanticism and the renewed interest in Germanic paganism with the Viking revival in the British Isles and Scandinavia. In addition, the late 19th century witnessed a resurgence of various forms of Western occultism, especially in England. Examples included societies such as the Hermetic Order of the Golden Dawn and the Ordo Templi Orientis. Several prominent writers and artists were involved in these organisations, including William Butler Yeats, Arthur Edward Waite and Aleister Crowley. Such movements attempted to merge Druid and Egyptian beliefs into one system. *The Golden Bough,* written by the anthropologist James George Frazer in 1900, was particularly influential here.

Neopaganism generally emphasises the sanctity of Earth and Nature, and its main manifestations include Druids and Wicca, and various Celtic, Icelandic, Germanic and Scandinavian reconstructions of folklore.

Most Neopagans do not have distinct temples, usually holding rituals in private homes or sacred groves and other outdoor locations. Many also practise their faith as 'solitaries', working within no fixed spiritual community. The Book of Shadows includes various compilations of spells and charms.

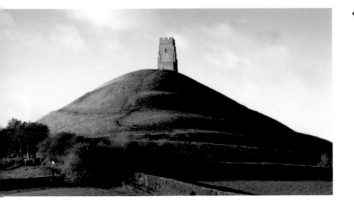

← Glastonbury Tor, Somerset, England
Although Glastonbury Tor is a Christian location, it has become a significant site for Neopagans who claim it to be Avalon, the home of the King of the Fairies and the goddess Rhiannon. It is believed that the terracing is the site of a Neolithic labyrinth constructed to worship the goddess. The tor is topped by the ruins of the medieval St Michael's Church.

→ **Relief Sculpture of the Green Man, Crowcombe Church, Crowcombe, Somerset, England**
Carved into a pew of the church, the sculpture depicts an image of the Green Man, a term coined by Lady Raglan in 1939 for a medieval figure often found in churches. Little is known about his original significance, but he is generally believed to be a pagan fertility god

 FRANCE
Er Lannic, Gulf of Morbihan, Brittany; Cordon des Druides, Stone Row, Ile-et-Vilaine, Brittany:
UK The Callanish Stone Circle, Isle of Lewis, Scotland; Stonehenge, Salisbury, Wiltshire, England; The Vale of Avalon, Glastonbury, Somerset, England; Woodhenge, Amesbury, Wiltshire

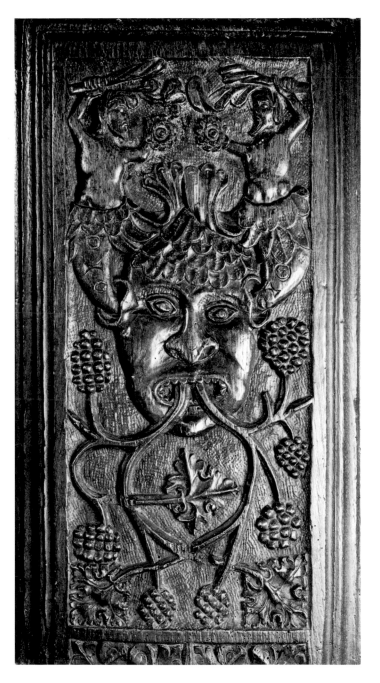

 Wicca is a pagan belief system and way of life based on the reconstruction of pre-Christian witchcraft traditions originating in Ireland, Scotland and Wales, and influenced by the activities of Gerald Gardner.

 MARGARET MURRAY (1863–1963); GERALD GARDNER (1884–1964); DOREEN VALIENTE (1922–99)

covens; magick; Sabbats; the Craft

In 1952, Margaret Murray promoted the idea that some of the witches exterminated by Christians in the Middle Ages were survivors of an earlier, organised and dominant pre-Christian religion in Europe. However, it is Gerald Gardner who is generally credited for Wicca's rise to mass-movement status, beginning in England during the 1950s with the publishing of several books by him on the subject. Since then, Wicca has grown at a very fast rate in North America and Europe, and now has an estimated 750,000 practitioners in the US.

According to Gardner, Wicca, or the Craft as it is sometimes called, originated in prehistoric rituals concerning hunting, fertility and curing disease, and developed into a religion that recognised a supreme deity but worshipped the Goddess of Fertility and her horned consort, the God of the Hunt. Gardner believed that this belief system survived Roman, Saxon and Norman invasions, before suffering major losses during various Christian persecutions. By the middle of the 20th century, most of its ritual and ideas had been lost. However, it was at this point that it was to be revived by Gardner, with the assistance of his high priestess Doreen Valiente, and others, who took the surviving beliefs and practices and added material from other religious, spiritual and ceremonial magick sources (Wiccans prefer the archaic spelling 'magick' to 'magic' as it differentiates the ability to influence events and physical phenomena by supernatural means from stage magic or conjuring).

Though Gardner claimed that he had received many letters from members of covens (informal gatherings of witches) who believed their groups had been in continuous existence for generations, or even centuries, other individuals disagree with the Gardnerian view and insist there has been no continuous Wiccan presence since Celtic times.

Wiccans can be solitary practitioners or form covens. Covens that have a high priestess and/or priest democratically elect one of the group for this role. Rituals are concerned with healing, divination and the consecration of tools, and such Esbats take place at the full or new moon. However, the main occasions are the eight major or minor Sabbats, which include the equinoxes and the winter and summer solstices.

← Opening to the Chalice Well, Chalice Well Gardens, Glastonbury, Somerset, England
The Chalice Well is one of the oldest continuously used holy wells in Britain. The spring has been used for over 2000 years and the well is also associated with the Arthurian legends and believed to be the hiding place of the Holy Grail. In pre-Christian times wells were regarded as gateways to the spirit world where communications could take place with the gods and goddesses of nature religions.

↓ The Whispering Knights, Rollright Stone Circle, Chipping Norton, Oxfordshire, England
The stone circle is known as the Kings Men, but also contains a prominent solitary stone known as the King Stone and the remains of a megalithic tomb known evocatively as the Whispering Knights. There is a well-known legend that the stones were once people cursed by a witch.

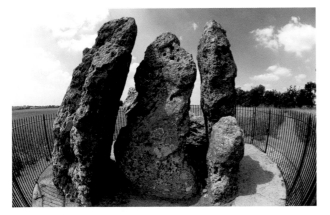

⊚ REPUBLIC OF IRELAND: Cill Dara pilgrimage town, County Kildare: UK Cerne Abbas giant, Cerne Abbas, Dorset, Englan; Din Lligwy Prehistoric Settlement, Isle of Anglesey, Wales; Saints Way Logan Stone, Lostwithiel, Cornwall, England: US Georgia Guidestones, Elberton, Georgia

Satanism

 Satanism includes a number of movements and individuals who worship Satan and are opposed to Western Christian religion and culture, judging it to be both corrupt and hypocritical.

 ALEISTER CROWLEY (1875–1947); ANTON SZANDOR LA VEY (d. 1997); MICHAEL AQUINO (1946–)

magick; Satan; *The Satanic Bible*; Set

Satanism is a religion that uses the figure of Satan, also known as Set, to promote personal development and egocentricity, often in opposition to both the religious and cultural values of Western Christianity. Many Satanists prefer the name Set for the deity they follow, arguing that the depiction of Satan in the Bible was simply an invention to maintain fear among Christians. In contrast to this, Set is not perceived as a sinister or evil figure, but as an archetypal rebel or god representing pride, self-interest and self-gratification. For some Satanist groups, Satan is not a being, just a symbol of self-interest and

individualism, encouraging opposition to institutional religion and the dominant culture. In this context, Satanism is a self-religion that draws upon the rebellious and the offensive. However, there are also some individuals who claim to worship the devil.

The most important Satanist groups are the Church of Satan and its smaller rival the Temple of Set. The Church of Satan was founded in California by Anton Szandor La Vey in 1966, when he declared himself to be the 'black pope', and announced the arrival of the 'Age of Satan'. His two books, *The Satanic Bible* (1969) and *The Satanic Rituals* (1972), remain key texts for many Satanists and have been translated into several languages. The Temple of Set was founded in 1975 by former Church of Satan follower Michael Aquino, and believes Satan to be a personal being as opposed to the more symbolic usage in the Church of Satan.

Satanists are influenced by the practices and theories of Aleister Crowley, including ritual and ceremonial 'magick' whereby it is believed that the world can be changed through the application of individual will. The notorious convicted murderer Charles Manson has been linked with various movements, but to date no firm evidence

has been discovered that confirms his membership of any Satanist organisation. Links to criminal activity have also occurred around the sensationalist issue of mass satanic child abuse. However, these are rarely proved to have any substance.

↑ **Eleventh-century Romanesque relief sculpture of a pact with the devil**
According to traditional folklore, the pact involves selling one's soul, but this view is not ascribed to by contemporary Satanists. The idea of a pact has been used as an indirect repudiation of one's own irrational inhibitions or a means of dealing with Satan or other spirits in the short term. However, some see it as a formal vow of long-term allegiance to Satan.

← **Statuette used in sorcery and bewitchment, Paris, 1986**
Satan represents the underworld, sorcery and opposition to the ruling gods. In one form of sorcery that has been used for centuries, statuettes such as the one here are used to represent a person in a ritual or spell. Known as poppets, such statuettes or objects were often created out of clay or wax, or a personal belonging of the person.

NEW ZEALAND The Order of the Deorc Fire; The Order of the Left-Hand Path: **UK** Society of the Dark Lily; The Order of the Nine Angles: **US** The Church of Satanic Liberation

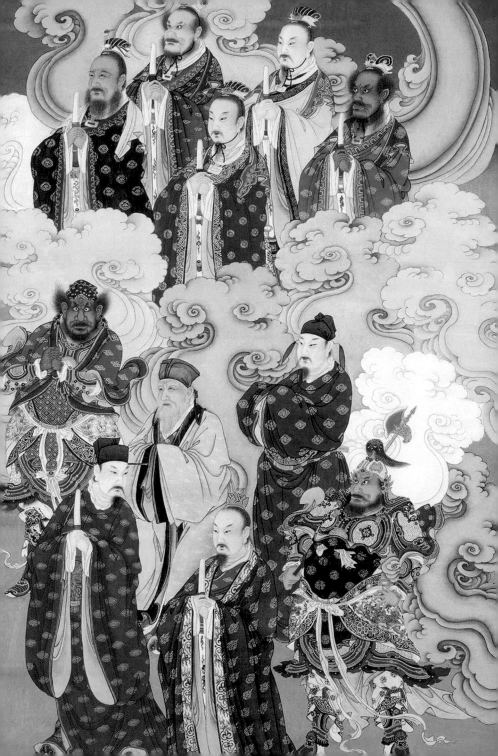

6

REGIONAL
RELIGIONS

Shintoism

Shintoism is the national religion of Japan and is based on worship or veneration of the kami, the native and indigenous spirits of Japan who are distinguished from the deities of Buddhism.

KADA NO AZUMAMARO (1669–1736); KAMO MABUCHI (1697–1769); MOTOORI NORINAGA (1730–1801); HIRATA ATSUTANE (1776–1843); MIKI NAKAYAMA (1798–1887)

Fukke Shinto; kami; Kojiki; Nihon Shoki; Ryobu Shinto

Although Shinto (the Way of the Gods) now exists as a formal state religion of Japan, its history demonstrates an eclectic amalgamation of a number of trends in Japanese religious life. The term 'Shinto' first appears less than 30 years after the introduction of Buddhism to Japan in the middle of the 6th century. Its appearance would suggest the need to find a defining term that separated the new religion from the indigenous folk religions of Japan. Even today, Shinto exists as a formal and official national religion alongside a wide range of popular folk practices that constitute Japanese vernacular religion. In addition, Shinto was later to form syncretic movements that combined with Buddhism. In modern Japan, old forms of State or Shrine Shinto exist alongside new forms of the religion known as Sect Shinto.

The earliest sources for Shinto can be found in the Kojiki (Record of Ancient Matters) and the Nihon Shoki (the Written Chronicles of Japan) produced in the 8th century. Both books contain creation myths that explain the origins of Japan and its primal spirits.

The 7th and 8th centuries saw the amalgamation of Buddhism and Shinto when, in 765 CE, Empress Shotoku announced that it was proper for the spirits of Shinto to protect and revere the teachings of the Buddha. The resulting movements were to become known as Dual Shinto or Ryobu Shinto.

From the 15th century there were increasing attempts to rid the religion of foreign influences, resulting in the reversal of the position that the Shinto spirits are subservient to the Buddhas, to one where the Buddhas and bodhisattvas are perceived as incarnations of the Shinto kami, or spirits. This new, reformed Shinto, known as Fukke or Restoration Shinto, is associated with four scholars: Kada no Azumamaro, Kamo Mabuchi, Motoori Norinaga and Hirata Atsutane. However, this new, or purged, form of Japanese national religion, with its emphasis on Japan as the land of the gods, ruled by an unbroken line of sun-born emperors in perfect harmony with the sun goddess, failed to provide ethical teachings, doctrines for liberation or beliefs concerning the afterlife. New cults, such as Tenrikyo founded by Miki Nakayama, which address these issues, emerged in the 19th century, and their popularity indicates the degree to which Shinto is embedded within Japanese religious psyche and culture.

↑ **Shinto deities**
The arrival of Buddhism introduced to the Japanese the concept of representational images, and by the 9th century the Shinto clergy had joined closely with the court and ruling aristocratic clans to allow the production of sculptural images of kami to be placed in shrines. These kami were usually crafted to resemble male and female aristocrats, as in this seated pair from the Heian period (12th century), which now sits in the Cleveland Museum of Art in Ohio, US.

← **Kami dragon**
Kami provide a mechanism through which the Japanese are able to regard the whole natural world as being both sacred and profane. They include gods and spirit beings, but also oceans and mountains, storms and earthquakes, which are revered for their powers. They respond to human prayers and can influence the course of natural forces and human events. Shinto tradition has it that there are eight million kami in Japan.

◎ **JAPAN** Ise Jingu Shrine, Ise City, Mie Prefecture; Izumo Taisha Shrine, Taisha, Shimane Prefecture; Meiji Jingu Shrine, Tokyo; Tsurugaoka Hachiman Shrine, Kamakura; Yasaka Jingu Shrine, Kyoto

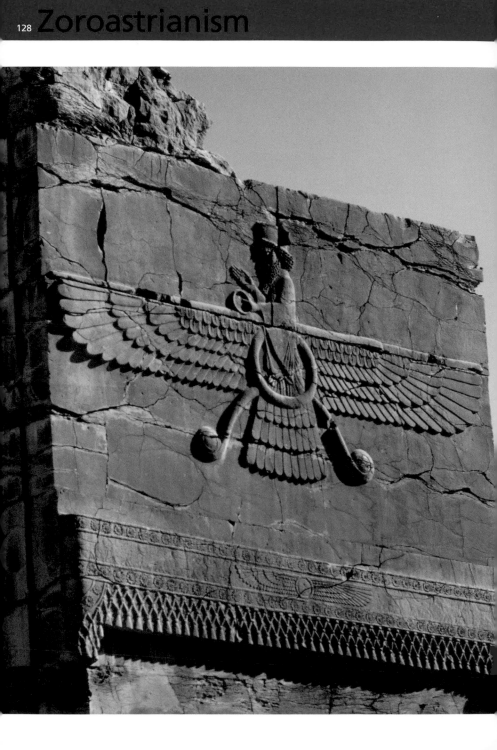

 An ancient monotheistic religion founded in Persia by Zarathustra, Zoroastrianism is the worship of Ahura Mazda, the One God, through complex fire ceremonies, and views the world as a cosmic struggle between good and evil.

ZARATHUSTRA (10th century BCE); **CYRUS THE GREAT** (b. 558 BCE); **KERDER** (3rd century BCE); **TOSAR** (3rd century BCE); **ASTVATERETA**

Ahura Mazda; Angra Mainyu; atar; Frashokeriti; Spenta Mainyu

The ancient state religion of Persia under Cyrus the Great is based on the visions and teachings of Zarathustra, who presented a worldview in which a cosmic struggle is played out between Angra Mainyu, the spirit of evil, and Spenta Mainyu, the spirit of goodness, both of whom were created by Ahura Mazda, the One God. This primordial conflict is a part of life for every individual, and all are given the free will to choose between good and evil and the moral responsibility to actively promote good in order to help move the whole world towards Frashokeriti, or final resurrection, when everyone will live in a state of everlasting bliss and perfection. The greatest of the awaited saviours is Astvatereta. Zoroastrian teachings are contained in ancient texts known as Avestas, which include the Gathas – the hymns believed to have been composed by Zarathustra. This early form of monotheism has influenced Judaism, Islam and Christianity.

Key to the development of Zoroastrianism as a state religion were Kerder and Tosar, but after the arrival of Islam in Persia the movement declined rapidly. However, it is still practised by small communities in Iran, India, Western Europe and North America. Many are migrants from India where they have had a presence in Bombay (now known as Mumbai) since the 11th century, and are known as Parsees. There are as many as 250,000 Zoroastrians around the world, united by their sacred fire rituals. All temples contain a ritually attended sacred fire (atar) that must not be allowed to expire. Zoroastrians also forbid cremation or burial, and in the past placed the bodies of their dead on high platforms known as towers of silence where they were allowed to deteriorate naturally. Today, a metal stretcher is enclosed in cement and placed in a cemetery.

← **Relief sculpture, Persepolis, Iran**
The relief depicts the Zoroastrian symbol the Faravahar, or Farohar, the spirit of a human being that pre-exists his or her birth and will continue to exist after death. It is interpreted as a reminder of the purpose of life – to progress spiritually and attain union with Ahura Mazda.

↓ **Ancient fire temple, Sura Khane, Baku, Azerbaijan**
This fire temple is probably older than recorded history. It was rebuilt by a Hindu merchant in the early 19th century and maintained by the Parsee community of Bombay who supported an attendant priest.

INDIA Ajmer Parsi Zarthosi Anjuman fire temple, Ajmer, Rajasthan; Navsari Anjuman fire temple, Mota Falia, Navsari, Gujurat: **IRAN** Ancient city of Persepolis; Pir-e Naraki temple and pilgrimage centre, Yazd; Pir-e Sabz (Chak Chaku) temple and pilgrimage centre, Yazd

This Chinese religion and philosophy is built around the concept of Tao, defined as emptiness, non-being and non-action, and divides the universe into two polar energies of yin and yang.

LAO-TZU (5th–6th century BCE); **CHUANG-TZU** (369–286 BCE); **CHANG TAO-LING** (2nd century CE); **CHANG-LU** (2nd century CE); **YANG-HSI** (4th century CE)

Lao-chun; Tai Ping; Tao; yin; yang

Taoism emerged in China as a rival to Confucianism and Buddhism during the 5th century BCE. The legendary Lao-Tzu is believed to be a contemporary of Confucius, but the well-known text, the *Tao-te Ching* (the Way of Power), of which there are more than 50 English translations, was certainly written later. The *Tao-te Ching* provides the philosophy of Taoism and teaches that there is an underlying and ineffable principle, known as Tao (or the Way), pervading the universe. As in Confucian teaching, human beings should harmonise themselves with the Way. However, Taoism differs from Confucianism in that it asserts that nature acts with spontaneity, and that it is therefore necessary to cultivate naturalness and spontaneity. Thus harmony with Tao cannot be followed or taught. Taoist tradition is quietist, emphasising meditation and inner stillness. Lao-Tzu's teachings were continued by Chuang-Tzu from the 4th century BCE.

In 142 CE, Chang Tao-Ling claimed to receive a vision of a deified Lao-Tzu and went on to establish Taoism as an organised sect. Although in some conflict with the authorities, Chang Tao-Ling's grandson Chang-Lu succeeded in achieving the protection and patronage of the Emperor Wei. The new religion divinised Lao-Tzu as the Lao-chun, the Heavenly Master, an incarnate manifestation of the Tao. This form of Taoism is still practised today, claiming a long line of such Heavenly Masters. The Tai Ping, or state of inner harmony with the Tao, was sought after via shamanist-type meditations that led to visions of the Heavenly Masters and, ultimately, the cosmic Lao-Tzu. In addition, Taoism developed techniques of alchemy and healing to promote longevity and even immortality; for example, the Shang Ching school, founded by Yang-Hsi, promotes visual meditation on celestial deities who are able to transport the adept to cosmic realms where they acquire the food of immortality.

The Emperor Kao-Tsung (649–683 CE) decreed that there should be state-sponsored Taoist and Buddhist monasteries throughout the Chinese empire, a situation that was to last in mainland China until as recently as 1911.

↑ Taoist yin/yang symbol
The Taoist yin/yang symbol describes the universe as one integrated whole, composed of two primal opposing, but complementary, forces. The light side is yang, masculine and strong like the sun. The dark side is yin, feminine and fertile like the ground. Yin/yang involves the two principles of li (idea), which is abstract, and qi (matter) – the material world. The goal of the Taoist is to try to realise a balance of the two.

→ **Hanging scroll of the Realm of All Mountain Kings and the Six Spirits of the Household, 1600, Ming Dynasty**

An example of a hanging scroll from the Chinese Ming Dynasty (1368–1644). The scroll portrays some of the multitude of spirits and gods that developed in later Taoism, for example the Stove God, Door God, Kitchen Door God, Well God and Earth God, all of which are household deities. The scroll is housed in the Musée National des Arts Asiatiques, Guimet, Paris.

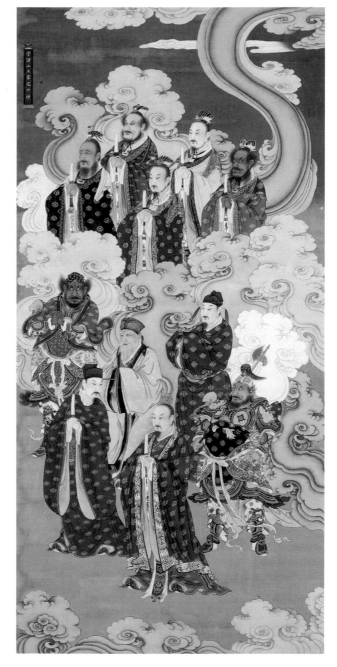

CHINA Qinghua Gong Temple, Xian; White Cloud Temple, Beijing; Wudang Taoist temples, Hubei Province: **SOUTH KOREA** Goguryeo tomb murals, near Kangso, Pyongan-do: **TAIWAN** Longshan Temple, Taipei

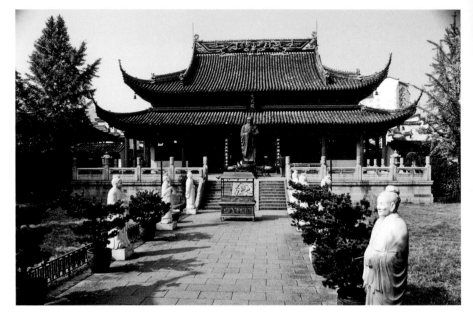

A system of government and rules of behaviour for members of the ruling classes, Confucianism is believed to have existed from time immemorial, but was taught by the last of the 'perfect sages', K'ung Fu-tzu (Confucius).

K'UNG FU-TZU (CONFUCIUS) (551–479 BCE); MENG-TZU (MENCIUS) (371–289 BCE); HSUN-TZU (3rd century BCE); CHU HSI (1130–1200 CE); LIU CHIU YUAN (1139–93 CE)

chun-tzu; he; hsun-tzu; li, Tai Chi

The name Confucius is a Latinisation of K'ung Fu-tzu, or 'K'ung the Master', by Jesuit missionaries. In many respects it is a misnomer to label Confucianism as a religion, as it is more a code of behaviour urged upon the Chinese ruling classes, and has no reference to the supernatural but rather to the ideal of the superior being who embodies all virtues (chun-tzu). Confucius was concerned about the constant chaotic warfare among the clans of his day, and he searched the old rituals for ethical human guidelines and moral principles to help see people through this turbulent era. Little is actually known about his life, but he founded the first recorded Chinese wisdom tradition, predating recorded Taoism by more than a century. His discourses have come down to us through the book named *Analectics* and, until their suppression in 1911, his ideas had considerable impact on the behaviour of the Chinese.

Confucius received a good education, which indicates that he was probably a member of the aristocratic elite, but one of his revolutionary ideas was to throw open his own academy to everyone. He fervently believed in the idea of a true gentleman (hsun-tzu) who was defined by moral behaviour rather than birth. He believed that good rule should occur through moral persuasion and example, and that rites and

ceremonies (li) should be encouraged to inculcate right behaviour and loyal public service in order to create harmony (he). At around the age of 50 he took service as a minister in the state of Lu, but left in wandering exile for 13 years accompanied by a small yet loyal group of students. He returned to Lu aged 68, where he died five years later.

Although Confucius's teachings did not attract a large following in his day, they later began to exert tremendous influence on the moral and philosophical thought of the people of China, and his ideal of a scholar as an administrator was to influence Chinese governance for around 2,000 years.

Meng-Tzu (Mencius) and Hsun-Tzu were later to form well-known rival schools based on Confucius's teachings, their doctrinal differences based on different perceptions of human nature. Neo-Confucianism – a rival metaphysical system to Buddhism and Taoism – emerged during the Sung dynasty (960–1126 CE), with Chu Hsi's declaration that the nature of reality originated in a supreme ultimate (Tai Chi), and Liu Chiu Yuan's claim that the universe and mind are one. Both also believed that human beings could perfect themselves through moral and ethical self-development.

Traditionally, the Chinese have practised Confucian principles alongside both Taoism and Buddhism, but today it is mainly practised in Vietnam, Korea and Taiwan rather than mainland China.

← **Painting depicting Confucius**
A traditional Chinese painting of Confucius. Though no portraits or depictions exist that are contemporaneous with his life, Chinese artists have conventionally portrayed him as a gentle and wise old man.

⇐ **Fuzi Miao Confucian temple, Nanjing, China**
The Nanjing temple was built during the Sung dynasty (1034 CE) and expanded during the East Jin dynasty. The buildings were ruined and rebuilt several times. The temple was seriously damaged by the Japanese in 1937 and later rebuilt by the Chinese government, using as much of the original stonework as possible.

◎ **CHINA** Confucius Temple and shrine, Qufu; Confucius Temple, Beijing; Imperial Temple, Hangzhou: **TAIWAN** Confucian Temple, Talung Street, Taipei; Confucius Temple, Taichung

A derivative of the Shi'a tradition, the Druze system of beliefs is named after one of its founders, al-Darazi, and its focus is the supposed divinity of another of its founders, the Fatimid caliph al-Hakim.

MUHAMMAD AL-DARAZI (d. 1020); AL-HAKIM (985–1021); HAMZAH IBN ALI IBN AHMAD (d. 1021); L'EMIR MAGID ARSLAN (1908–83); KAMAL JUMBLATT (1917–77)

ajawid; hikma; juhhal; uqqal

The Druze believe the Fatimid caliph al-Hakim, who demolished the church of the Holy Sepulchre in Jerusalem, to be the incarnation of the Divine and destined to return to the world in order to rule over a new golden age. God is also believed to have incarnated as five superior ministers under whose spiritual authority are the living functionaries, preachers and heads of communities. However, knowledge of this hierarchical system is obscure as the hikma (Druze theology) is only passed on to the initiated clerical elite (uqqal) who practise the religion on behalf of the community, who are known as the juhhal, or 'ignorant'. It is from the uqqal that the ajawid, or spiritual leaders of the Druze are selected. Druze was spread by two of al-Hakim's followers: Muhammad al-Darazi, and a Persian named Hamzah ibn Ali ibn Ahmad.

Though the Druze practise very few Shi'ite Muslim rituals, such as prayer, pilgrimage or fasting during Ramadan, they do follow seven moral principles: love of truth, taking care of one another, renouncing all other religions, avoiding the devil and all wrongdoers, accepting divine unity in humanity, accepting all the acts of al-Hakim, and acting in total obedience to his will. Unusually for a Semitic religion the Druze believe in reincarnation, all souls being continuously reborn as human beings until perfection is achieved and union

with God obtained. Heaven is the place where rebirth stops, and hell the distance from God experienced by any one soul on his or her journey to perfection.

The Druze live in the Levant, and their strongest presence is in the Jabal'd-Daruz region, which was bequeathed to them by the League of Nations in 1921 but is now shared by Lebanon, Syria and Israel. Although fiercely independent and living in isolation – marriage to outsiders and conversion to and from the religion is forbidden – Druze are permitted to live among people of other religions and adopt their practices when under persecution. They have played a prominent role in the politics of Lebanon. L'Emir Magid Arslan was the independence leader of the country in 1943 and Kamal Jumblatt founded the Lebanese Progressive Socialist Party in the middle of the 20th century.

← **Al Nabi Sabalan Shrine, Galilee, Israel**
Sabalan was a Druze prophet, believed to be either Zebulun, the sixth son of the Patriarch Jacob, or one of the emissaries who propagated the Druze religion in the 11th century. His tomb is located above the Druze village of Hurfeish, and is the site of an annual festive pilgrimage.

↙ **Tomb of Nabi Shueib, Galilee**
The Druze have many holy shrines, the most important of which is Nabi Shueib, the tomb of Jethro, father-in-law of Moses, near the Horns of Hittin, Tiberius. According to Druze tradition, Saladin had a dream in which an angel promised him victory over the crusaders. It is said that where his horse stopped he would find the burial site of Nebi Shueib.

↓ **The Druze Star**
The Druze Star symbolises the five superior ministers and the quality each possessed. Green is for the mind, which is necessary to comprehend the Truth. Red is for the soul. Yellow is for the Word, the purest expression of the Truth, and blue is for power of the Will. White is for the realisation of the Will in the world of matter.

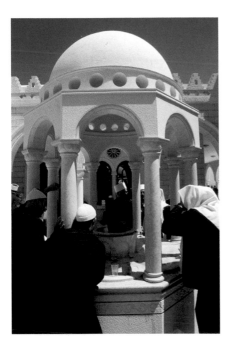

ISRAEL Abu Ibrahim Shrine, Daliyet el-Carmel, Mount Carmel, Haifa; Nabi al-Khadr Shrine, Kafr Yasif, Akko; Nabi Zakarya Tomb, Abu Sinan, near Akko; **SYRIA** Al-Ya'afuri Shrine, Majdah Shams, Golan Heights; Jabal al-Duruz sacred mountains

Santeria is one of the many syncretic religions created by Africans and brought to the Caribbean islands by slaves. It originated in Cuba, and thus also includes elements from Iberian Catholicism as well as from the religion of the West African Yoruba people.

WALTER EUGENE KING (1928–2005); ERNESTO PICHARDO (1954–)

ashe; ebo; Lukumi; Olodumare; orisha

The Santeria religion was established in 1517 by West African Yoruba slaves in the Caribbean, though its origins lie in Cuba, and it therefore also includes certain aspects of Spanish Catholicism. It is also known as Lukumi (the Yoruba for 'friend'), which describes both the religion and its practioners. As in other countries to which African slaves were sent, they were discouraged and even forbidden from practising their native religion. However, observing similarities between their own belief system and Catholicism, they created a secret religion that used Catholic saints and personages as fronts for their own god and for spiritual emissaries, known as orishas. When the slave trade was abolished, Santerianism continued to flourish in the US (in New York and Florida), in South America and Europe.

Santerian churches usually remain secretive. However, the Church of the Lukumi Babalu Aye, formed in southern Florida by Cuban Americans and led by Ernesto Pichardo, practises Santeria freely and publicly despite the religion's ritual animal sacrifice. Other churches in the US include, most notably, the African Theological Archministry, in South Carolina, which was founded by Walter Eugene King, and the Church of Seven African Powers, also in Florida and founded in the 1980s. It is estimated that the number of practitioners of Lukumi orisha worship in the US is now around five million.

Santerians believe in one supreme god, Olodumare, who is the main source of ashe, the spiritual energy that makes up the universe, all life and material objects. Olodumare interacts with the world through orishas, who rule over the forces of nature and human life. Orishas can be approached through prayer, ritual offerings (ebo) and trance possession, and often come to the aid of followers, guiding them to a better life. Olodumare corresponds to Jesus Christ in Catholicism, and the orishas to the various Roman Catholic saints.

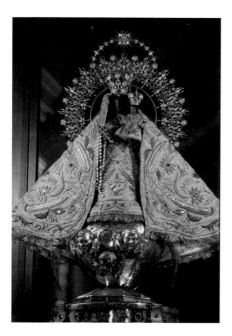

← **The patron saint of Cuba, El Cobre, Cuba**
In Santeria, the Virgen de la Caridad, declared in 1916 by Pope Benedict XV to be the patron saint of Cuba, is associated with the orisha Ochún, the Yoruba goddess of love and dancing, who is represented by the colour yellow. Roman Catholic iconography was used by African slaves to disguise their own deities.

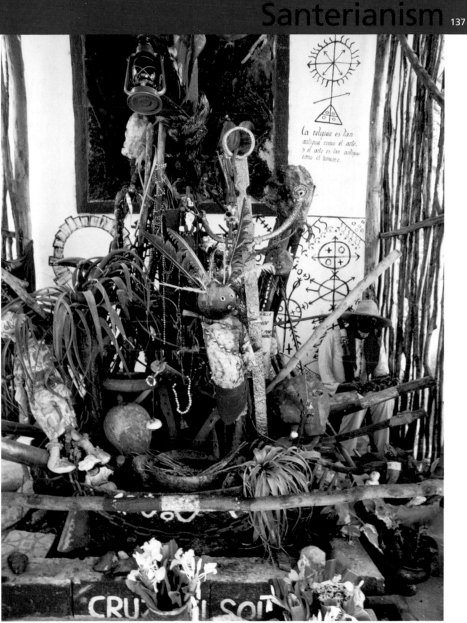

la religion es tan
antigua como el arte,
y el arte es tan antiguo
como el hombre.

↑ **Santeria altar, Havana, Cuba**
Covered with images of the spirits and offerings left by
devotees, altars are found in public places or in
basements and bedrooms. They can be to several spirits,
or only one, but each altar must be constructed with
careful attention to the spirits' likes and dislikes.

◉ **US** African Theological Archministry, Sheldon,
South Carolina; Church of the Lukumi
Babalu Aye, Hialeah, southern Florida; Church of
Seven African Powers, Miami, Florida

The Bahai follow the teachings of Bahaullah, the founder of a 19th-century messianic movement in Iran whose followers believed him to be their link to the Hidden Imam of the Shi'ite Muslims.

MIRZA HUSAYN ALI NURI (BAHAULLAH) (1817–92); **SAYYID ALI MUHAMMAD (THE BAB)** (1819–1850); **SHOGHI EFFENDI RABBANI** (1899–1957)

Administrative Order; Guardian of the Faith; Kitab i-Aqdas; Universal House of Justice

Bahai is a relatively new religion that originated in 19th-century Iran and now has around two million followers worldwide with strong growth in South Asia and Africa. Its roots lie in the eschatological teachings of Shi'ite Muslims, but it has transcended its origins to become a separate religion with its own characteristics. Although it remains the largest religious minority in Iran, Bahai has experienced considerable difficulties since the Islamic revolution.

The forerunner of Bahai was Sayyid Ali Muhammad, known as the Bab (the Gate), who was born in Shiraz and executed in Tabriz for rebellion against the regime. In 1844 he announced the imminent appearance of the Messenger of God awaited by all the religions in the world.

The Bahai believe the Bab was the Messenger of God whose mission was to prepare humanity for the coming of Mirza Husayn Ali Nuri (Bahaullah). After the execution of the Bab, Bahaullah was imprisoned in Tehran and it was during this period that he received his revelation. Upon his release, he was exiled and spent his time travelling and teaching throughout the Middle East until he finally settled in Acre, Palestine, in 1868. It was here that he wrote the Kitab-i-Aqdas, which outlines the essential principles and laws to be observed by his followers. He died in Acre in 1892, and the nearby place known as Bahji is still the most sacred site for the Bahai, thus Israel is their holy land.

The Bahai regard Bahaullah as the herald of a new age during which the human race will move towards world government and the equality of all men and women, the development of a world language (English) and non-violence in all human affairs. They are tolerant of all religions, believing in their underlying unity, and are consequently open to diverse forms of religious experience.

↑ **Seat of the Universal House of Justice, Haifa, Israel**
After the death of Bahaullah's grandson, Shoghi Effendi Rabbani (known as the Guardian of the Faith), the leadership of the Bahai became an elected body chosen by its membership (the Administrative Order). The Universal House of Justice, the governing council of the Bahai faith, was instituted in 1963 when nine individuals were elected. Elections continue to take place every five years.

→ **Shrine of the Bab, Haifa, Israel**
The shrine of the Bab is located on the side of Mount Carmel, overlooking the sea. The site also contains terraced gardens landscaped on the mountainside. The shrines of the Bab and Bahaullah in the Holy Land are the main pilgrimage centres for the Bahai.

AUSTRALIA Bahai House of Worship, Sydney: **INDIA** Lotus Temple, Delhi: **ISRAEL** Grave of Bahiyyah Khanum (Bahaullah's daughter), Haifa; Shrine of Bahaullah, Bahji, near Acre

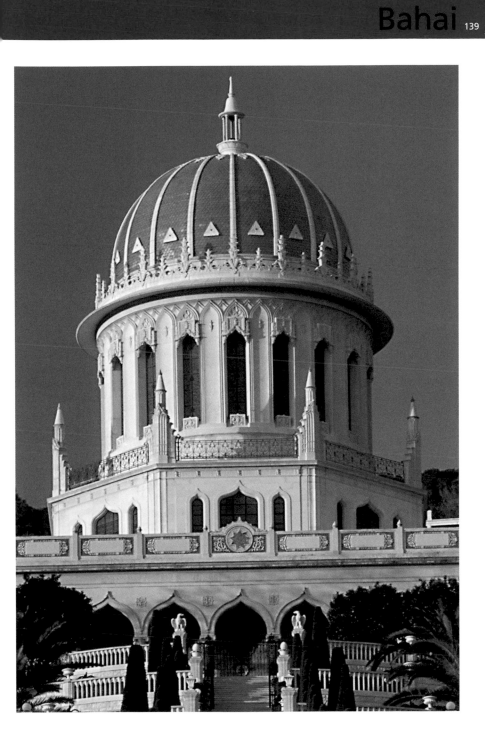

Caodaism

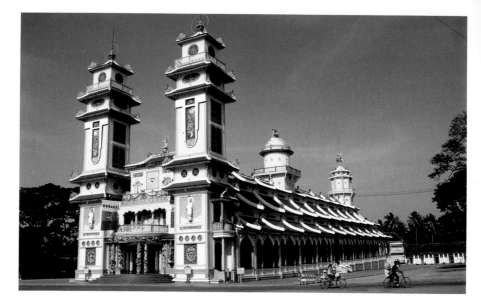

Caodaism is an eclectic Vietnamese religion founded in 1926 by Ngo Van Chieu, a civil servant from the island of Pho Quoc, which incorporates elements of Taoism, Buddhism, Confucianism, Christianity and Islam.

CAO HOAI SANG (unknown); NGO VAN CHIEU (b. 1878); CAO QUYNH CU (1888–1929); LEE VAN TRUNG (d. 1934); PHAM CONG TAC (1893–1958)

Bat Quai Dai; Dai Dao Tam Ky Pho Do; esotericism; exotericism; Giao Tong

Caodaism, Cao Dai or, more fomally Dai Dao Tam Ky Pho Do, was founded by Ngo Van Chieu in 1926, and although highly eclectic its major influence would appear to be Taoism. Ngo Van Chieu's small group of followers at the time included Cao Quynh Cu, Pham Cong Tac, Cao Hoai Sang and Le Van Trung, who became the religion's first pope (Giao Tong).

The term Cao Dai is derived from the Taoist 'High Tower', a name for the Supreme Being. However, the religion is also strongly influenced by spiritualism. During séances, Ngo Van Chieu had experienced visions and revelations from the spirits of a number of prominent figures from artistic, cultural, political and religious backgrounds. And it was these experiences that formed the foundation for the movement's teachings. The religion is divided into two main sects, the esoterics and the exoterics, the former adding meditation and eradication of the ego to Cao Dai practices.

It is believed that the first attempt by God to communicate the truth to human beings resulted in the religions of Judaism, Hinduism and Yi King in China, and that in the second attempt God communicated with the Buddha, Jesus, Lao Tse and Confucius. But Caodaists believe these messages were distorted by their messengers, and that the only way to ensure the truth is undefiled is to experience it through the Caodaist monks

who have direct communication with the spirits (Bat Quai Dai). Caodaism thus claims to be the 'Third Alliance between God and Man'. Spirits play a central role in Caodaism, and can include warriors and poets, as well as religious figures. Caodaist saints are beatified for their contribution to culture and include Victor Hugo, Joan of Arc, Descartes, Shakespeare, Louis Pasteur and Sun Yat-Sen.

In its efforts to fuse philosophical, cultural and religious influences from East and West, Caodaism remains popular in Vietnam. Its organisation is based on Roman Catholicism, its hierarchy thus consisting of a pope, cardinals, archbishops, bishops and priests (of both sexes), though its rituals are based on Taoism and Buddhism. After it was officially recognised by the French colonial authorities in 1926, the religion grew rapidly throughout South Vietnam, even maintaining its own paramilitary. However, in 1975 the Communists closed its temples and confiscated its property. In the 1980s, the new government returned the temples to their rightful owners and Caodaism is once again flourishing, albeit under strict government control.

← **Cao Dai Holy See, Tay Ninh, Vietnam**
Caodaism's spiritual centre, 93 kilometres (58 miles) northwest of Saigon, is known as the Holy See. Its architecture combines features of a church, pagoda and shopping centre, and the highly colourful central hall has nine levels representing the nine steps to heaven.

↓ **Caodaist ritual ceremony, Cao Dai Holy See**
Caodaist ritual ceremonies are visually spectacular, and take place four times a day, at 6am, noon, 6pm and midnight. Worshippers wear simple white robes, though priests are colourfully dressed. The ceremonial pageant attracts crowds of tourists as well as worshippers. Men and women process from different sides of the temple and make offerings of incense, fruits and flowers.

AUSTRALIA Than That Cao Dai, Wiley Park, New South Wales: **CANADA** Than That Cao Dai, Rue St Urbain, Montreal: **US** Cao Dai Temple, Metro Area, Washington DC: **VIETNAM** Thanh-That Cao-Dai, Thon Phuc Duc, Xa Sai Son and Tinh Ha Ta temples, North Vietnam; Thanh That Vinh Loi, Duong Hung Vuong and Thang Pho Hue temples, Central Vietnam

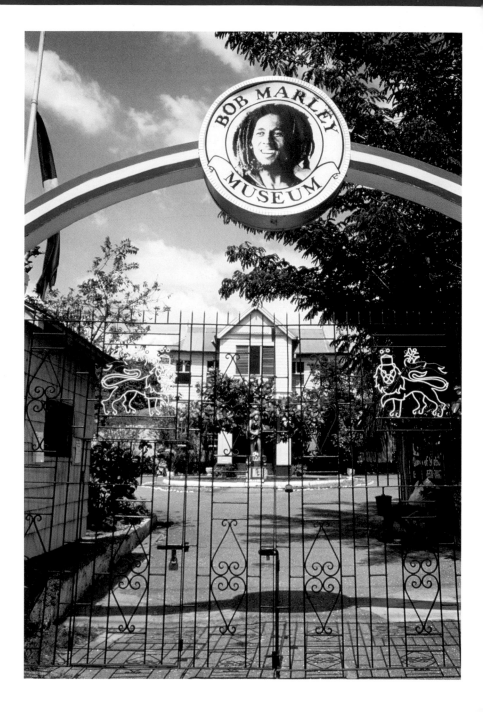

An African-Caribbean religion that acknowledges Emperor Haile Selassie of Ethiopia as the Supreme Being and the only ruler of black people, Rastafarianism also seeks the liberation of black races from white exploitation and oppression.

MARCUS GARVEY (1887–1940); **HAILE SELASSIE** (1892–1975); **WALTER RODNEY** (1942–80); **BOB MARLEY** (1945–81)

Babylon; grounations; 'I' and 'I'; Jah; Lion of Judah

The original Rastas were inspired by Marcus Garvey , who promoted the Universal Negro Improvement Association (UNIA) in the 1920s. The organisation's main purpose was to organise and unite blacks throughout the world. Garvey believed that all black people should return to Africa since they were all descended from Africans. He told black people to look towards Africa and watch for the crowning of a king that would herald their redemption. In 1930, Prince Ras Tafari Makonnen was crowned the new Emperor of Ethiopia and, upon his coronation, claimed for himself the title Emperor Haile Selassie and Lion of Judah. This event was seen by many blacks in Africa and the Americas as the fulfilment of Garvey's prophecy, and marked the official beginning of the Rastafarian movement. During the 1940s and 1950s, Rastafarian group leaders intensified their opposition to the colonial state in Jamaica by defying the police and organising illegal street marches.

In Jamaica, from 1930 until the mid-1960s, Rastafarianism was little more than a local religious movement. No Jamaica-wide Rastafarian church developed and there was no agreement on basic doctrine or a canon of scripture, although music is an integral part of worship ceremonies, known as grounations. In 1968, Walter Rodney, a professor at the University of the West Indies, published *The Grounding with My Brothers* discussing his experiences of Rastafarians, and this pamphlet became the key text for the Caribbean Black Power movement. But it was not until the 1970s that Rastafarianism became more of a positive cultural force, and began to influence Jamaican art and music (especially reggae). In the late 1970s, one reggae musician in particular, Bob Marley, came to symbolise Rastafarian values and beliefs. His success ensured a worldwide audience for the Rasta message and ideas. Today, worldwide, the total following is about a million people.

Three overriding concepts are key to Rastafarian beliefs. The first is Jah, the Rastafarian name for God, though there is no afterlife or hell. The second is the concept of 'I and I', which signifies that Jah is within all individuals. The third is the idea of Babylon, the Rastafarian term for the white political power structure that has been holding back the black race for centuries.

Rastas' appearance is distinguished by dreadlocks, their distinctive uncut matted hair.

← **Bob Marley Mausoleum, Nine Miles, Jamaica**
Now a significant place of pilgrimage for Rastafarians, Nine Miles, a tiny hamlet in the middle of Jamaica, was Bob Marley's birthplace. His coffin was driven across the island after his funeral in Kingston and it is estimated that half of Jamaica's population gathered to pay their respects. In April 1981, Marley was awarded Jamaica's Order of Merit.

ETHIOPIA Birthplace of Haile Selassie, Harer; Jamaican Rastafarian Development Community, Shashamene, Shoa Province: **JAMAICA** Bobo Ashanti Community, Bull Hill, Bull Bay; Rastafarian Centralization Organization, Melody Drive, Kingston

Scientology is an expanding new religion based on a system of beliefs and practices that originated in the philosophy of L Ron Hubbard, an American science-fiction writer, in 1952.

L RON HUBBARD (1911–86)

auditors; dianetics; E-meter; thetans

Scientology means the study of knowledge or truth and was founded by the American science-fiction writer L Ron Hubbard over a period of about 34 years, from 1952 until his death in 1986. It developed from Hubbard's dianetics system of self-improvement, which differs from Scientology in that it claims to focus on rehabilitating an individual's mind, giving the individual full conscious recall of his or her experiences. Scientology, on the other hand, is more concerned with rehabilitating the human spirit.

Scientologist practices are revealed in a series of levels that lead to the more advanced stages of esoteric knowledge. Scientologists believe that human beings are immortal spiritual beings (called thetans) who possess a mind and body, and who have lived through many past lives. A person is basically good, but becomes 'aberrated' by moments of pain and unconsciousness and retains many emotional problems caused by the early stages of evolution. According to the church, the ultimate goal is to get the thetan back to his or her native state of total freedom. This level is described as the state of operating thetan, or OT for short.

The central practice of Scientology is a one-on-one counselling session, called auditing, in which the auditor follows an exact procedure designed to rehabilitate the human spirit, usually using an E-meter, a device that supposedly measures very small changes in electrical resistance through the human body. The auditing process is intended to help the practitioner free him- or herself of specific incidents or bad decisions that are believed to restrict the 'preclear' from achieving his or her goals and lead to the development of a reactive mind. A number of Hollywood celebrities are now part of the movement, which claims to have up to 10 million followers. However, others claim the figure to be less than 100,000 worldwide.

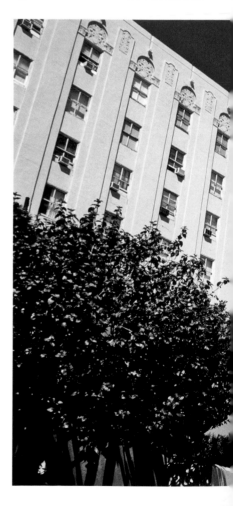

Scientology headquarters, Los Angeles, California, US

The entrance to the headquarters of the controversial Scientology Church, known as the Church of Scientology International (CSI). The church is the mother church for all Scientology and provides the overall direction, planning and guidance for the network of churches, missions, field auditors and volunteer ministers that form the Scientology hierarchy.

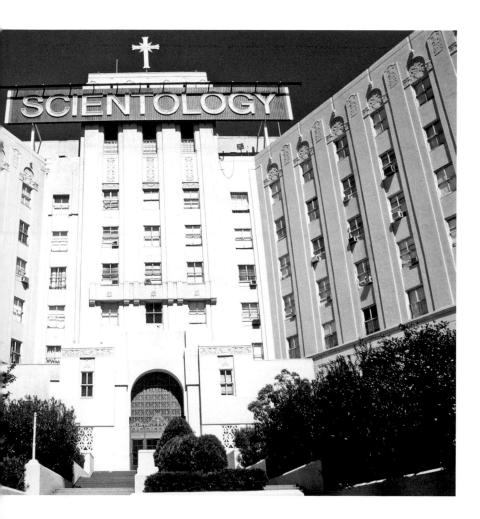

UK The Church of Scientology of London, Tottenham Court Road, London; Saint Hill Manor, East Grinstead, West Sussex, England:
US The Founding Church of Scientology, Washington DC; The Pacific Area Command Base, Fountain Avenue, Hollywood, California; The Scientology Archiving Project, Trementina, Santa Fe, New Mexico; The Scientology Worldwide Spiritual Headquarters, Flag Land Base, Fort Harrison Hotel, Clearwater, Florida

बाला

7

REFERENCE
SECTION

AHIMSA
In Jainism, reverence for all life through avoidance of mental, verbal and physical injury.

AHURA MAZDA
The Avestan language name for a divinity of an ancient proto-Indo-Iranian religion, declared by Zarathustra (Zoroaster) to be the one Creator God.

ANEKANT
The Jainist doctrine of many-sidedness which asserts that knowledge can only come from many changing modes of perception.

ANGRA MAINYU
The Zoroastrian personalisation of evil or 'the hostile spirit' who is described as the leader of the demons.

APARIGRAHA
The Jainist non-attachment to material possessions and mental states. Ascetics maintain a strict non-possession of material objects. Lay Jains ideally maintain a vow of limited possession.

APOCALYPSE
In Christianity, the prophetic revelation predicting universal and widespread utter destruction or disaster.

APOCRYPHA
The 14 books of the Bible not considered canonical and usually omitted from the Protestant Bible

APOSTOLIC SUCCESSION
The belief that a church, or a leader of a church, is the successor to the body of Apostles of the early Christian church.

ARHAT
An enlightened Buddhist disciple or one who has attained enlightenment.

ARMAGEDDON
The climactic battle between the forces of Christ and the forces of Satan mentioned in the Book of Revelation.

ARIYA ATTHANGIKA MAGGA
The noble eightfold path taught by the Buddha as the skilful means or middle way to obtain release from suffering.

ATAR
In earlier Zoroastrian texts, the Atar is a vehicle of judgement. However, later Avestan texts have the divinity representing, and being represented by ,fire, associated with warmth and light and essential for growth.

ATMAN
In Hinduism, used as distinct from Brahman when it refers to the eternal or ultimate power within the individual rather than in the cosmos.

AVATARA
The Hindu manifestation of a god into human or animal incarnations.

BHAKTI
The Hindu path of devotion or loving adoration towards the divine.

BODHI
The enlightened condition of a Buddha, bodhisattva or arhat.

BODHISATTVA
An individual destined to become a Buddha but who renounces entry to nirvana in order to help other beings through compassion.

BRAHMAN
In Hinduism, the power present in the whole universe or the ultimate reality behind creation.

CATECHISM
A summary or exposition of doctrine used in Christian religious teachings.

CHARISMATIC
An umbrella term for Christians who emphasise the importance of experience of manifestations of the Holy Spirit, such as healing, prophesying and speaking in tongues

CHRIST
'The anointed one'. A title of Jesus who is believed by Christians to have been the Messiah prophesied in Jewish scriptures.

CHUN-TZU
One who lives by the Confucianist ideal of Jen (all-encompassing love) and is neither petty, arrogant, mean-spirited nor vengeful.

DEACON
In mainstream Christian churches a deacon assists priests in pastoral and administrative duties, and in administering the Eucharist and reading the Gospel during worship.

DHARMA
Though it has a variety of meanings (right, law, truth, justice, doctrine), the term is usually understood as the Buddha's teachings and their application. In Hinduism it is a cosmic principle variously translated as righteousness, right conduct, duty and way of life or religion.

DHIKR
The remembrance of Allah's names in all walks and arenas of life.

DIGAMBARA
The branch of Jains whose monks do not wear any clothing. With a stronger presence in southern India, the Digambaras believe they maintain the original doctrines and practices of Jainism,and include far fewer scriptures than the Svetambaras in their canon.

DUKKHA
The essence of the teaching of the Buddha that the nature of existence and the condition of all beings except for the enlightened is suffering or, more accurately, dissatisfaction.

EPISCOPY
Government of the Christian church by bishops.

EUCHARIST
Literally meaning 'thanksgiving', the Eucharist is the Christian ritual of sharing bread and wine, symbolising Christ's body and blood, instituted by Jesus in his last Passover supper with his disciples.

EVANGELICAL
This term includes Christian denominations and individuals who stress the authority and supremacy of scripture and a conservative interpretation of the Bible.

GURU GRANTH SAHIB
A collection of poems composed by Sikh religious figures of northern India whose teachings reflected that of the gurus. It is now the main sacred text of the Sikhs.

GURU PANTH
The community that follows the teachings of the Sikh gurus. It is believed that the spirit of the guru is present wherever Sikhs are gathered together in the presence of the *Guru Granth Sahib*.

GLOSSALIA
'Speaking in tongues', which is a phenomenon of being possessed by the Holy Spirit.

HAGGADAH
An authoritative interpretation of Jewish written law.

HIJRA
The flight or emigration of Muhammad and the early Muslims from Mecca to Medina in 622 CE. The Islamic calendar begins from this event and continues through a lunar year based on 354 days.

HOLY SPIRIT
The third member of the Godhead (the Trinity) in Christian belief, together with God the Father and Jesus Christ.

IMAM
In the Sunni tradition of Islam, the title simply refers to one who leads public prayers in the mosque. The

Shia give the title to the Prophet's successors through the line of Ali and Fatimah who are regarded as the spiritual leaders of their community.

INDULGENCES
The remission of temporal punishment granted by the Christian church for sins already forgiven by God after the penitence and reconciliation of the sinner.

KAABA
A cube-shaped structure in Mecca and the geographical focal point for Muslim communal prayer. It is believed to have been constructed by Abraham and Ishmael for the worship of the one God.

KARMA
The Hindu immutable law of cause and effect that controls rebirth. It is a cosmic law that governs samsara and ensures that all good and bad deeds bring their desired result.

KHALSA
The orthodox brotherhood founded by Guru Gobind Singh in 1699 which today includes around 20 per cent of all Sikhs.

LI
The term 'li' has several meanings, often translated as propriety, reverence, courtesy, ritual or the ideal standard of conduct. Confucius believed it to be the ideal standard of religious, moral and social conduct.

LITURGY
A particular arrangement of readings from scripture, chants and prayers in public worship in the Christian church, especially of the Eucharist.

MATA
Independent goddesses found in village or rural Hinduism.

MILLENNIALISM
The Christian belief in a period of a thousand years prior to the end of

the world when Christ will return and reign in the world, followed by a battle with Satan and the Day of Judgement.

MOKSHA
In Hinduism, the final release of the soul from samsara or the cycle of rebirth.

NIRVANA
In Buddhism, the cessation of the wheel of existence and the end of samsara.

NORITO
Words addressed to a Shinto deity or deities in an ancient style of Japanese. The chief priest recites the norito on behalf of the faithful. It was believed that beautiful, correct words brought about good, and that words of the opposite sort caused evil.

ORDINATION
In Christianity, the investiture of an individual with priestly or ministerial functions.

PAROUSIA
The second coming of Christ.

PRESBYTER
From the Latin *presbuteros* ('elder'), a presbyter is a priest, pastor or minister of the church in various Christian denominations

PURGATORY
In Roman Catholicism, the place where the minor sins of those who are saved is paid for by temporal punishment, as opposed to eternal punishment for the damned, so that they achieve the necessary state of purity to enter heaven.

QURAN (KORAN)
The book believed to be the final revelation of Allah to humanity and also believed to be God's speech.

RASUL
A prophet or messenger of Allah who is sent with a book of revelation.

REFORMATION
The movement initiated by Martin Luther in the 16th century to reform the Roman Catholic Church and remove from it what was, according to Luther, erroneous doctrine and practice within the church.

RESURRECTION
The raising of Christ to life after his death and burial. In general, the raising of the dead on Judgement Day.

SANGHA
The assembly of monks and nuns in Theravada Buddhism, but often used for all the community in Mahayana Buddhism.

SATGURU
Literally meaning 'the true teacher', the term is used by Sikhs either as a name for God or to describe the 10 human gurus.

SATNAM
In Sikhism, Satnam refers to the true Name of God, which is revealed by the Satguru to his followers.

SATORI
The term used in Zen Buddhism to describe a state of being where differentiation and duality are overcome.

SHAMAN
In Animism, an intermediary between the natural and spiritual worlds who travels between the two in a state of trance, and communicates with the spirits for assistance with healing, hunting or weather management.

SPENTA MAINYU
Spenta Mainyu (the holy spirit) is the Zoroastrian god of life and the personification of the good and the light. He is the twin brother of Angra Mainyu,the god of darkness, with whom he fights an eternal battle.

SUIJAKO
This was originally a Buddhist term used to explain the Buddha's nature as a metaphysical being (honji) and the historical figure Sakyamuni (suijaku). This theory was used in Japan to explain the relation between Shinto gods and Buddhas; the Buddhas were regarded as the honji, and the Shinto gods as their incarnations, or suijaku.

SVETAMBARA
The numerically dominant form of Jainism found primarily in northern and western India. Literally meaning 'white-clad', the name comes from its monks who dress in simple white cotton robes.

TALMUD
The Talmud is a record of rabbinic discussions on Jewish law, ethics, customs and history. It includes the Mishnah, a compilation of Jewish oral law, and the Gemarah, a discussion of the Mishnah and the Hebrew Bible.

TANTRA
A series of Hindu scriptures written in the form of a dialogue between Shiva and his consort Parvati, which describe a variety of practices that lead to release through union. Tantra has developed into a unique path to liberation in which the goddess is the supreme deity.

TARIQA
Literally meaning 'the way', the term is used to describe the various paths of inner purification achieved through remembrance of Allah.

TASSAWUF
The inner path of purifying the heart through the remembrance of Allah.

TAWHID
The central doctrine of Islam concerning the oneness and uniqueness of God.

TIRTHANKARAS
In Jainism, the title used for the 24 great spiritual teachers and liberated souls who are born throughout each half-cycle of time and commit their lives to preaching the path to liberation.

TORAH
The first five books of the Jewish Bible, namely Genesis, Exodus, Leviticus, Numbers and Deuteronomy.

TRANSUBSTANTIATION
The Christian belief that the bread and wine of the Eucharist are turned into the actual body and blood of Jesus Christ.

TRINITY
The Christian concept that the Godhead comprises three persons: God the Father, God the Son (Jesus Christ) and God the Holy Spirit.

UNIVERSALISM
The concept in some Christian denominations that all human beings will be reconciled to God and saved from eternal punishment.

VARNA
The four classes, or principal divisions, of Hindu society, namely Brahmin, Kshatriya, Vaishya and Shudra.

YIN/YANG
In Taoism, two primal opposing but complementary forces found in all things in the universe. Yin is the darker element and corresponds to the night, and yang is the brighter element which corresponds to the day.

ZAZEN
Zen Buddhist forms of sitting meditation usually practised in the lotus position.

AFGHANISTAN
BAMIYAN VALLEY: Buddhism
MAZAR AL-SHARIF: Shi'ism

ANGUILLA
Jehovah's Witnesses

AZERBAIJAN
BAKU: Zoroastrianism

AUSTRALIA
CARLINGFORD, NEW SOUTH
WALES: Mormonism
SYDNEY: Bahai
ULURU, NEW SOUTH WALES:
Animism
WILEY PARK, NEW SOUTH WALES:
Caodaism

BENIN
Voodoo

CANADA
LONDON, ONTARIO: Methodism
MONTREAL: Caodaism
NELSON, BRITISH COLUMBIA:
Christian Scientism
SACKVILLE, NEW BRUNSWICK:
Baptistism
TORONTO: Presbyterianism
VANCOUVER: Animism

CHINA
BEIJING: Confucianism; Taoism
HANGZHOU: Confucianism;
Mahayana Buddhism
HUBEI PROVINCE: Taoism
NANJING: Confucianism
QUFU: Confucianism
SHANSI: Mahayana Buddhism
XIAN: Taoism

CUBA
HAVANA: Santerianism

CZECH REPUBLIC
PRAGUE: Judaism

EGYPT
ASWAN: Ishmaelism
CAIRO: Greek Orthodox;
Ishmaelism; Sunni'ism
MOUNT SINAI: Greek Orthodox;
Judaism

ETHIOPIA
ADDIS ABABA: Rastafarianism
HARER: Rastafarianism
SHASHAMENE, SHOA PROVINCE:
Rastafarianism

FRANCE
CHARTRES: Catholicism
GULF OF MORBIHAN, BRITTANY:
Neopaganism
ILE-ET-VILAINE, BRITTANY:
Neopaganism
LOURDES: Catholicism
NOYON: Protestantism
PARIS: Catholicism

GERMANY
BERLIN: Baptistism
EISENACH: Protestantism
ERFURT: Lutheranism
LUNEBURG: Seventh-day
Adventism
WARBURG: Lutheranism
WITTENBERG: Lutheranism;
Protestantism

GREECE
MOUNT ATHOS: Greek Orthodox
SANTORINI: Greek Orthodox

HAITI
CARREFOUR: Voodoo
GRESSIER: Voodoo

HUNGARY
BUDAPEST: Orthodox Judaism

INDIA
AGRA, UTTAR PRADESH: Islam
AJMER, RAJASTHAN:
Zoroastrianism
AMRAVRATI, MAHARASHTRA:
Jainism
AMRITSAR, PUNJAB: Sikhism
ANANDPUR, PUNJAB: Sikhism
AYODHYA, UTTAR PRADESH:
Hinduism; Vaishnavism
BHOPAL, MADHYA PRADESH:
Buddhism
BODHGAYA, BIHAR: Buddhism
CHENNAI, TAMIL NADU:
Anglicanism; Presbyterianism
CHEZERLA, ANDHRA PRADESH:
Shaivism
CHIDAMBARAM, TAMIL NADU:
Shaivism
CHURU, RAJASTHAN: Shaktism

COCHIN, KERALA: Orthodox Judaism
COPRASTHAM MEHNDIYAN, OLD DELHI: Sufism
DELHI: Bahai; Islam; Sufism
DHARAMSALA, HIMACHAL PRADESH: Mahayana Buddhism
DWARKA, GUJARAT: Vaishnavism
FATEHPUR SIKRI, RAJASTHAN: Sunni'ism
GOA: Catholicism
HARIDWAR, UTTAR PRADESH: Hinduism; Shaivism
JUNAGADH, GUJARAT: Jainism
KANGRA, HIMACHAL PRADESH: Shaktism
KHAJURAHO, MADHYA PRADESH: Hinduism
KOLKATA, WEST BENGAL: Anglicanism; Baptistism; Hinduism; Shaktism; Unitarianism
KURNOOL, ANDHRA STATE: Shaivism
LUDHIANA, PUNJAB: Sikhism
MADURAI, TAMIL NADU: Hinduism
MOUNT ABU DILWARA, RAJASTHAN: Jainism
MYSORE, KARNATAKA: Shaktism
NAINITAL, UTTAR PRADESH: Shaktism
NAKODA, RAJASTHAN: Jainism
NANKANA SAHIB, PUNJAB: Sikhism
NAVSARI, GUJURAT: Zoroastrianism
NEW DELHI: Sikhism
OLD DELHI: Sikhism
PUNE, MAHARASHTRA: Ishmaelism
PURI, ORISSA: Vaishnavism
RISHIKESH, UTTAR PRADESH: Hinduism; Shaivism
SAMVASARAN MANDIR, GUJURAT: Jainism
SRAVANABELAGOLA, KARNATAKA: Jainism
TIRUCHIRAPPALLI, TAMIL NADU: Vaishnavism
VARANASI, UTTAR PRADESH: Buddhism; Hinduism; Shaivism
VRINDAVAN, UTTAR PRADESH: Hinduism; Vaishnavism

IRAN
MASHAD: Shi'ism
PERSEPOLIS: Zoroastrianism
QUM: Shi'ism
TEHRAN: Shi'ism
YAZD: Zoroastrianism

IRAQ
BAGHDAD: Shi'ism; Sufism
KARBALA: Shi'ism
MOSUL: Judaism
NAJAF: Shi'ism

ISRAEL
ACRE: Bahai
AKKO: Druze
GALILEE: Druze
HAIFA: Bahai; Druze
JERUSALEM: Christianity; Islam; Judaism

ITALY
ROME: Catholicism; Christianity

JAMAICA
BULL BAY: Rastafarianism
KINGSTON: Rastafarianism
NINE MILES: Rastafarianism

JAPAN
ISE CITY, MIE PREFECTURE: Shintoism
KAMAKURA: Shintoism
KYOTO: Mahayana Buddhism; Shintoism; Zen Buddhism
NARA: Mahayana Buddhism
TAISHA, SHIMANE PREFECTURE: Shintoism
TOKYO: Shintoism; Zen Buddhism

KENYA
MOMBASA: Anglicanism

NEPAL
PASHUPATINATH: Shaivism

NEW ZEALAND
COOK ISLANDS: Congregationalism

PAKISTAN
LAHORE: Sunni'ism
MULTAN, PUNJAB: Sufism
NANKANA SAHIB, PUNJAB: Sikhism
SEHWAN SHARIF: Sufism

PALESTINIAN TERRITORIES
JERICHO: Judaism

REPUBLIC OF IRELAND
CILL DARA, COUNTY KILDARE: Wicca
COUNTY DUBLIN: Jehovah's Witnesses

ROMANIA
BUCHAREST: Jehovah's Witnesses

SAUDI ARABIA
MECCA: Islam

SOUTH KOREA
ASAN: Unificationism
GYEONGGI-DO: Unificationism
KANGSO, PYONGAN-DO: Taoism
PUSAN: Unificationism
SEOUL: Unificationism

SPAIN
GRANADA: Islam
SERVETO, ARAGON: Unitarianism

SRI LANKA
ANURADHAPURA: Theravada Buddhism
KANDY: Buddhism
POLONNARUWA: Theravada Buddhism

SWITZERLAND
ZURICH: Protestantism

SYRIA
DAMASCUS: Sunni'ism
GOLAN HEIGHTS: Druze
JABAL AL-DURUZ MOUNTAINS: Druze

TAIWAN
TAICHUNG: Confucianism
TAIPEI: Confucianism; Taoism

THAILAND
BANGKOK: Animism: Mahayana Buddhism; Theravada Buddhism
CHIANGMAI: Animism
LAMPHUN: Theravada Buddhism
PHITSANULOK, CHANGWAT PROVINCE: Buddhism
SUAN MOKKH: Theravada Buddhism
SUKHOTHAI HISTORIC PARK: Buddhism

TIBET
LHASA: Mahayana Buddhism

TOGO
LOME: Voodoo

TUNISIA
MAHDIA: Ishmaelism

TURKEY
EDIRNE: Islam
KONYA: Sufism
ISTANBUL: Greek Orthodox; Islam

UK
AMESBURY, WILTSHIRE: Druidism; Neopaganism
AVEBURY, WILTSHIRE: Druidism
BEDFORD: Christian Scientism
BRISTOL: Congregationalism
CANTERBURY: Anglicanism; Episcopalianism
CERNE ABBAS, DORSET: Wicca
CHIPPING NORTON, OXFORDSHIRE: Wicca
COVENTRY: Anglicanism; Christianity
EAST GRINSTEAD, WEST SUSSEX: Scientology
EDINBURGH: Presbyterianism
GLASTONBURY, SOMERSET: Neopaganism; Wicca
HAVERFORDWEST: Congregationalism
ISLE OF ANGLESEY: Wicca
ISLE OF LEWIS: Neopaganism
ISLE OF WIGHT: Druidism
LEICESTER: Jainism
LIVERPOOL: Orthodox Judaism
LONDON: Anglicanism; Baptistism; Buddhism; Christianity; Episcopalianism; Ishmaelism; Methodism; Pentecostalism; Quakerism; Scientology; Sunni'ism; Unitarianism
LOSTWITHIEL, CORNWALL: Wicca
MANCHESTER: Reform Judaism
NEWCHAPEL, SURREY: Mormonism
NOTTINGHAM: Unitarianism
OXFORD: Baptistism; Episcopalianism; Methodism
SALISBURY: Druidism; Neopaganism
SNOWDONIA NATIONAL PARK: Druidism
THORNBOROUGH, NORTH YORKSHIRE. Druidism
ULVERSTON, CUMBRIA: Quakerism

UXBRIDGE, MIDDLESEX: Pentecostalism
WATFORD, HERTFORDSHIRE: Vaishnavism
YORK: Anglicanism; Episcopalianism

UKRAINE
LVIV: Orthodox Judaism
TOPOROUTZ: Greek Orthodox

US
ARCOLA, ILLINOIS: Amish
ATLANTA, FLORIDA: Baptistism
BALTIC, OHIO: Amish
BALTIMORE, MARYLAND: Methodism
BARRINGTON, RHODE ISLAND: Reform Judaism
BATTLE CREEK, MICHIGAN: Seventh-day Adventism
BOSTON, MASSACHUSETTS: Christian Scientism
CHICAGO, ILLINOIS: Unitarianism
CLEARWATER, FLORIDA: Scientology
CONCORD, NEW HAMPSHIRE: Christian Scientism
DALLAS, TEXAS: Methodism
EASTON, MARYLAND: QuakerismELBERTON, GEORGIA: Wicca
ELKINS PARK, PENNSYLVANIA: Reform Judaism
GORHAM, MAINE: Seventh-day Adventism
HIALEAH, FLORIDA: Santerianism
HOLLYWOOD, CALIFORNIA: Scientology
LANCASTER, LANCASTER COUNTY, PENNSYLVANIA: Amish
LOS ANGELES, CALIFORNIA: Pentecostalism; Scientology
MARION, OHIO: Congregationalism
MEMPHIS, TENNESSEE: Christian Scientism; Pentecostalism
METAIRIE, NEW ORLEANS, LOUISIANA: Protestantism
MIAMI, FLORIDA: Reform Judaism; Santerianism; Voodoo
MORRIS TOWN, NEW JERSEY: Orthodox Judaism
NAUVOO, ILLINOIS: Mormonism
NEWARK, NEW JERSEY: Lutheranism
NEW ORLEANS, LOUISIANA:

Voodoo
NEW YORK: Catholicism; Jehovah's Witnesses
PHILADELPHIA, PENNSYLVANIA: Quakerism
PROVINCE TOWN, MASSACHUSETTS: Unitarianism
SALEM, OREGON: Quakerism
SALT LAKE CITY, UTAH: Mormonism
SANTA FE, NEW MEXICO: Scientology
SAVANNAH, GEORGIA: Reform Judaism
SHELDON, SOUTH CAROLINA: Santerianism
SILVER SPRING, MARYLAND: Seventh-day Adventism
SIMI VALLEY, CALIFORNIA: Seventh-day Adventism
ST GEORGE, UTAH: Jehovah's Witnesses; Mormonism
STODDARD, NEW HAMPSHIRE: Congregationalism
TOPEKA, KANSAS: Pentecostalism
WABAUNSEE, KANSAS: Congregationalism
WASHINGTON DC: Caodaism; Episcopalianism; Presbyterianism; Scientology; Unificationism
WASHINGTON, NEW HAMPSHIRE: Seventh-day Adventism
WICHITA, KANSAS: Lutheranism

UZBEKISTAN
SAMARQAND: Sunni'ism

VIETNAM
TAY NINH: Caodaism

ZAMBIA
VICTORIA FALLS: Presbyterianism

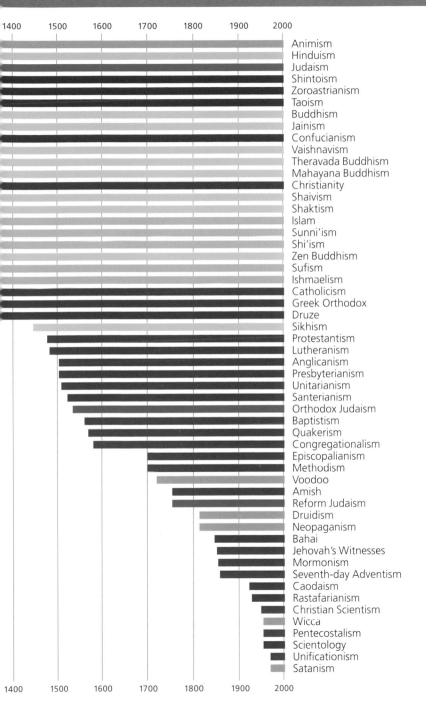

	1400	1500	1600	1700	1800	1900	2000	

Animism
Hinduism
Judaism
Shintoism
Zoroastrianism
Taoism
Buddhism
Jainism
Confucianism
Vaishnavism
Theravada Buddhism
Mahayana Buddhism
Christianity
Shaivism
Shaktism
Islam
Sunni'ism
Shi'ism
Zen Buddhism
Sufism
Ishmaelism
Catholicism
Greek Orthodox
Druze
Sikhism
Protestantism
Lutheranism
Anglicanism
Presbyterianism
Unitarianism
Santerianism
Orthodox Judaism
Baptistism
Quakerism
Congregationalism
Episcopalianism
Methodism
Voodoo
Amish
Reform Judaism
Druidism
Neopaganism
Bahai
Jehovah's Witnesses
Mormonism
Seventh-day Adventism
Caodaism
Rastafarianism
Christian Scientism
Wicca
Pentecostalism
Scientology
Unificationism
Satanism

Scientology
Mormonism
Jehovah's Witnesses
Pentecostalism

Christian Scientism
Seventh-day Adventism

Voodoo
Rastafarianism

KEY: for detailed view, see over

1 Presbyterianism
2 Episcopalianism
3 Wicca
4 Satanism
5 Quakerism
6 Neopaganism
7 Druidism
8 Congregationalism
9 Methodism
10 Anglicanism
11 Baptistism
12 Lutheranism
13 Orthodox Judaism
14 Protestantism
15 Reform Judaism
16 Amish

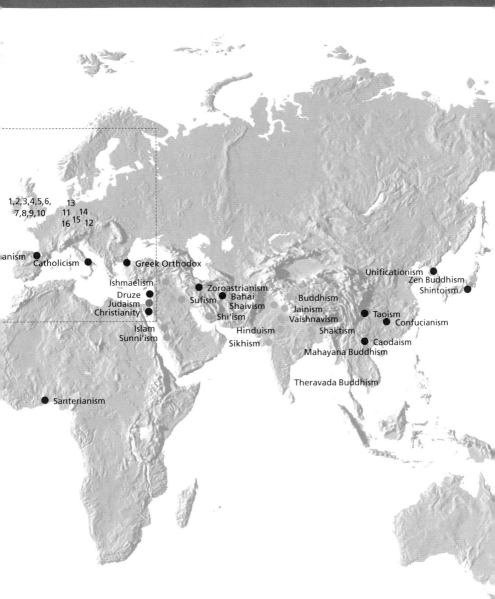

1,2,3,4,5,6,
7,8,9,10 13
 11 14
 16 15 12

anism
 Catholicism

 Greek Orthodox

Unificationism
 Zen Buddhism
 Shintoism

 Ishmaelism
 Zoroastrianism
 Druze Bahai
Judaism Sufism Shaivism
Christianity Shi'ism
 Buddhism
 Jainism
 Vaishnavism Taoism
 Confucianism
 Islam Hinduism Shaktism
 Sunni'ism Sikhism Caodaism
 Mahayana Buddhism

 Theravada Buddhism

 Santerianism

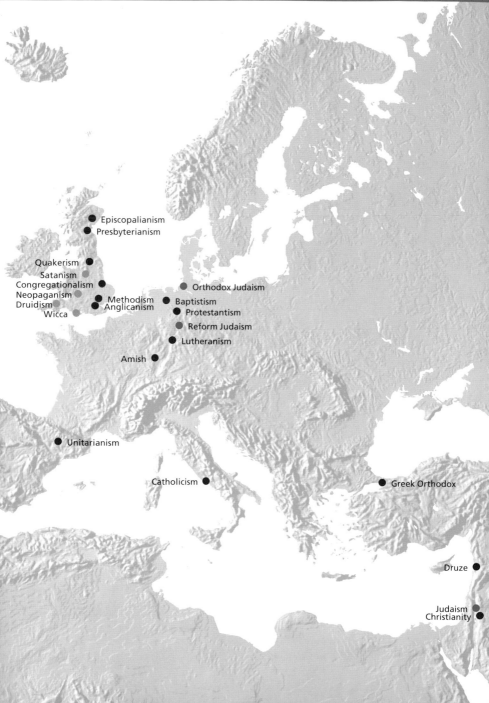

Episcopalianism
Presbyterianism
Quakerism
Satanism
Congregationalism
Neopaganism
Druidism
Wicca
Methodism
Anglicanism
Orthodox Judaism
Baptistism
Protestantism
Reform Judaism
Lutheranism
Amish
Unitarianism
Catholicism
Greek Orthodox
Druze
Judaism
Christianity

Photographic Credits

pp 2, 43 © Summerfield Press/CORBIS

pp 10, 18 © Estate of John David Roberts, by courtesy of The William Roberts Society

pp 12, 23 © Carmen Redondo/CORBIS

pp 13, 14, 33, 34, 60 © The Bridgeman Art Library

pp 15, 24, 30–1, 54 © 1990. Photo Scala, Florence

p 17 © Wolfgang Kaehler/CORBIS

p 19 © Thomas A Heinz/CORBIS

p 20 © 1990. Photo Scala, Florence, courtesy of the Ministero Beni e Att. Culturali

p 25 © Richard T Nowitz/CORBIS

pp 26, 83, 140 © Chris Lisle/CORBIS

p 27 © Yann Arhus-Bertrand/CORBIS

p 28 © Araldo de Luca/CORBIS

p 29 © National Gallery, London

p 31 © Alessandro Bianchi/Reuters/CORBIS

pp 32, 68(t) © Sandro Vannini/CORBIS

p 35 © Svenja-Foto/zefa/CORBIS

p 36 © John Slater/CORBIS

p 37 © Richard Klune/CORBIS

p 38 © The Cleveland Museum of Art, Leonard C Hanna, Jr, Fund 1976.2

p 39 © Vittoriano Rastelli/CORBIS

pp 40-1 © Robert Holmes/CORBIS

p 42 © Flip Schulke/CORBIS

p 44 © Patrick Ward/CORBIS

p 45, 47, 61 © Lee Snider/Photo Images/CORBIS

pp 46, 64-5 © Bettmann/CORBIS

p 48 © Danny Bailey

p 49 © Klaas Lingbeek van Kranen

p 50 © 2006. Photo National Portrait Gallery, Smithsonian/Scala Art Resource/Scala, Florence

p 51 Angelo Hornak/CORBIS

pp 52–3 © Michael Nicholson/CORBIS

p 55 © 1987 The Metropolitan Museum of Art

p 56 Richard Cummins/CORBIS

p 57(t) © Mark E Gibson/CORBIS

p 57(b) © Danny Lehman/CORBIS

p 58 © 2002 General Conference of Seventh-day Adventists. Used by permission

p 59 © Intellectual Reserve, Inc

pp 62–3 © 1990. Photo Opera Metropolitana Siena/Scala, Florence

p 66 © The British Library Board. All rights reserved

p 68(b) © Vanni Archive/CORBIS

pp 70–1 © Reuters/CORBIS

p 72 © CORBIS

p 74 © Nabil Mounzer/epa/CORBIS

p 75 © Ali Haider/CORBIS

p 76 © Chris Heller/CORBIS

pp 77–8 © KM Westermann/CORBIS

p 79 © Jose Fuste Raga/CORBIS

pp 80, 98 © Gustavo Tomsich/CORBIS

pp 82, 113 © Royalty-Free/CORBIS

p 84 © Tibor Bognár/CORBIS

p 85 © The Cleveland Museum of Art. Gift of Katherine Holden Thayer, 1970.62

p 86 © Historical Picture Archive/CORBIS

pp 87, 116 © Adam Woolfitt/CORBIS

p 88 © Craig Lovell

p 89 © Omkarananda Ashram Himalayas, Muni-ki-reti, Rishikesh, India

p 90 © 2003. Photo Scala, Florence/HIP

p 91 © Private Collection, Archives Charmet/The Bridgeman Art Library

p 93 © Lindsay Hebberd/CORBIS

p 94 © Mami Sheehy

pp 92, 95 © David Cumming; Eye Ubiquitous/CORBIS

p 96 © John Sheehy

p 97 © Maurizio Gambarini/dpa/CORBIS

p 99 © Masumi Nakada/zefa/CORBIS

pp 100, 128 © Charles & Josette Lenars/CORBIS

p 101 © Alison Wright/CORBIS

pp 102–3 © Earl & Nazima Kowall/CORBIS

p 104 © Free Agents Ltd/CORBIS

p 106–7 © Catherine Karnow/CORBIS

pp 108, 146 © Dinodia/The Bridgeman Art Library

p 109 © Bennett Dean; Eye Ubiquitous/CORBIS

pp 110, 118, 119 © Homer Sykes/CORBIS

p 112 © Mae Wallace

pp 114–15 © Caroline Penn/CORBIS

p 117 © Roger Ressmeyer/CORBIS

p 120 © Greenhalf Photography/CORBIS

p 121 © Robert Estall/CORBIS

p 122 © Pierre Perrin/Sygma/CORBIS

p 123 © Gianni Dagli Orti/CORBIS

pp 124, 131 © RMN/© Thierry Ollivier

p 126 © Lebedev Alexey

p 127 © The Cleveland Museum of Art, Leonard C Hanna Jr, Fund 1987.3.1

p 129 © ROSHANAK.B/CORBIS SYGMA

p 130 © Michael S Yamashita/CORBIS

p 132 © Liu Liqun/CORBIS

p 133 © Archivo Iconografico, SA/CORBIS

pp 134, 135(l) © Hanan Isachar/CORBIS

p 136 © Bob Krist/CORBIS

p 137 © Daniel Lainé/CORBIS

pp 138 9 © Bahá'í International Community (http://media.bahai.org)

p 141 © Keren Su/CORBIS

p 142 © David Cumming; Eye Ubiquitous/CORBIS

pp 144–5 © Jerzy Dabrowski/dpa/CORBIS

Front cover (left to right, from top)

© Dinodia/The Bridgeman Art Library

© Tibor Bognár/CORBIS

© National Gallery, London

© 1990. Photo Scala, Florence

© Free Agents Ltd/CORBIS

© RMN/© Thierry Ollivier

© 2003. Photo Scala, Florence/HIP

© Michael S Yamashita/CORBIS

© Chris Lisle/CORBIS

© Earl & Nazima Kowall/CORBIS

© Ali Haider/CORBIS

© Estate of John David Roberts, by courtesy of The William Roberts Society

© Sandro Vannini/CORBIS

© Lindsay Hebberd/CORBIS

© Alison Wright/CORBIS

Inside front and back covers

Moses on Mount Sinai and Worship of the Golden Calf, Sistine Chapel, Vatican, Rome, Cosimo Rosselli

© 1990. Photo Scala, Florence

First published in the United States of America in 2007 by
UNIVERSE PUBLISHING
A Division of Rizzoli International Publications, Inc.
300 Park Avenue South
New York, NY 10010
www.rizzoliusa.com

AN IQON BOOK
This book was designed and produced by
Iqon Editions Limited
Sheridan House
112–116a Western Road
Hove BN3 1DD

Publisher, concept and direction:
David Breuer

Design, typesetting and cartography:
Isambard Thomas, London

Editor and Picture Researcher:
Caroline Ellerby

Printed in Singapore by
Star Standard

ISBN-10: 0-7893-1530-0
ISBN-13: 978-0-7893-1530-4

Library of Congress Control Number: 2006909561

2007 2008 2009 2010 /
10 9 8 7 6 5 4 3 2 1

Cover illustration details
(left to right, from top)

Painting of Guru Nanak, Baba Atali gurdwara, Amritsar, Punjab, India (p 108)

Erotic carvings from the sculptures at Khajuraho, Madhya Pradesh, India (p 84)

The Virgin and Child, c. 1515–25, Fiorenzo de Lorenzo (p 29)

Creation of the Sun and Moon and Plants on Earth, 1512, Michelangelo (p 54)

Kinkaku-ji Temple of the Golden Pavilion, Kyoto, Japan (p 104)

Hanging scroll of the Realm of All Mountain Kings and the Six Spirits of the Household, 1600, Ming Dynasty (p 131)

Kali, the dark goddess (p 90)

Taoist yin/yang symbol (p 130)

The Dormition of Mary (p 26)

Carving of the Maitreya Buddha, Lingying Temple, Hangzhou, China (pp 102–03)

Mausoleum of Imam Hussein, Karbala, Iraq (p 75)

The Day of Atonement, 1919, Jacob Kramer (p 18)

Dome of the Rock, Jerusalem, Israel (p 68)

Parsvanatha Temple, Nakoda, Rajasthan, India (p 93)

Nepalese Thangka painting depicting a central image of the bodhisattva Avalokiteshvara (p 101)

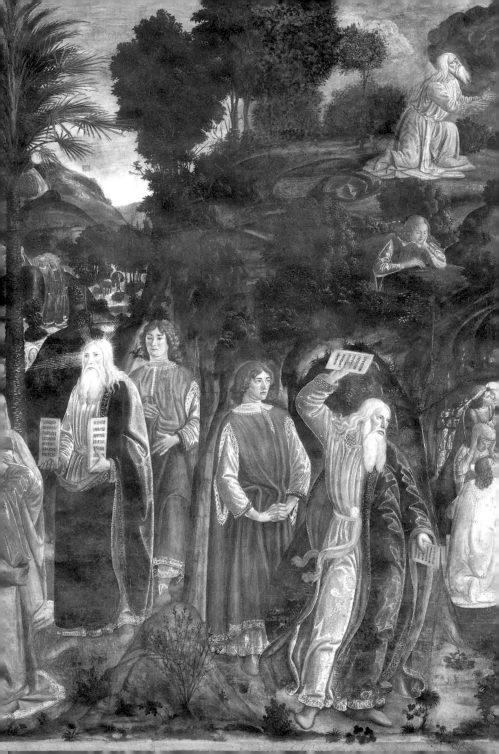